DESERT

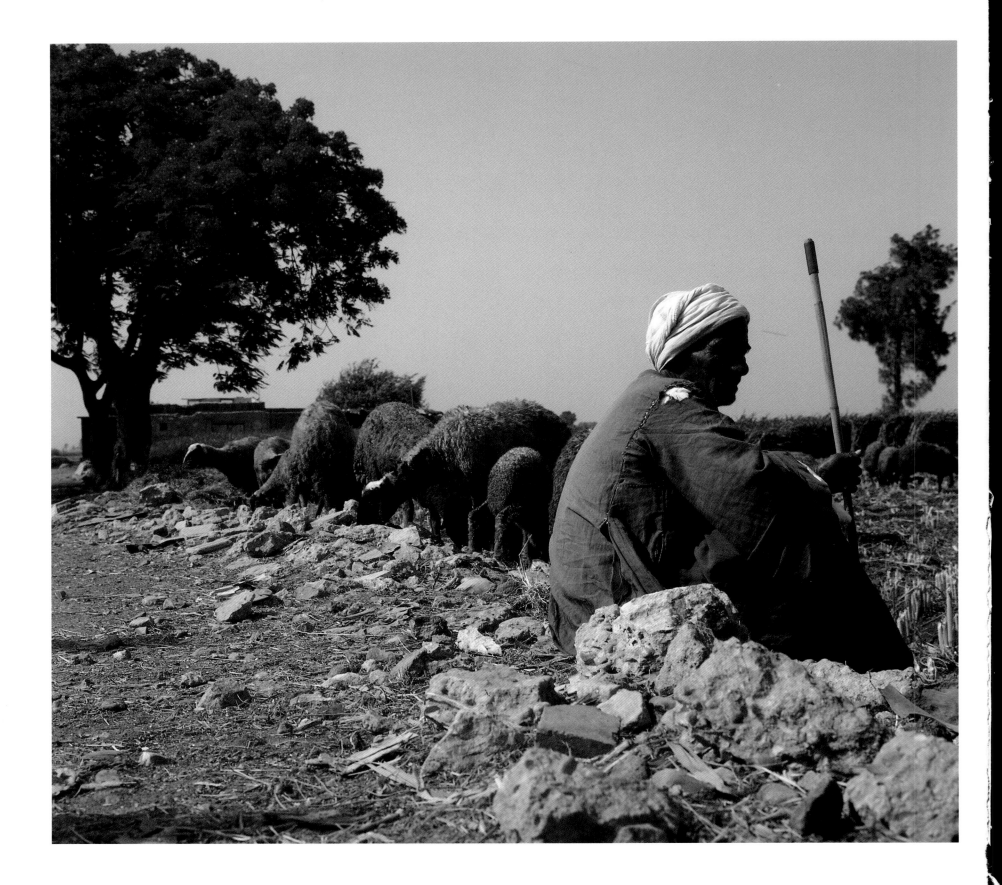

CHRISTOPH HEIDELAUF

DESERT

THE COLOUR OF EGYPT
DIE FARBE ÄGYPTENS
LA COULEUR D'EGYPTE

KÖNEMANN

© 1994 Könemann Verlagsgesellschaft mbH
Bonner Str. 126, D-50968 Köln

Photography and text: Christoph Heidelauf

Design: Peter Feierabend, Berlin
Editing: Bettina Hesse, Cologne
English translation: Michael Hulse
French translation: Marie-Anne Trémeau-Böhm

Typesetting: Zentralsatz Dieter Noe, Cologne
Colour separation: Columbia Offset, Singapore
Printing and binding: Neue Stalling, Oldenburg

Printed in Germany
ISBN 3-89508-043-8

Contents

Inhalt

Sommaire

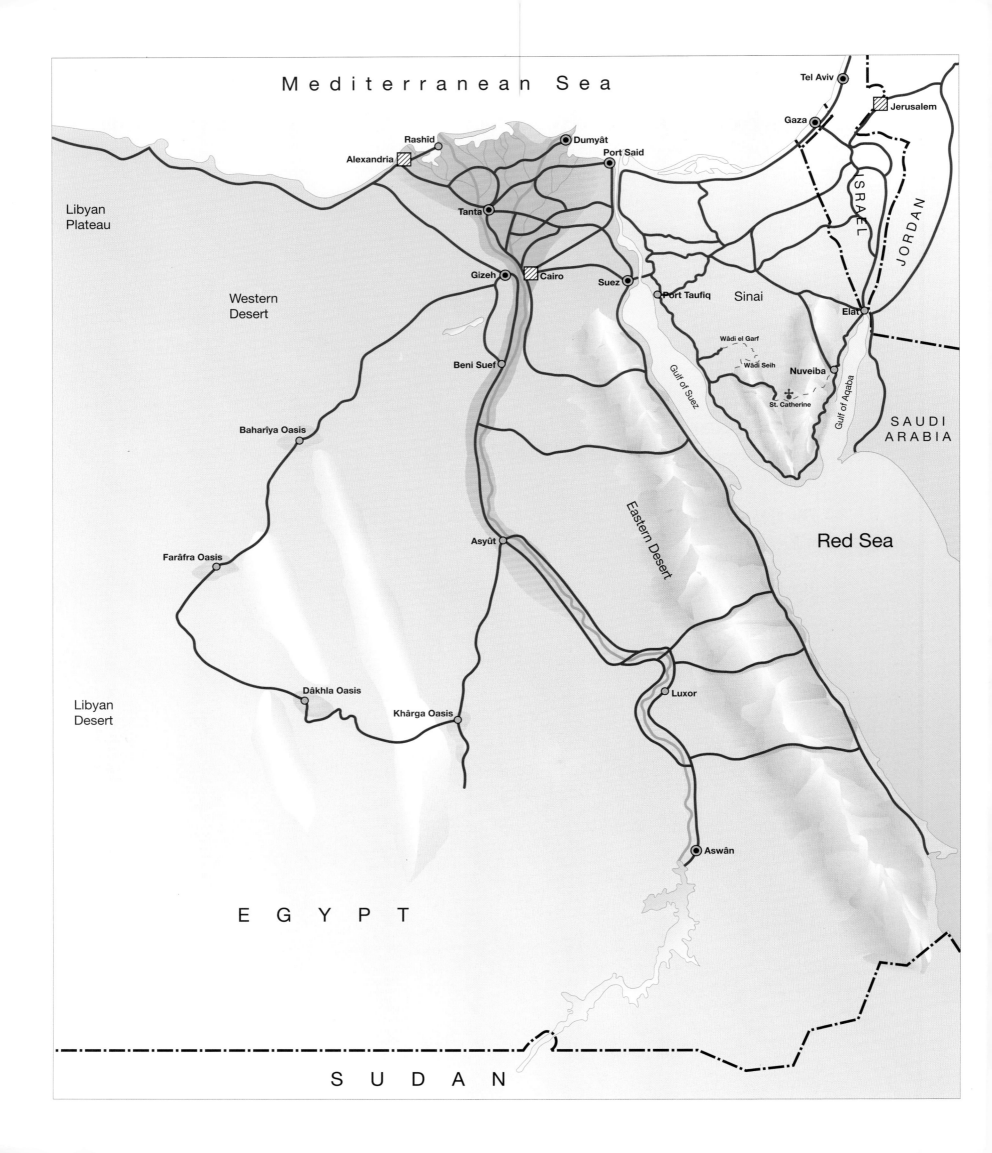

Tacker-tacker-tacker« must mean climbing. Overcoming obstacles. It's not Arabic, nor English, and certainly not German. But it's quite clear what the little man beside me means by the sound, as he mimics climbing with a crook'd index and middle finger and points with outstretched arm at the massive mountain ridge. We have to cross those heights if we're to reach the place I'm after.

And he's off, skipping nimbly as a mountain goat across the sheer face, which affords only scant, smooth purchase to the foot. I follow him cautiously, anxious to keep my balance, a queasy feeling somewhere around my stomach. It takes twenty minutes, and then I'm at the top, where my companion, who has waited for me patiently, offers me his hand. It is a gesture of acceptance, one which I realise is rarely extended to strangers.

Another ten minutes of foot slog lie ahead, along a ridge with steep drops on either side, and then we're at our goal. It's a majestic sight: before me, in finely nuanced shades of white and yellow through to red, bizarre in its shapes, lies a vast canyon.

This is the heart of Sinai. It is a place that seems far from the bustle of life, a place visited only by stray Bedouin. Salim, my companion, clad in headscarf and galabeia, is a Bedouin himself.

I arranged the climb a couple of days earlier after we had camped overnight with our camels down in the canyon.

I lay stretched out on my sleeping bag. The fire was almost out, and in the dying glow of the embers I gazed at my affable companion, busy at his prayers some distance off with his back to me. The little man must have been about fifty, but his gentle, fluid movements as he stood or knelt, softly addressing his god, were those of a child. A sense of exclusion came upon me. The cultural achievements of the world I came from seemed as nothing beside those minutes of humility, calm and tranquillity my companion was experiencing. Poor he might be, but he was contented, and in full possession of a faith that linked him directly with something higher.

It felt embarrassing to go on watching him, and I had to look away. I rolled onto my back and stared up at the night. Above me was the great vault of the starry heavens, the heavens of the desert: vaster, clearer, brighter, and yet nearer than the skies of Europe.

Salim had finished his prayers. He returned to the dying fire in thoughtful mood, squatted beside it, and put out the last of the embers with a stick. Before he lay down to sleep he still had to see to the camel. Climbing a nearby tree, twisting lithe and feline amid the thorny branches, he cut off a

bunch of prickly twigs with his clippers. For some minutes the Bedouin was silhouetted against the deep blue of the night sky; then he was on the ground again, offering his camel the thorny fare he had gathered. To my surprise, the undemanding animal devoured it with obvious relish. There was deliberation in every move the Bedouin made. He gave his full concentration even to the seemingly insignificant; his every step seemed carefully considered; his every action was carried out with the self-same air of serene calm. When he prepared food – a ritual he repeated three times a day with identical ingredients – I couldn't take my eyes off him: I was witnessing a solemn ceremony essentially unchanged among his people for thousands of years.

When I bade Salim farewell, I gave him my thermos flask, the magic of which had fascinated him. In exchange he presented me with a number of rusty keys tied together with cord, and the change of owner seemed a gesture of immense dignity.

From Nuveiba, a beach resort on the Gulf of Aqaba, I moved on to the Sinai plateau, this time travelling by car once again. The road was newly surfaced, and cut the peninsula diagonally in half. After a number of snaking switchbacks and a considerable gradient, the country opened out into a stony desert waste. The hostile inhospitality of the area discourages even the Bedouin from going there.

Then, around the Mitla Pass (which saw fierce fighting in the Six-Day War), some thirty kilometres from the entrance to the Suez Canal Tunnel, I came upon burnt-out trucks, howitzers and jeeps on either side of the road. It was a gigantic graveyard of military hardware: shot to pieces, blown up, smashed. Tanks, half concealed by sand dunes, aimed their cannon at me. Dead black spiders in the sand. The eerie memorials of senseless bloodshed.

I turned off south at the sign that read *St. Catherine*. For a while, the road ran parallel to the bank of the Red Sea, then, after the *Spring of the Pharaohs,* angled off left into the interior. A short time later I reached *Djebel Mousa,* the mountain of Moses, at the foot of which the famed monastery nestles amongst the crags. The monks are not of the Coptic (Egyptian Christian) order, but Greek Orthodox.

The view from the summit of *Mt. Sinai* is breath-taking. There, according to biblical tradition, Moses received the tablets of the Law. From the top, you gaze far across the rugged, rocky terrain of Sinai, where chasms yawn and mountain ridges seam the horizon. It is a landscape that now towers, now plunges, now rages with geological fury and now is at rest. Strips of reddish brown

run like veins through the rocks, like the pathways where blood courses through an organism of stone. This is Nature as a sublime artist, of infinite diversity and imaginative power – an artist whose tools are the wind and the sand. And water, too, which at some remote time immemorial, when mighty torrents flowed about these rocks, hollowed them out, breaking them, sculpting them. The job was completed by the filing wind and the sand. Deeply affected, I began the descent; and the steps hewn into the rock the whole way from the monastery to the summit (by a diligent monk who took twenty years to complete his task, undertaken to fulfil a vow) finished off my already shaky leg muscles.

Next day, the *Blue Mountains*. Not far from the monastery of *St. Catherine*, a sandy track branched off the tarmac road and led to a plateau: vast, tranquil, meditative. There I spent a day and a night absorbing the impact of that land art, created from October to December 1980 by Jean Verame, the Belgian artist.
The night, at that height, was cold; the sky was pitch-black; and an unusually biting wind blew from the north-west, forcing me onward at sunrise. At the *Springs of the Pharaohs,* where hot sulphurous waters pour from the rocks and warm the Red Sea to localized temperatures as high as 40° C, I rested briefly.

My plan to cross Sinai via Wadi El Garf and Wadi El Biyar was brought to nought two days later by the Ras El Gineina, the immense, impassable ridge that bars the way in the heart of Sinai. Offroad gears and obstacle differentials are powerless to tackle the incline.
But I did find the *Forest of Pillars,* one of the most bizarre legacies of Creation: corkscrew pillars of stone rising from the ground to heights of two metres, looking for all the world like slender, charred tree-trunks after a forest fire. On the return drive through the Wadi Seih, the majestic mountain landscape of Sinai again unfolded before me. The rough crag formations, the deep and narrow chasms, and the broad, dried-out river beds, afforded a prospect of the silent and primaeval that prompted thoughts of an archaic world.

As I approached Port Taufiq, the checkpoint across from the city of Suez, my line of vision was suddenly log-jammed with ships – huge tankers apparently plotting a course through the sands. Beyond Gizeh I filled up the car and the reserve drum, the pump attendant wastefully pouring diesel on the ground. A few kilometres further on I came to the turn-off for Bahariya.

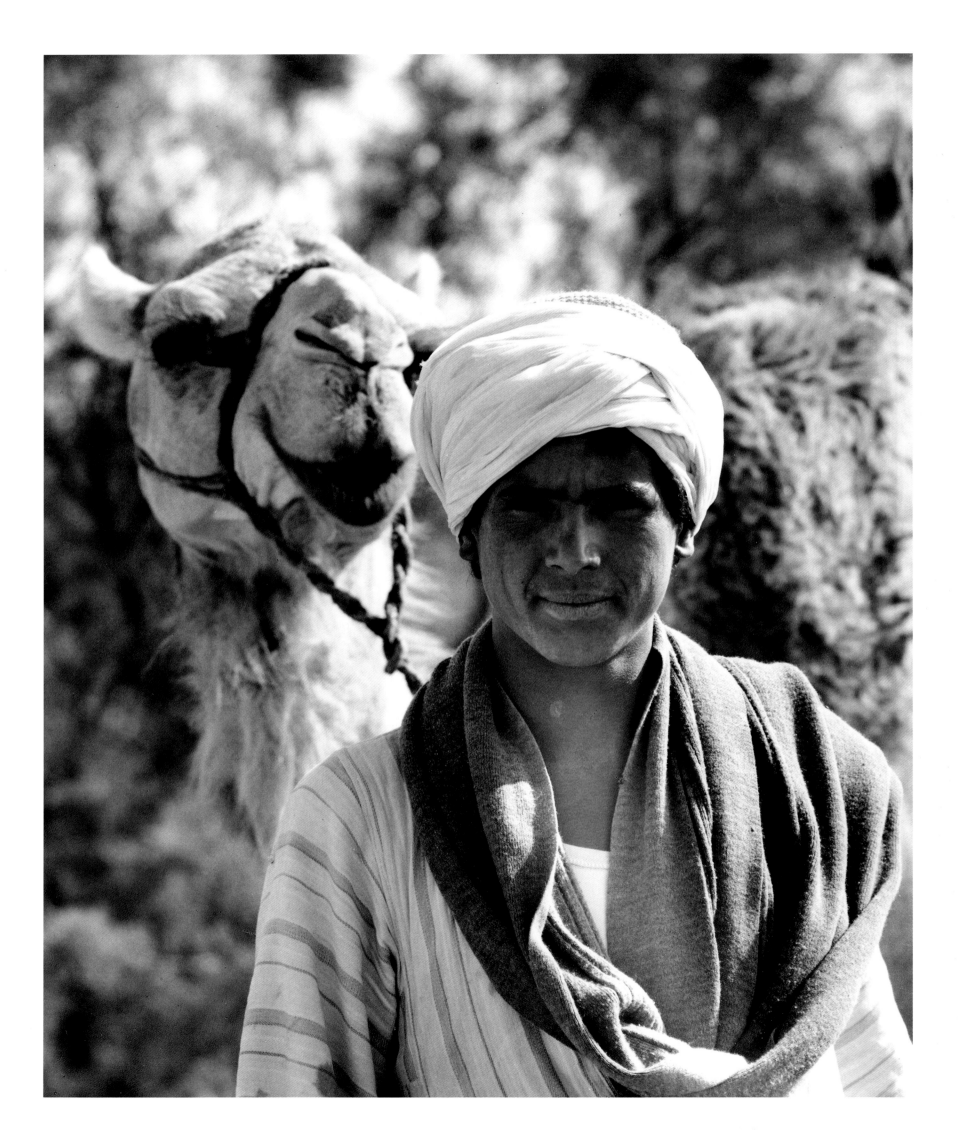

The cauldron of Cairo lay behind me. Before me lay deserts of yellow vastness: the Sahara. Only the desert highway, a black strip running straight as an arrow westward, broke its endlessness. The sudden solitude mantled me in a welcome breath of stillness, that unmistakable silence of the desert, a silence one supposes one can *hear*, a silence in which the sound of the bloodstream in the inner ear can seem a fantastical audio-mirage.

The tarmac track traced its path across the level monotony of the sand and boulders like an outsize finger pointing the way. A clapped-out truck thundered by, daringly overloaded. And then I was alone again. Before I reached the Baharia valley, where a steep declivity marks the oasis region, the landscape abruptly came alive. There were table mountains, and the rocks shimmered a bluish grey in the glaring sunlight, contrasting gently with the yellow of the sand.

A few hundred kilometres to the south, a small distance from Farafra, a quiet and remote oasis where life had been conducted at the same pace for countless generations, I left the road again and made for the fabulous world of the *White Desert*. It is a grotesque fruit of evolution, far from human kind. In the year zero or 2000 it will have looked the same. Time is immaterial there. Time shrinks, warps, vanishes – as if it could be gauged only in millennia. The clockwork of human civilization ticks to a different rhythm; the desert knows neither minute nor hour, and days or months are as nothing. A pebble may come loose. Limestone may flake. A crack in a rock may widen. And that, as a year passes by, then ten years, is that. My own vantage point, at a modest height on a rocky ridge, offered me a view of the whole surreal theatre – where mankind has no part to play – as if from a box.

As midday approached, the scene changed abruptly; another act on the natural stage began. Out west, the sky turned a menacing yellow, then a dirty grey, and broad daylight was transformed into the darkness of night. The wind picked up, mounted to a storm, and was soon mercilessly lashing sand at the vehicle's windscreen. I waited for the storm to pass; it took all of six hours to do so. That was the first of four sandstorms I drove into.

By way of Dakhla oasis, where fertile fields seem to ride like succulent green islands on a sea of sand, I reached the El Kharga district. A sleepy market town may be found there, a little place that threatens to become a soulless concrete outpost thanks to the water supply laid on by a central administration. Enormous migrant dunes, their majestic crests upbuilt in elegant, rhythmic lines towards the sun, »eat away« at the tarmac strip as if intent on averting any intrusion by civilization into a natural Creation as yet intact.

Ahmed the Bedouin,
proud owner of 50 camels.

Ahmed, der Beduine,
stolzer Besitzer von 50 Kamelen

Ahmed le bédouin, fier propriétaire
de cinquante dromadaires

The road twisted up steeply out of the oasis depression in a series of tight switchbacks that recalled roads in the Alps. Once I had made it to the top, and before I moved on to the Nile (where the bankside traffic would roar in an infernal din), I paused one more time to savour the silence and the magnificent view across the infinite desert. It is not consistent in tonality, not a level plain, not a flat surface. Rather, it is a thing of many shapes and colours. There are red vastnesses, purple and blue vastnesses, yellow and black and white vastnesses. There are rocks, hills, mountains. There are mountains like tables, like ninepins; rocks like trees, like pillars, rocks in which one sees faces. The faces of birds. The faces of devils.

A real face comes back to mind, that of Ahmed, the young lord over fifty camels, a son of the desert fit to be a Berber prince, who wore his galabeia as a king wears his robes, and whose roots gave a pride to his features that is only seen, in our time, in peoples who live close to Nature.

Ahead, before the banks of the Nile, lay 250 more kilometres of sand, boulders and stones. The highway was a treacherous thing; with its tarmac surface softened by the heat, and sharp stones poking out, it was more like a plank studded with nails. Drifts of sand blocked the road. Time and again the engine had its work cut out to fight free of the yielding ground. The outside temperature rose to 50° C. The air shimmered above the horizon, where nothing could be seen but endless, yellowish-brown vastness. In the end I quit the road and followed a trail that someone I imagined as my scout had printed in the sand, till somewhere south of the town of Asyut I hit the Nile. Abruptly, the desert was at an end. In its place there was fertile arable land. It was a seam where two realities impacted visibly upon each other.

There were mud huts, a village of biblical cast that might have survived millennia unchanged. Date palms. Sleepy donkeys. A stray dog. And the majestic passage of feluccas gently working their way on the waters. Women in brightly coloured clothing, shrieking, bawling children, all came running up to see the stranger. Soon I was encircled, hemmed in, even alarmed. Days and nights of solitude in the desert, where the alternation of euphoric and depressed states of mind had become the normal condition of life, had stripped me of my sense of the simple things of everyday existence.

Suddenly I felt I had to go back. I had to take a last walkabout. Wrapped head to foot, a ghost from far-off Europe, with a tune in my head: Beethoven's Ninth. An echo of the Creation.

Tacker – tacker – tacker« bedeutet soviel wie klettern, überwinden. Es ist weder Arabisch, noch Englisch, schon gar nicht Deutsch, doch indem der kleine Mann neben mir seine Hand mit gekrümmtem Zeige- und Mittelfinger durch die Luft wandern läßt und dabei mit dem freien Arm auf einen gewaltigen Bergrücken deutet, wird mir klar, was er meint: Da also müssen wir noch rüber, um an die Stelle zu gelangen, die ich suche.

Schon tänzelt der Mann behende wie eine Bergziege quer über die steile Wand, deren wenige glatte Vorsprünge den Füßen nur minimalen Halt geben. Vorsichtig balancierend, mit flauem Gefühl in der Magengegend, folge ich ihm. Nach zwanzig Minuten bin ich oben und mein Begleiter, der geduldig auf mich gewartet hat, streckt mir die Hand entgegen. Ich weiß, daß es Anerkennung bedeutet und eine Geste ist, die Fremden nur selten zuteil wird.

Nach weiteren zehn Minuten Fußmarsch über einen schmalen, rechts und links steil abfallenden Grad, haben wir es geschafft. Der Anblick ist gewaltig: unter mir erstreckt sich ein Canyon in bizarren Formen und Farben, deren Palette feinster Nuancen von weiß über gelb bis rot reicht. Wir befinden uns im Herzen des Sinai, an einem Ort, der allem Leben entrückt scheint und nur von Menschen betreten wird, die hier vereinzelt leben, den Beduinen. Salim, mein Begleiter, bekleidet mit Kopftuch und Galabeia, ist einer von ihnen. Diese Tour hatte ich mit ihm verabredet, nachdem wir zwei Tage zuvor bei einem Kameltrip dort unten im Canyon für die Nacht gelagert hatten.

Ich lag ausgestreckt auf dem Schlafsack. Das Feuer war fast erloschen, im Widerschein der letzten Glut betrachtete ich den freundlichen kleinen Mann, der in einiger Entfernung, mir den Rücken zugewandt, sein Gebet verrichtete. Er mochte etwa 50 Jahre alt sein, doch seine fließenden und sanften Bewegungen waren wie die eines Kindes, wenn er sich erhob und auf die Knie sank und mit leisen Worten zu seinem Gott sprach. In diesem Moment überkam mich ein Gefühl des Ausgeschlossenseins, die kulturellen Errungenschaften der Welt, aus der ich kam, zerfielen zur Wertlosigkeit angesichts der Minuten voll Demut, Ruhe und Gelassenheit, wie sie dieser Beduine gerade empfinden mußte: arm aber zufrieden und in vollem Besitz eines Glaubens, der ihn auf direkte Weise mit etwas Höherem verband.

Ich mußte mich abwenden, da es mir peinlich wurde, ihn weiter zu beobachten. Ich drehte mich auf den Rücken und schaute in die Nacht. Über mir wölbte sich ein Sternenhimmel, wie man ihn nur in der Wüste findet: voller, klarer, heller und näher als in Europa.

Salim hatte sein Gebet beendet, kam nachdenklich zur Feuerstelle zurück, hockte sich nieder und löschte mit einem Stöckchen die letzten Glutreste. Bevor er sich schlafen legte, galt es noch das Kamel zu versorgen. Dazu erklomm er einen nahegelegenen Baum, schlängelte sich katzenhaft durch das dornenreiche Geäst und schnitt ein Bündel stacheliger Zweige ab. Für Minuten hob sich der Körper des Beduinen silhouettenhaft gegen den dunkelblauen Nachthimmel ab. Dann war er schon wieder unten und reichte seinem Kamel das dornige Futter, das dieses genügsame Tier zu meiner Verwunderung mit offensichtlichem Genuß verzehrte.

Jede Bewegung des Beduinen vollzog sich mit Bedacht, voll Konzentration auch auf das scheinbar Nebensächlichste, jeder seiner Schritte schien sorgsam überlegt, und jede Handlung geschah mit einer fast feierlichen Ruhe. Wenn er das Essen zubereitete, ein Ritual, das er dreimal am Tag mit den immer gleichen Zutaten vollzog, war ich jedesmal der gespannte Zuschauer einer feierlichen Zeremonie, wie Menschen seiner Herkunft sie seit Jahrtausenden ohne Veränderung zelebrieren.

Als ich mich von Salim verabschiede, überreiche ich ihm meine Thermoskanne, deren magische Funktion ihn fasziniert hatte. Als Gegengeschenk erhalte ich einige angerostete, mit einer Kordel zusammengehaltene BKS-Schlüssel, die mit würdevoller Geste ihren Besitzer wechseln.

Von Nuveiba aus, dem Badeort am Golf von Aqaba, dringe ich – nun wieder mit dem Wagen – ins Hochplateau des Sinai vor. Die Straße ist frisch geteert und zerschneidet die Halbinsel diagonal in zwei Hälften. Nach einigen Serpentinen und einem beachtlichen Anstieg der Strecke weitet sich die Landschaft zu einer öden steinigen Wüste. Die lebensfeindliche Unwirtlichkeit dieses Gebiets wird selbst von Beduinen gemieden.

Dann, um den im 6-Tage-Krieg hart umkämpften Mitla-Paß, 30 Kilometer vor der Einfahrt in den Suezkanaltunnel, entdecke ich links und rechts der Straße ausgebrannte LKWs, Haubitzen, Jeeps: ein gigantischer Friedhof von zerschossenem, gesprengtem und geborstenem Kriegsmaterial. Halb hinter Dünen versteckte Panzer zielen mit ihren Rohren auf mich. Schwarze tote Spinnen im Sand. Gespenstische Mahnmale sinnlosen Blutvergießens.

Bei dem Hinweisschild *St. Catherine* biege ich in Richtung Süden ab. Die Straße verläuft einige Zeit parallel zum Ufer des Roten Meeres und knickt dann, nahe den *Pharaonenquellen,* links ins Landesinnere ab. Wenig später erreiche ich den *Gebel Musa,* den Mosesberg, an dessen Fuße

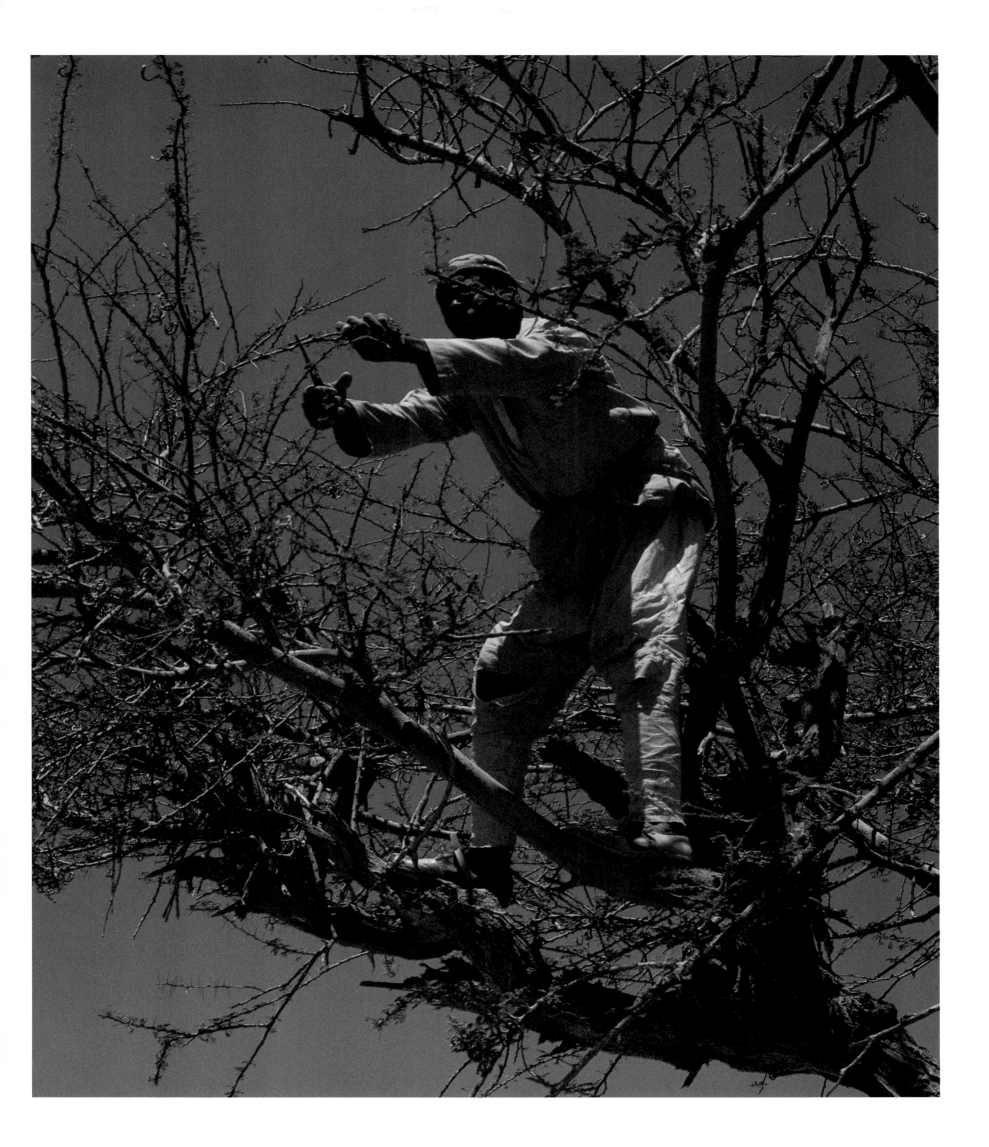

sich das berühmte Kloster in die Felsen schmiegt. Es wird nicht von Kopten, den ägyptischen Christen, sondern von griechisch-orthodoxen Mönchen bewirtschaftet. Atemberaubend ist der Blick vom Gipfel jenes Berges, auf dem der Legende nach Moses die Gesetzestafeln empfangen haben soll. Die Sicht öffnet sich über die zerklüftete Felsenlandschaft des Sinai: Schluchten brechen auf, Bergkämme säumen den Horizont. Es türmt sich und fällt und ragt und ruht. Rotbraune Streifen durchziehen wie Adern den Fels. Venen und Aorten, Blutbahnen eines steinernen Organismus'. Die Natur in der Rolle der erhabenen Künstlerin, unendlich in ihrer Vielfalt und Phantasie. Ihre Werkzeuge: der Wind und der Sand. Auch Wasser, vor undenklicher Zeit, als Ströme und reißende Fluten den Fels wuschen, höhlten, brachen und formten. Den Rest tat der Wind mit seiner Feile, dem Sand. Benommen steige ich hinab. Die Stufen, die ein emsiger Mönch nach einem Gelübde in 20jähriger besessener Arbeit vom Kloster bis zum Gipfel des Berges in den Fels gehauen hat, geben meiner Beinmuskulatur den Rest.

Anderntags dann, die *Blauen Berge.* Unweit des Katharinenklosters zweigt eine Sandpiste von der asphaltierten Straße ab und endet auf einem Hochplateau von stiller, meditativer Weite. Hier bleibe ich einen Tag und eine Nacht, um das Werk des belgischen Künstlers Jean Verame, der diese *land art* von Oktober bis Dezember 1980 schuf, auf mich wirken zu lassen. Die Nacht hier oben ist kalt, pechschwarz der Himmel, und von Nordwesten weht ein ungewöhnlich scharfer Wind, der mich bei Sonnenaufgang zum Aufbruch veranlaßt. An den *Pharaonenquellen,* wo heißes, schwefelhaltiges Wasser dem Berg entströmt und das Rote Meer stellenweise auf 40 Grad erwärmt, mache ich eine kurze Rast.

Mein Plan, den Sinai durch die Wadis El Garf und El Biyar zu durchqueren, scheitert zwei Tage später am Ras el Gineina, einem gewaltigen Bergrücken, der mir im Zentrum des Sinai wie ein unüberwindbarer Riegel den Weg versperrt. Die Steigung ist selbst mit eingelegtem schweren Geländegang und Sperrdifferenzial nicht zu schaffen. Doch immerhin finde ich den *Forest of Pillars,* ein bizarres Meisterwerk der Schöpfung aus korkenzieherähnlichen Steinsäulen, die wie schlanke verkohlte Baumstümpfe nach einer Feuersbrunst bis zu zwei Metern Höhe aus dem Boden ragen. Die Rückfahrt durch das Wadi Seih eröffnet mir noch einmal die gigantische Berglandschaft des Sinai, dessen schroffe Felsformationen, schmale tiefe Schluchten und breit ausladende, vertrocknete Flußbetten sich zu einem Bild stiller archaischer Urwüchsigkeit verdichten.

Als ich mich Port Taufiq nähere, dem Kontrollpunkt gegenüber der Stadt Suez, säumen unvermittelt Schiffe den Horizont. Gigantische Tanker, die gemächlich ihre Bahn durch den Sand ziehen.

Hinter Gizeh lasse ich noch einmal volltanken und die Reservekanister füllen, wobei der Tankwart wie üblich hemmungslos das Diesel verschlabbert. Dann, einige Kilometer weiter erreiche ich die Abzweigung Richtung Bahariya.

Der Hexenkessel Kairo liegt hinter mir, und vor mir erstreckt sich in endloser gelber Weite die Sahara. Durchbrochen wird sie nur vom schwarzen Band der Wüstenpiste, das schnurgerade nach Westen verläuft. Die plötzliche Einsamkeit umfängt mich wie ein stiller wohltuender Hauch. Es ist jene unverwechselbare Stille der Wüste, die man zu hören glaubt, in der das Rauschen des Blutes in den Ohren zur phantastischen Wahrnehmung wird.

Die Teerpiste bohrt sich in die platte öde Ebene aus Sand und Geröll wie ein überdimensionaler Finger, der die Richtung weist. Ein klappriger LKW donnert vorbei, abenteuerlich überladen, dann bin ich wieder allein.

Vor der Bahariya-Senke, deren Steilabfall das Areal der Oase markiert, beginnt die Landschaft plötzlich zu leben. Tafelberge tauchen auf, der Fels schimmert blau-grau in der gleißenden Sonne, sanft kontrastiert vom Gelb des Sandes.

Einige hundert Kilometer südlich dann, kurz vor Farafra, der stillen weit abgeschiedenen Oase, in der das Leben seit unzähligen Generationen im gleichen Rhythmus verläuft, verlasse ich die Piste erneut, um einzutauchen in die Wunderwelt der *Weißen Wüste,* diesem bizarren Produkt der Evolution abseits menschlicher Existenz. Im Jahre Null. Im Jahr Zweitausend. Die Zeit verschiebt sich, schrumpft zusammen, hebt sich auf, als wäre Zeit hier ein Faktor, der nur in Jahrtausenden merkbar zu messen ist. Die Uhr der Zivilisation schlägt in einem anderen Rhythmus. Die Uhr der Wüste kennt keine Minuten, keine Stunden. Ein Tag, ein Monat ist nichts: ein Kiesel löst sich, ein Kalkstein blättert ab, ein Riß im Fels wird etwas größer und ein Jahr oder zehn sind vergangen... Mein Standplatz, etwas erhöht auf einem Felsrücken, erlaubt mir diese surreale Theaterkulisse, in der der Mensch als Akteur keinen Platz findet, wie aus der Loge heraus zu betrachten.

Gegen Mittag ändert sich die Szenerie schlagartig. Ein anderer Akt auf der Bühne der Natur beginnt. Der Himmel gegen Westen verfärbt sich bedrohlich gelb, bald schmutzig grau, dann bricht am hellichten Tag die Nacht herein. Der Wind nimmt zu, schwillt zum Sturm an und peitscht schließlich den Sand unerbittlich gegen das Heck des Wagens. Ich warte sechs Stunden, bis es vorbei ist. Es war der erste von vier Sandstürmen, in die ich geraten sollte.

Über die Oase Dakhla, deren fruchtbare Felder wie saftige grüne Inseln auf einem Meer von Sand zu schwimmen scheinen, erreiche ich das Gebiet um El Kharga, einen kleinen verträumten Marktflecken, der durch ein Bewässerungsprojekt der Zentralverwaltung zur seelenlosen Beton-siedlung zu entarten droht.

Riesige Wanderdünen, die ihren gewaltigen Rücken in sanftem Schwung der Linienführung majestätisch gegen die Sonne recken, »fressen« hier, Kraken gleich, die Teerpiste, als wollten sie jeglichen zivilisatorischen Eingriff in die Unberührtheit der Natur verhindern.

In engen Serpentinen, die an eine alpine Bergstrecke erinnern, windet sich die Straße den Steil-hang der Oasen-Senke hinauf. Oben angelangt genieße ich, bevor ich den Nil erreiche, an dessen Ufern sich der Verkehr zum infernalischen Getöse verdichten wird, noch einmal die Stille und den grandiosen Blick über die endlose Weite der Wüste. Sie zeigt sich nicht Ton in Ton, ist nicht Ebene, nicht Fläche. Vielgestaltig in Farbe und Form dehnt sie sich aus. Rote Weite, violette, blaue Weite, gelbe Weite, schwarze, weiße Weite. Felsen, Hügel, Gebirge. Berge wie Tische, wie Kegel, Felsen wie Bäume, wie Säulen, einige wie Gesichter. Vogelgesichter. Dämonengesichter.

Und ein reales Gesicht taucht aus der Erinnerung auf: Das des Menschen Ahmed, des jungen Herrschers über 50 Kamele, Sohn der Wüste, vom Format eines Berberfürsten, der seine Galabeia trug wie ein König seine Robe, und dessen Herkunft seinen Zügen jenen Stolz verlieh, wie er nur noch Naturvölkern eigen ist.

Vor mir, bis zu den Ufern des Nils, liegen noch 250 Kilometer Sand, Geröll und Steine. Die Piste ist tückisch und gleicht durch ihren aufgeweichten Teerbelag, aus dem spitze Steine ragen, eher einem Nagelbrett. Sandverwehungen versperren den Weg. Der Motor muß ganze Arbeit leisten, um sich wieder und wieder aus dem nachgebenden Boden freizukämpfen. Die Außentemperatur steigt auf 50 Grad. Die Luft liegt flirrend über dem Horizont, der nichts freigibt als endlose, gelb-braune Weite. Schließlich verlasse ich das Nagelbrett und folge einer Spur, die ein imaginärer Scout für mich in den Sand gewalzt hat. Irgendwo südlich der Stadt Asyut stoße ich auf den Nil. Abrupt endet die Wüste, um sich von einem Meter zum nächsten in fruchtbares Ackerland zu verwandeln. – Ein Riß zwischen zwei Wirklichkeiten. – Lehmhütten tauchen auf, ein Dorf aus biblischen Zeiten, unverändert durch die Jahrtausende. Dattelpalmen, dösende Esel, ein streunender Hund und der majestätische Zug sanft auf dem Wasser treibender Feluken. Frauen in

El Qasr, Dakhla oasis El Qasr, Oase Dakhla El Qasr, oasis de Dakhléh

bunten Tüchern und Kinder, die schreiend und johlend dem Fremden entgegenrennen. Bald bin ich umringt, eingekesselt und … verschreckt. Die Tage und Nächte allein mit der Stille der Wüste, in der das Wechselspiel zwischen Euphorie und Depression zur dauerhaften Erfahrung wird, haben mir das Gefühl für die einfachen Dinge des Lebens genommen.

Es treibt mich plötzlich noch einmal zurück, und ich wandere ein letztes Mal umher, verschleiert in Tüchern – ein Gespenst aus dem fernen Europa. Mit einer Melodie im Kopf: Beethovens Neunte – eine Reminiszenz an die Schöpfung …

Tacker-tacker-tacker» signifie grimper, surmonter. Ce n'est ni de l'arabe, ni de l'anglais, ni de l'allemand, mais tandis que le petit homme agite à côté de moi une main dont l'index et le majeur sont déformés, tout en montrant avec son bras libre une immense croupe de montagne, je comprends ce qu'il veut dire: il faut que nous passions par là pour parvenir à l'endroit que je cherche.

L'homme cabriole déjà comme une chèvre de montagne à travers la paroi escarpée dont les rares saillies ne donnent aux pieds qu'un minimum de prise. Je le suis en veillant à garder l'équilibre, avec une drôle de sensation au creux de l'estomac. Au bout de vingt minutes, je parviens au sommet, et mon guide, qui m'a patiemment attendu, me tend la main. Je sais que c'est un signe d'approbation rarement octroyé à un étranger.

Au bout de dix minutes de marche sur une étroite crête en pente raide, à droite et à gauche, nous touchons au but. La vue est superbe: à mes pieds s'étend un canyon aux formes bizarres dont les couleurs subtilement nuancées vont du blanc au rouge, en passant par le jaune.

Nous sommes au cœur du Sinaï, en un lieu qui semble soustrait aux regards du monde et où seuls s'aventurent les hommes qui vivent ici, isolés, les bédouins. Salim, mon guide, vêtu d'un chèche et d'une galabia en est un. Nous avions convenu de cette excursion deux jours auparavant, alors que nous passions la nuit en bas, dans le canyon, au cours d'un voyage à dos de chameau.

J'étais allongé sur mon sac de couchage. Le feu était presque éteint; à la lueur de la dernière braise, je regardais l'aimable petit homme qui, à quelque distance de là, faisait sa prière, le dos tourné. Il pouvait avoir une cinquantaine d'années, mais ses mouvements souples et doux étaient comme ceux d'un enfant quand il se levait, s'agenouillait et parlait tout bas à son Dieu. Je me sentis alors exclu, les conquêtes culturelles du monde dont je venais perdaient toute valeur face aux minutes remplies d'humilité, de calme et de sérénité que le petit homme devait éprouver à ce moment précis: pauvre, mais satisfait, et en pleine possession d'une foi qui le liait directement à quelque chose de plus haut.

Je dus me détourner, car il m'était pénible de continuer à l'observer. Je me mis donc sur le dos et regardai la nuit. Au-dessus de moi, un ciel étoilé comme on en voit seulement dans le désert formait une voûte plus pleine, plus claire et plus proche qu'en Europe.

Salim avait fini de prier. Il revint, pensif, vers le feu, s'accroupit et éteignit les dernières braises avec un bâtonnet. Avant de se coucher, il lui fallut encore s'occuper du dromadaire. Il escalada

donc un arbre proche, se faufila comme un chat à travers les branchages hérissés d'épines et coupa une botte de rameaux épineux avec des ciseaux. Pendant quelques instants, le corps du bédouin se détacha, silhouetté sur le ciel nocturne bleu foncé. Il ne tarda pas à descendre et tendit à son dromadaire la nourriture épineuse que ce sobre animal consomma, à mon grand étonnement, avec un plaisir évident.

Tous les mouvements de ce bédouin étaient circonspects, se concentraient sur ce qui semblait le plus insignifiant; chacun de ses pas avait l'air soigneusement réfléchi, et chacun de ses actes se déroulait dans un calme solennel. Quand il préparait le repas, un rituel qu'il accomplissait trois fois par jour avec les mêmes ingrédients, j'étais chaque fois le spectateur passionné d'une cérémonie analogue à celles que célèbrent ses semblables depuis des milliers d'années sans rien y modifier.

Quand je prends congé de Salim, je lui offre ma thermos dont la fonction magique l'avait fasciné. En échange, il me fait cadeau de quelques clefs rouillées reliées les unes aux autres par un cordon, qui changent de propriétaire dans un geste digne.

De Nouveiba, la station balnéaire du Golf d'Aqaba, je traverse – de nouveau en voiture – le haut-plateau du Sinaï. La route est fraîchement goudronnée et coupe la péninsule en diagonale. Après quelques virages en épingle à cheveux et une sensible montée du parcours, le paysage se transforme en désert rocailleux. Même les bédouins évitent cette région inhospitalière, voire hostile. Ensuite, autour du col de Mitla, où se déroulèrent de rudes combats pendant la guerre des Six jours, trente kilomètres avant l'entrée du tunnel du canal de Suez, je découvre à gauche et à droite de la route des camions calcinés, des obusiers, des jeeps: un gigantesque cimetière de matériel de guerre criblé de balles, dynamité et éclaté. Des chars à moitié cachés derrière les dunes me visent avec leurs canons. Araignées, noires et mortes, dans le sable. Monuments fantomatiques du sang absurdement versé.

Au panneau indicateur *Sainte-Catherine,* je tourne en direction du Sud. Pendant quelque temps, la route suit la rive de la mer Rouge, puis elle fait un coude près des *sources du pharaon,* à gauche, vers l'intérieur du pays. Peu après, j'arrive au *Djebel Mousa,* le mont Moïse, au pied duquel le célèbre monastère se blottit contre la roche. Il n'est pas exploité par les coptes, les chrétiens égyptiens, mais par des moines grecs-orthodoxes.

La vue que l'on a depuis le sommet du Sinaï, la montagne sur laquelle Moïse aurait reçu les tables de la Loi, est époustouflante. Elle s'ouvre sur le paysage déchiqueté du Sinaï: des gorges apparaissent, des crêtes montagneuses bordent l'horizon. Cela s'entasse, tombe, se dresse et repose tour à tour. Des rayures brun-rouge parcourent la roche comme des artères. Veines et aortes, circuits sanguins d'un organisme de pierre. La nature dans le rôle de l'artiste noble, infinie dans sa diversité et sa fantaisie. Ses outils: le vent et le sable. L'eau, aussi: il y a très longtemps, les fleuves et les flots lavèrent, creusèrent, cassèrent et formèrent la roche. Le vent fit le reste avec sa lime, le sable. Tout étourdi, je descends les marches qu'un zélé moine tailla dans la roche par suite d'un vœu, durant vingt ans de travail acharné, depuis le monastère jusqu'au sommet de la montagne, et cela m'achève.

Le lendemain, j'arrive aux *Montagnes bleues*. Non loin du monastère Sainte-Catherine, une piste de sable part de la route goudronnée et se termine sur un haut-plateau propice au calme et à la méditation. J'y passe un jour et une nuit, laissant opérer l'œuvre de l'artiste belge Jean Verame qui créa ce *land art* entre octobre et décembre 1980.
Ici, la nuit est froide, le ciel noir comme jais; un vent extraordinairement vif souffle du Nord-Ouest et m'oblige à partir au lever du soleil. Je fais une petite halte aux *sources du pharaon,* où de l'eau sulfureuse chaude jaillit de la montagne et échauffe par endroits la mer Rouge à une température de 40°C.

J'avais l'intention de traverser le Sinaï en passant par les oueds El Garf et El Biyar, mais échoue deux jours plus tard au Ras el Gineina, une puissante croupe de montagne qui me barre la route en plein milieu du Sinaï, comme un obstacle insurmontable. La montée n'est pas faisable, même après avoir passé la vitesse tout terrain et mis le différentiel à verrouillage.
Je trouve toutefois la *Forest of Pillars* – un bizarre chef-d'œuvre de la création composé de colonnes de pierres ressemblant à des tire-bouchons, qui s'élèvent jusqu'à deux mètres de haut, comme de sveltes souches d'arbre noircies après un incendie. Le retour au travers de l'oued Seih m'ouvre une fois encore le gigantesque paysage montagneux du Sinaï dont les formations rocheuses escarpées, les gorges étroites et profondes, et les lits de rivières, larges et à sec, se réduisent à une image d'une naïveté archaïque et paisible.
Près de Port Taufiq, le point de contrôle situé en face de Suez, l'horizon est soudain bordé de bateaux. Ce sont des pétroliers géants qui se frayent lentement un chemin à travers le sable.

Après Guizèh, je fais encore le plein et laisse remplir les bidons; comme d'habitude, le pompiste fait gicler le carburant diesel. Quelques kilomètres plus loin, j'arrive au croisement en direction de Bahariéh.

Je laisse derrière moi le tohu-bohu du Caire; devant moi, la vaste étendue jaune du Sahara s'étend à perte de vue. Elle est seulement interrompue par le noir ruban de la piste qui s'étire en ligne droite vers l'Ouest. La brusque solitude m'entoure comme un souffle paisible et bienfaisant. C'est la paix unique du désert que l'on croit entendre et où le bruissement du sang dans les oreilles se transforme en perception fantastique.

La piste goudronnée s'enfonce dans la plaine déserte de sable et d'éboulis comme un énorme doigt indiquant la direction à prendre. Un vieux tacot surchargé me dépasse dans un bruit de ferraille; ensuite, je suis de nouveau seul. Avant la dépression de Bahariéh, dont la pente abrupte marque la zone de l'oasis, le paysage se met soudain à vivre. Des montagnes à plateau surgissent, la roche luit d'un gris bleuté sous le soleil éclatant, formant un doux contraste avec le sable jaune. Quelques centaines de kilomètres plus au Sud, peu avant Farafréh, la tranquille oasis solitaire, où la vie se déroule au même rythme depuis d'innombrables générations, je quitte de nouveau la piste pour plonger dans le monde merveilleux du *désert blanc,* bizarre produit de l'évolution à l'écart de toute vie humaine. En l'an zéro. En l'an 2000. Le temps recule, se réduit, s'annule, comme si le temps était un facteur uniquement mesurable en milliers d'années. L'horloge de la civilisation bat à un autre rythme. L'horloge du désert ne connaît ni les minutes ni les heures. Un jour, un mois n'est rien: un caillou se détache, une pierre calcaire s'effrite, une fissure dans le rocher s'agrandit, et un an ou dix ont passé … Mon poste, un peu surélevé sur une crête rocheuse, me permet de contempler cette coulisse surréelle, où l'homme ne trouve pas de place en tant qu'acteur, comme depuis une loge.

Vers midi, le décor change brusquement. Un autre acte commence sur la scène de la nature.

A l'Ouest, le ciel est d'un jaune menaçant, puis d'un gris sale, et la nuit tombe en plein jour.

Le vent s'intensifie, devient tempête et finit par fouetter impitoyablement le sable contre l'arrière de la voiture. Pendant six heures, j'attends que cela se termine. C'était la première des quatre tempêtes de sable que je devais essuyer.

Je traverse l'oasis de Dakhléh, dont les champs fertiles semblent nager comme des îles verdoyantes sur une mer de sable, et arrive dans la région de Khargéh, petite bourgade paisible,

Waterwheel at El Qasr. Wasser-Schöpfrad in El Qasr Noria, El Qasr

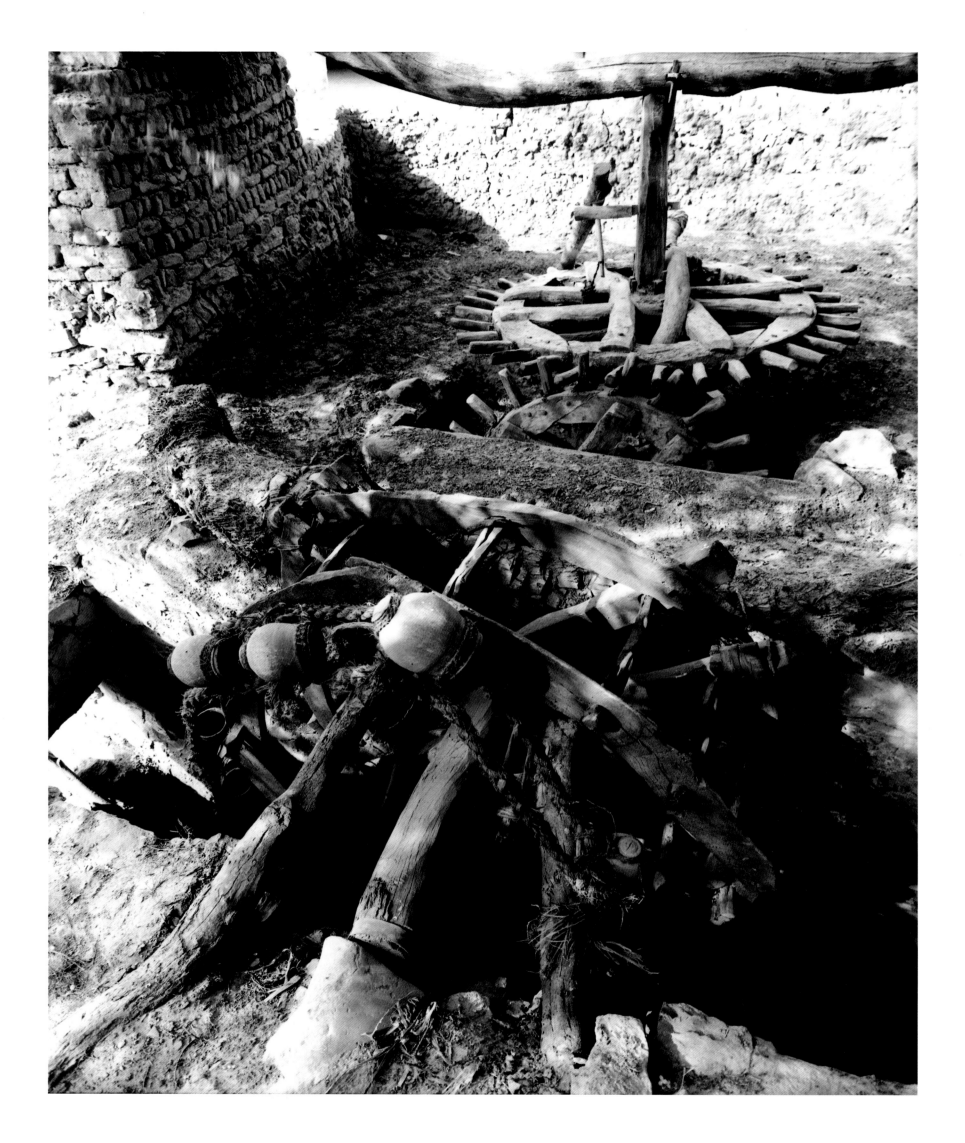

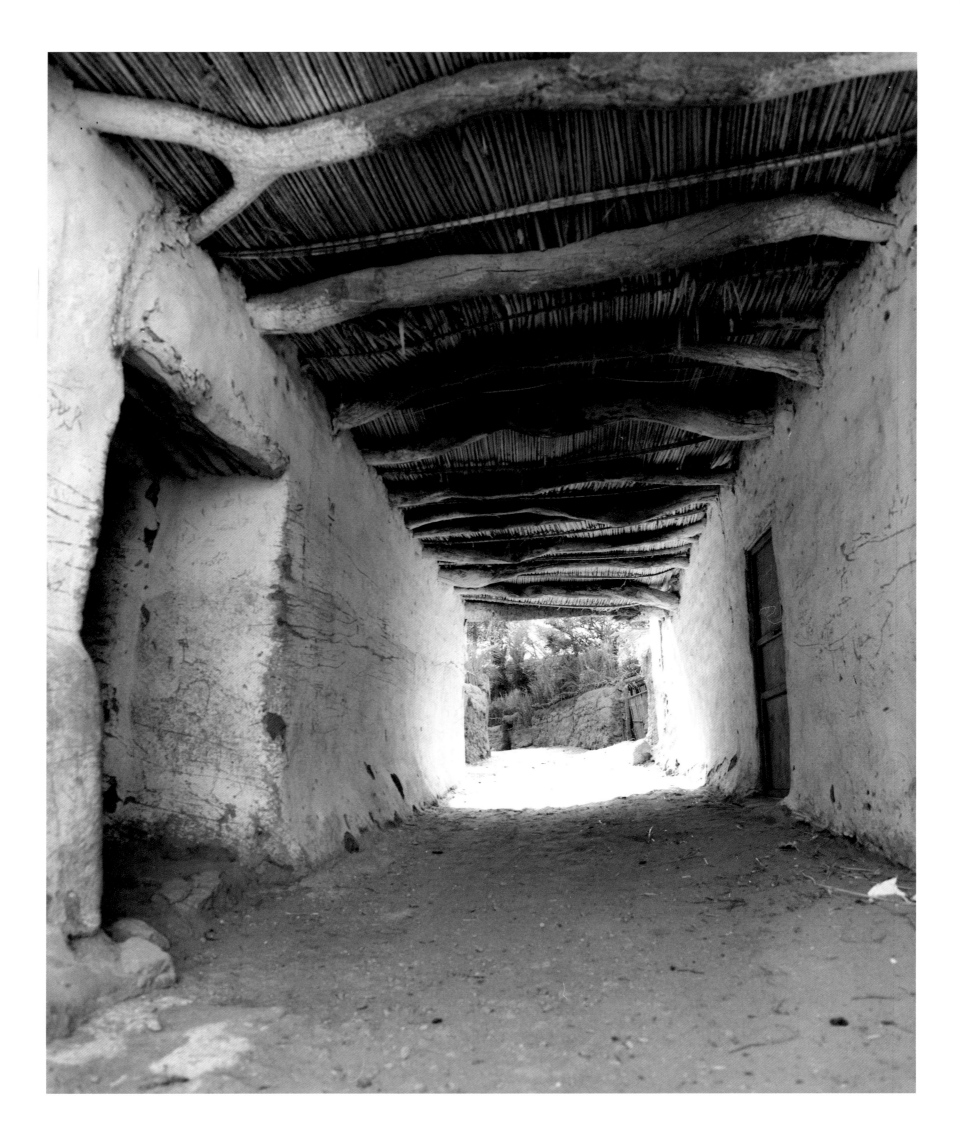

qui menace de dégénérer en cité de béton sans âme par suite d'un projet d'irrigation caressé par l'administration.

D'immenses dunes mouvantes, qui étirent majestueusement leurs puissantes croupes vers le soleil, avec un doux mouvement du tracé, «dévorent», telles des pieuvres, la piste goudronnée, comme si elles voulaient empêcher toute intervention civilisatrice dans la nature vierge.

La route escalade le versant abrupt de la dépression de l'oasis en empruntant d'étroits lacets rappelant les circuits alpins. Parvenu au sommet, je jouis une fois encore du silence et de la vue grandiose sur l'immensité du désert, avant d'atteindre le Nil et ses rives où la circulation fait un vacarme d'enfer. Le désert n'est pas ton sur ton, il n'est ni plaine ni surface, mais s'étend dans une grande variété de formes et de couleurs. Etendue rouge, étendue bleue, violette, étendue jaune, étendue noire, blanche. Rochers, collines, montagnes. Montagnes comme des tables, comme des cônes, rochers comme des arbres, comme des colonnes, certains comme des visages. Visages d'oiseaux. Visages de démons.

Et un visage réel surgit du souvenir. Celui d'Ahmed, jeune maître de 50 dromadaires, fils du désert, de la classe d'un prince berbère, qui portait sa galabia comme un roi porte sa robe, et dont l'origine donnait à ses traits la fierté caractéristique des peuples primitifs.

Devant moi, jusqu'aux rives du Nil, s'étendent encore 250 kilomètres de sable, d'éboulis et de pierres. La piste est perfide et ressemble plutôt à une planche à clous avec sa couche de goudron ramollie dont jaillissent des pierres pointues. Des amas de sable obstruent le chemin. Le moteur peine pour se dégager du sol qui se dérobe. La température extérieure monte jusqu'à 50°C. L'air vibre au-dessus de l'horizon qui montre seulement une étendue sans fin, d'un brun jaunâtre. Je finis par quitter la planche à clous et suis une piste qu'un scout imaginaire a tracée pour moi dans le sable. Quelque part au Sud d'Assiout, je rencontre le Nil. Le désert se termine brusquement pour se métamorphoser en fertile terre labourée. Fissure entre deux réalités.

Des cabanes en torchis surgissent, village des temps bibliques, non altéré par les milliers d'années. Des dattiers, des ânes somnolents, un chien vagabond et la majestueuse procession de felouques glissant doucement au fil de l'eau. Des femmes vêtues de tissus multicolores et des enfants qui courent au-devant de l'étranger en criant et hurlant. Je suis bientôt entouré, encerclé et …

A lane covered with beams and reed thatch for protection against the scorching sun	Gasse, überdacht mit Balken und Schilfrohr gegen die brennende Sonne	Ruelle recouverte de poutres et de roseaux pour protéger contre les brulûres du soleil

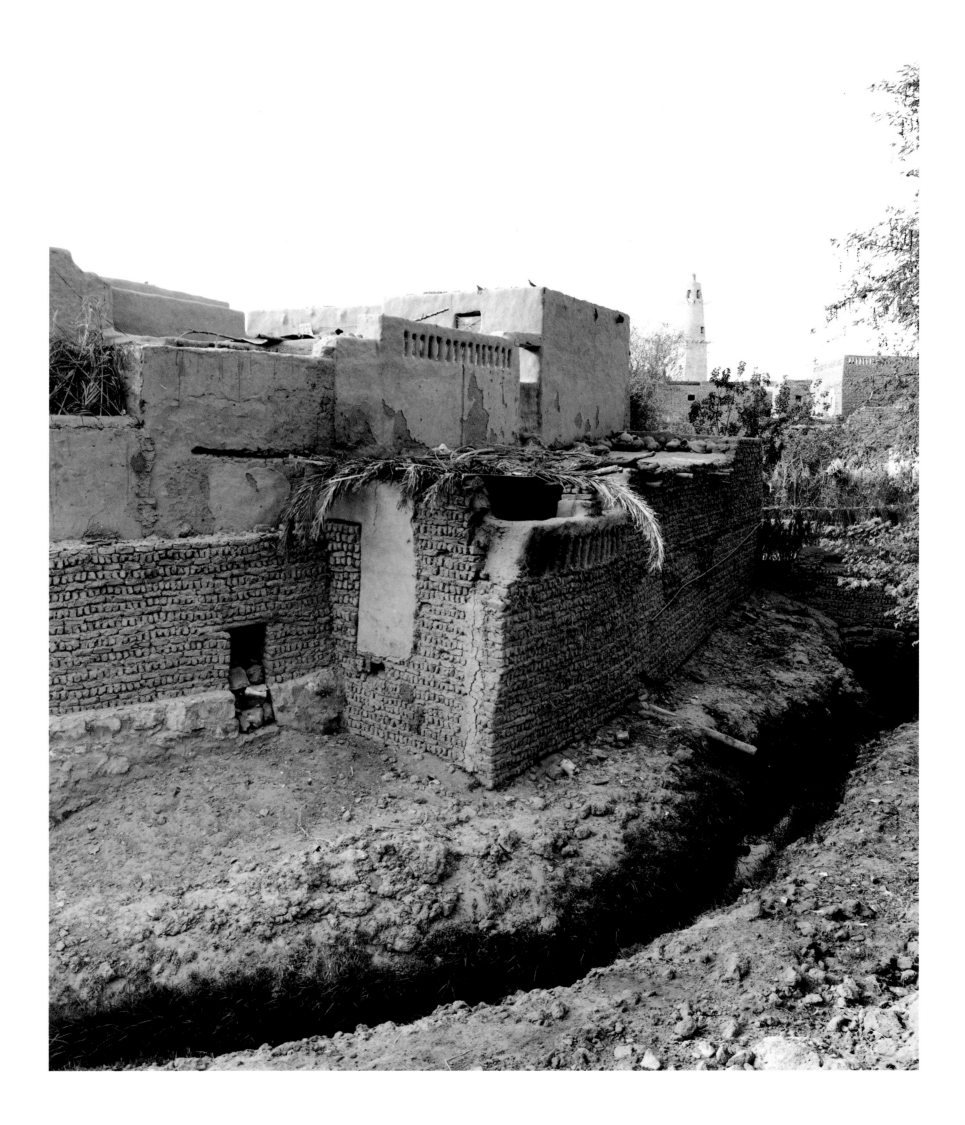

effrayé. Les jours et les nuits que j'ai passés seul dans le calme du désert, où alternent l'euphorie et la dépression, m'ont ôté le sens des choses simples de la vie.

J'éprouve soudain le besoin de m'en retourner, et il faut que je vagabonde une dernière fois: dissimulé sous des étoffes – fantôme de la lointaine Europe. Avec une mélodie en tête: La Neuvième Symphonie de Beethoven – une réminiscence de la création …

Dakhla, the prettiest of the oases in the Libyan desert, consists of ten settlements with a total population of some 35,000. The ancient village of El Qasr recalls biblical times when life was still led after a natural rhythm. With its picturesque lanes, weatherworn walls of sundried brick, shady squares and lush vegetation, it is a memorable place. Above it all towers a minaret spiked with defensive bars to ward off incursions.

Dakhla, die landschaftlich reizvollste der Oasen in der Lybischen Wüste, besteht aus zehn Ortschaften und beherbergt ca. 35 000 Menschen. Das uralte Dorf El Qasr erinnert an biblische Zeiten, in denen das Leben noch im Rhythmus mit der Natur pulsierte. Malerische Gassen, verwitterte Lehmziegel-Mauern, schattige Plätze und eine üppige Vegetation prägen den Ort, hoch überragt von einem Minarett, gespickt mit Wehrbalken gegen Eindringlinge.

Dakhléh, la plus charmante oasis du désert libyque, est composée de dix villages où vivent environ 35 000 personnes. Le village séculaire d'El Qasr, où la vie se déroule encore au rythme de la nature, rappelle les temps bibliques. Les rues pittoresques, les murs en brique d'argile rongés par le temps, les places ombragées et la végétation luxuriante donnent leur empreinte à la localité, qui est dominée par un minaret et bardée de poutres afin de repousser les intrus.

The Libyan desert

Die Lybische Wüste

Le désert libyque

The Pyramids of Gizeh (from the west)
Die Pyramiden von Giseh (von Westen)
Les pyramides de Guizèh (Ouest)

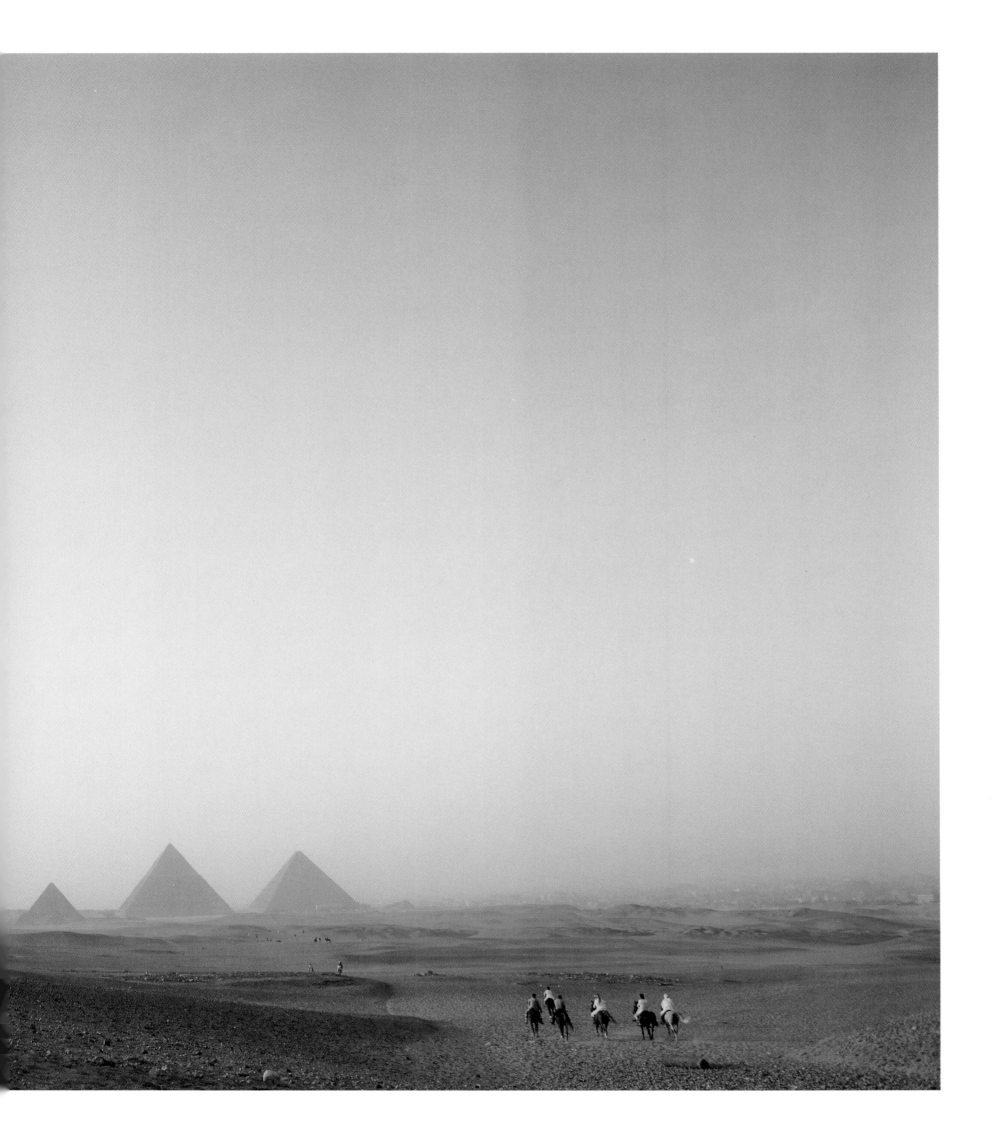

The Bahariya Oasis

Oases are commonly supposed to be green areas in the midst of surrounding desert. In fact, it would be apter to see them as depressions in the land where a number of settlements cluster. At the Bahariya, for instance, which is pent in by steep slopes on every side, there are three distinct settlements where the ground water reaches the surface along geological fault lines.

Oase Bahariya

Nach landläufiger Meinung werden Oasen als grüne Flecken inmitten der Wüste betrachtet. Richtiger ist, daß Oasen das Areal einer Depression (Bodensenkung) markieren, auf der meist mehrere Ortschaften entstanden. So finden sich in der Oase Bahariya, die von einem mächtigen Steilanstieg umgeben ist, drei verstreute Ansiedlungen, in denen das Grundwasser am Ende tektonischer Bruchlinien an die Oberfläche tritt.

Oasis de Bahariéh

Une opinion communément répandue dans le pays tient les oasis pour des taches vertes au milieu du désert. Il est plus exact de dire que les oasis marquent la zone d'une dépression où plusieurs localités ont généralement vu le jour. On trouve ainsi dans l'oasis de Bahariéh, qui est entourée d'une grande pente escarpée, trois villages éparpillés, où la nappe phréatique apparaît à la surface à l'extrémité des lignes de faille.

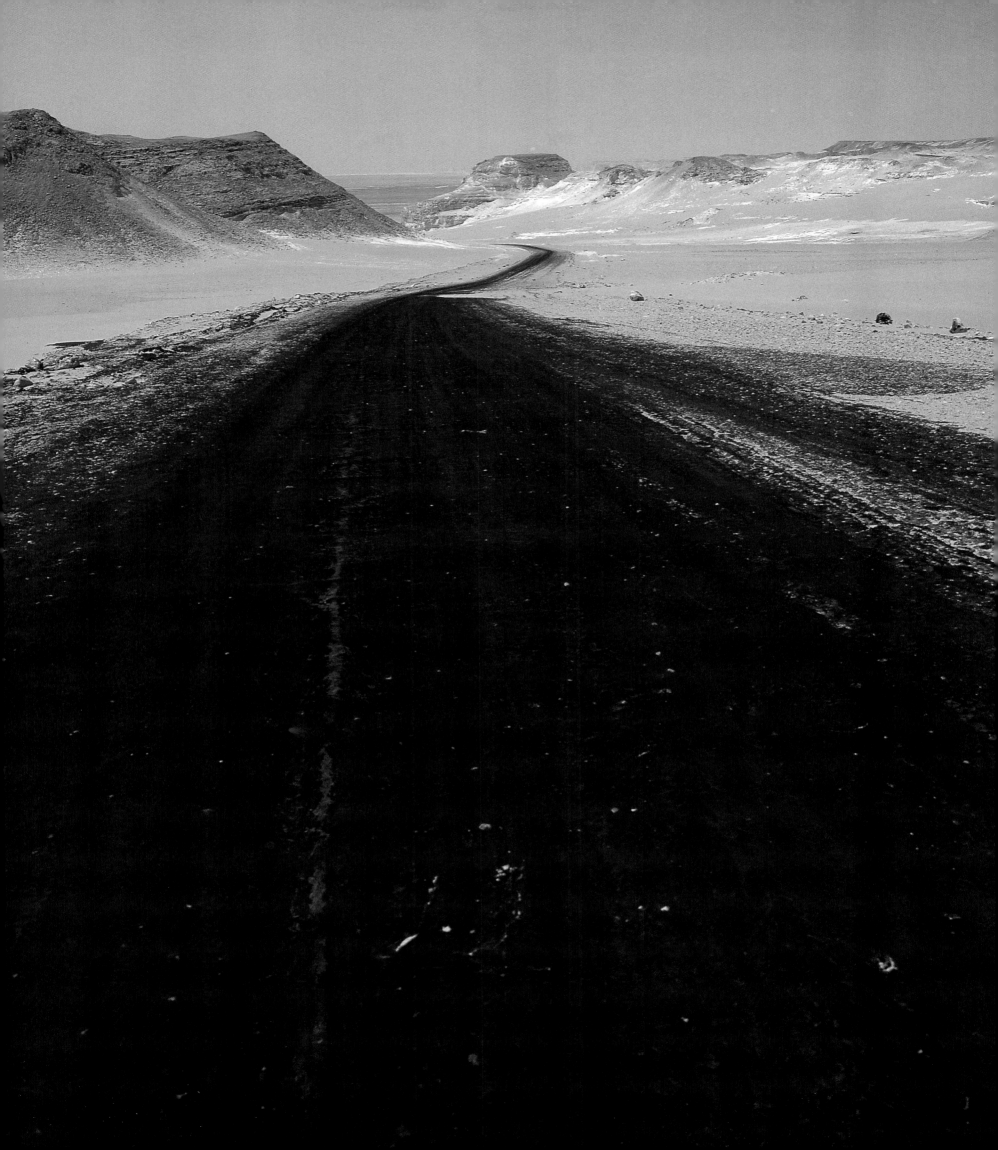

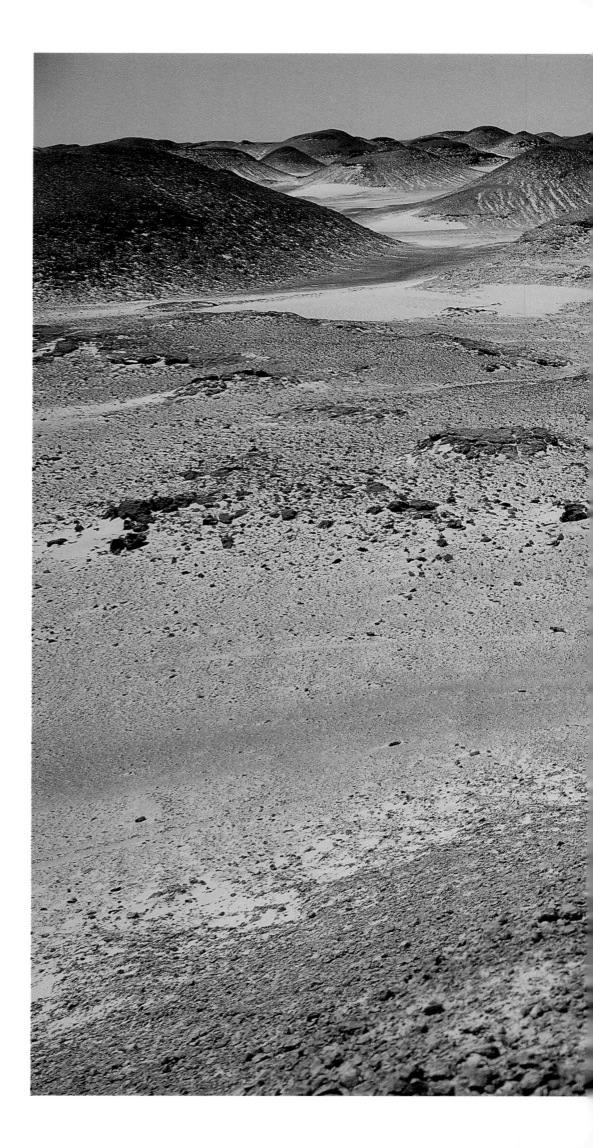

The »humped desert« near Gizeh
Die »Buckelwüste«, nahe Giseh
Le «désert bossu», près de Guizèh

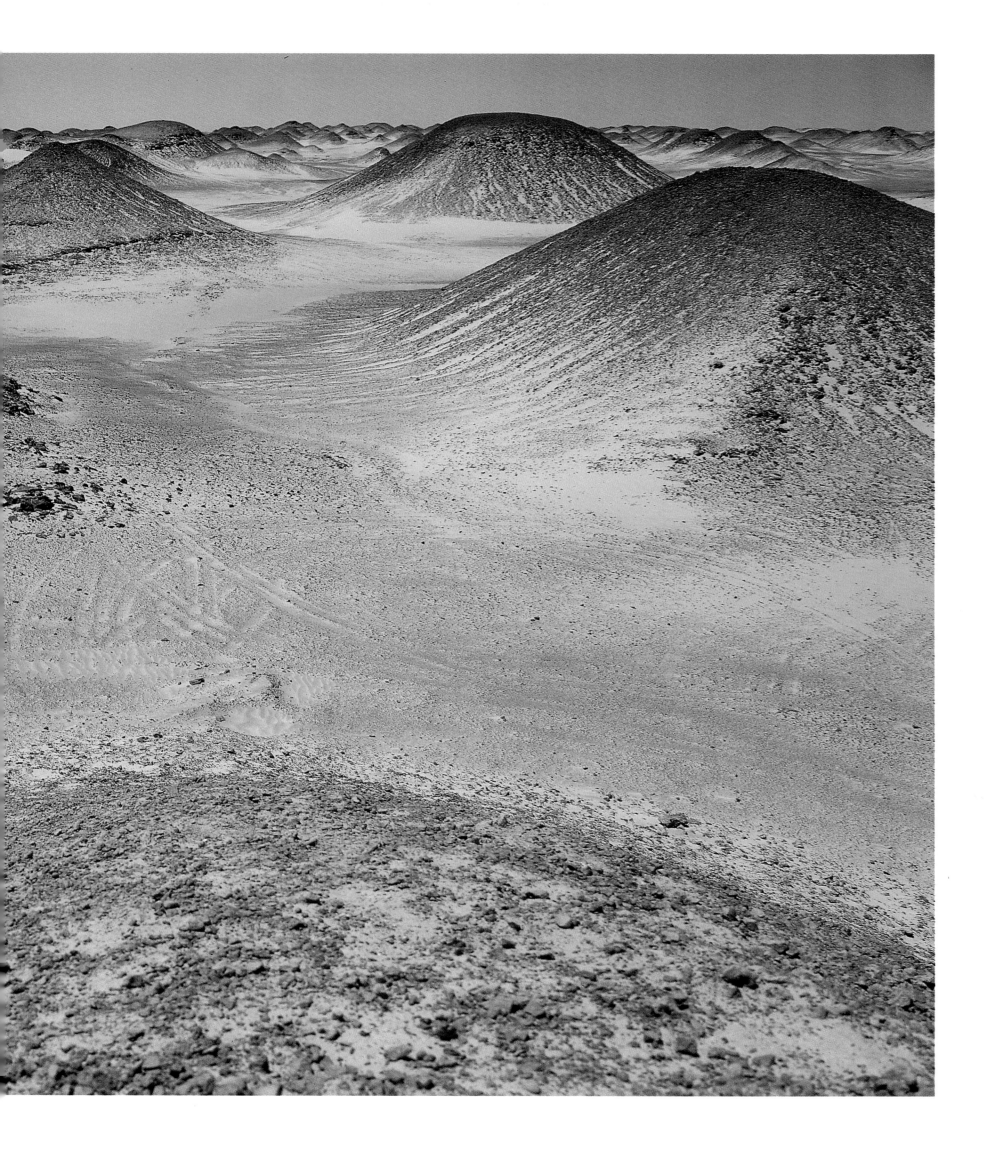

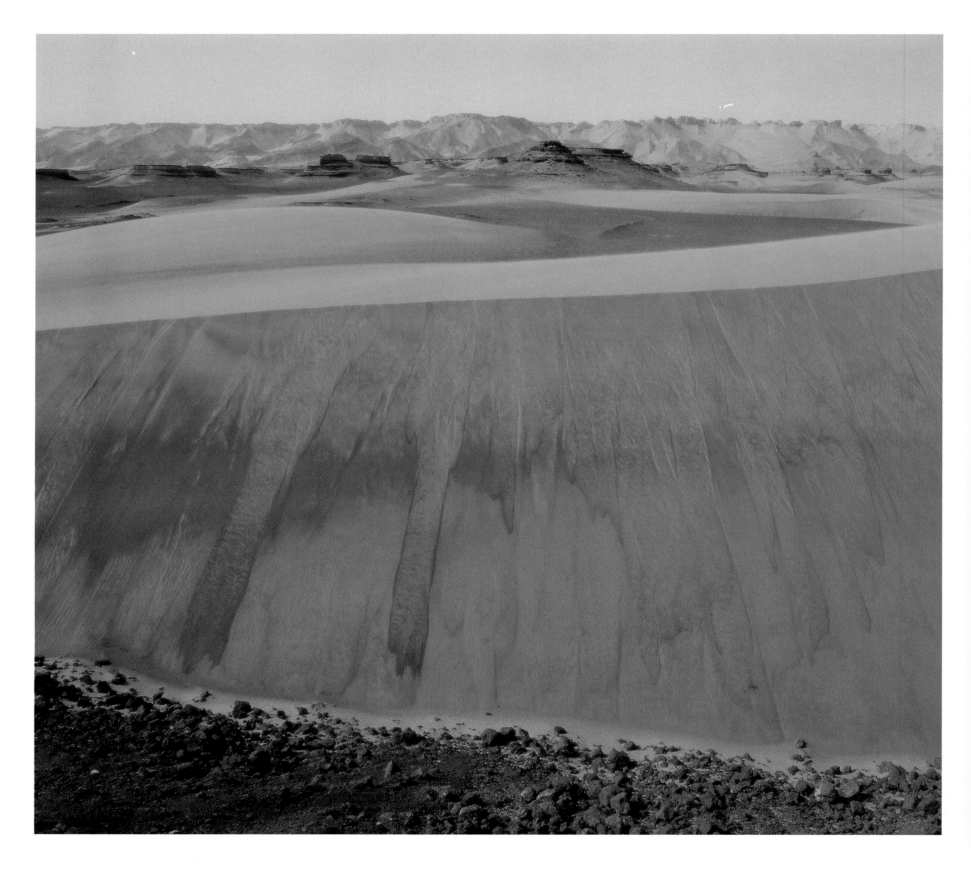

Great shifting dune, Bahariya oasis
Große Wanderdüne, Oase Bahariya
Grande dune mouvante, oasis de Bahariéh

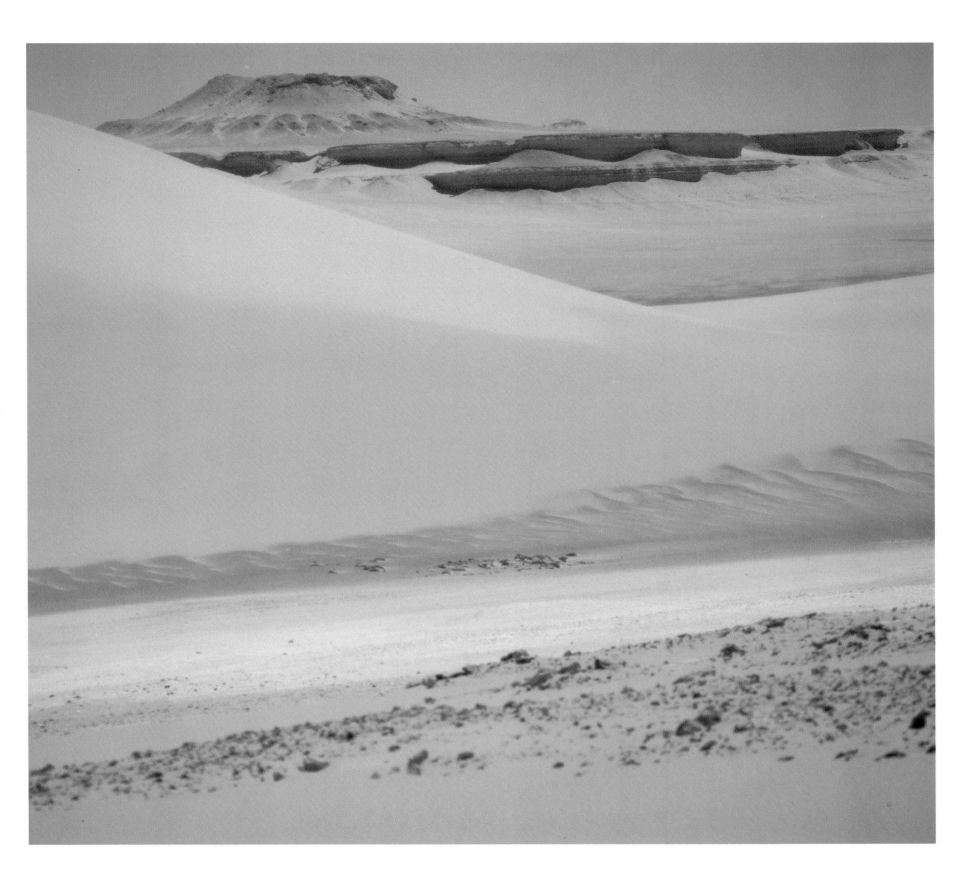

Dune and table mountain near Bahariya
Düne und Tafelberg, nahe Bahariya
Dune et montagne à plateau, près de Bahariéh

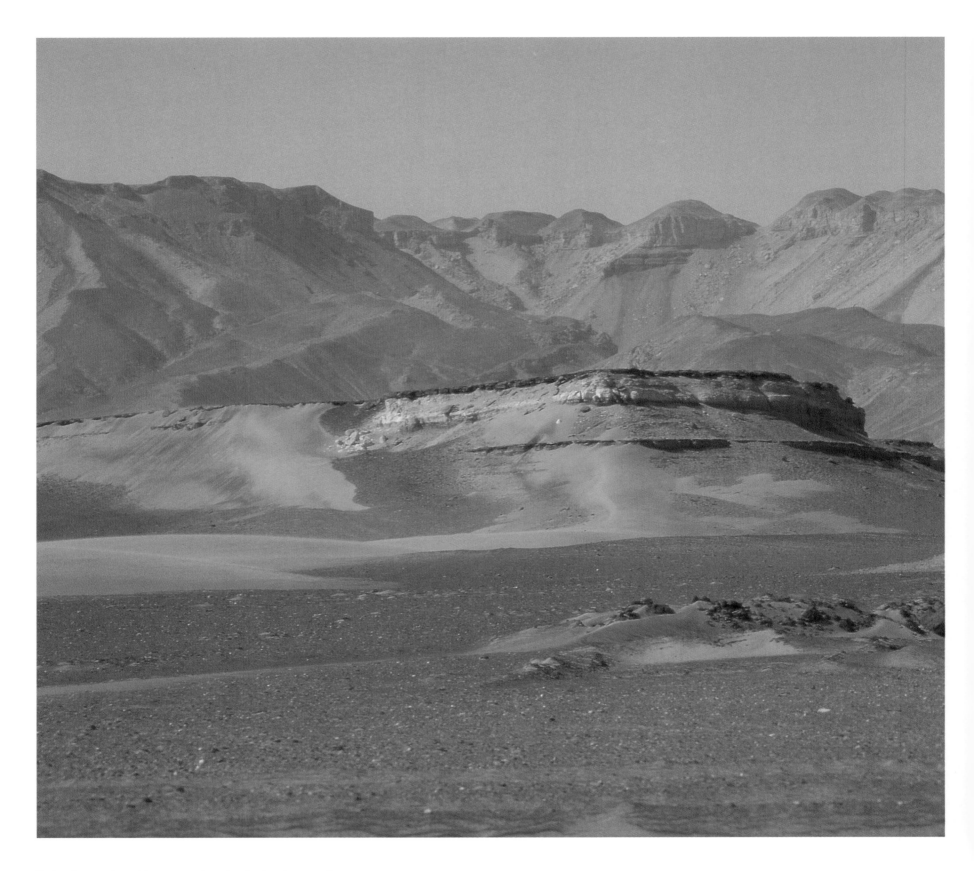

Bahariya oasis, with a steep face in the background

Oase Bahariya, im Hintergrund Steilabfall

Oasis de Bahariéh, au fond pente escarpée

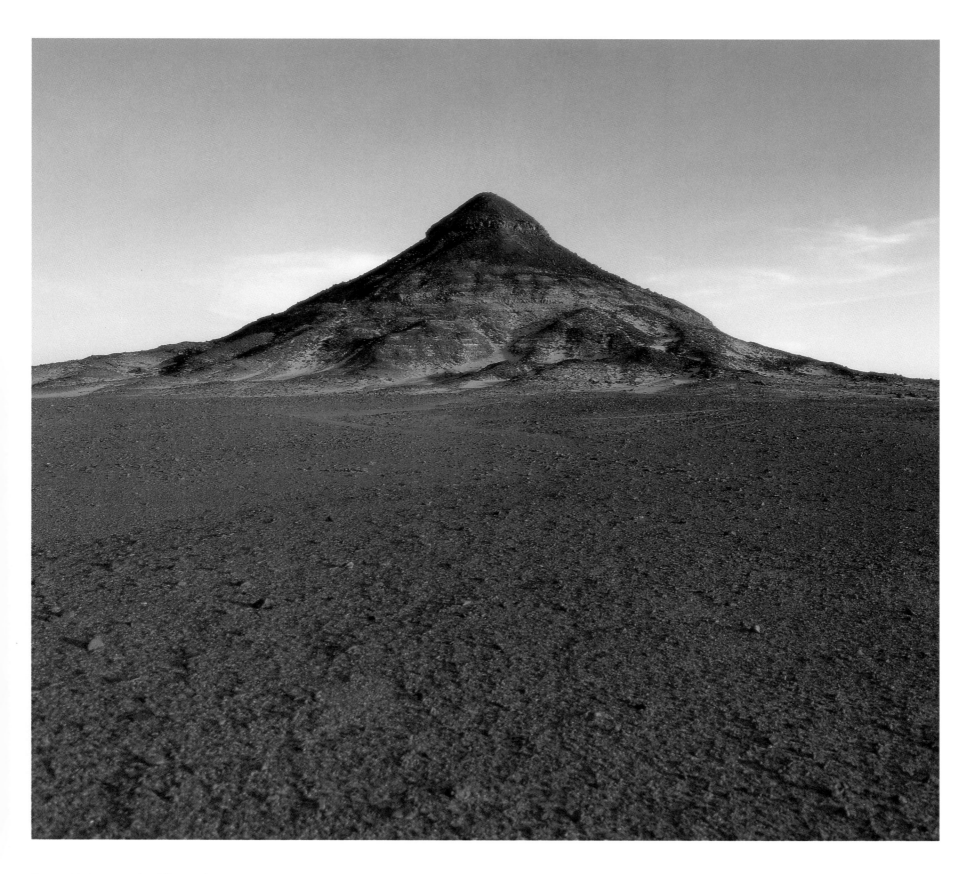

Pyramidal mountain, Libyan desert
Kegelberg, Lybische Wüste
Montagne conique, désert libyque

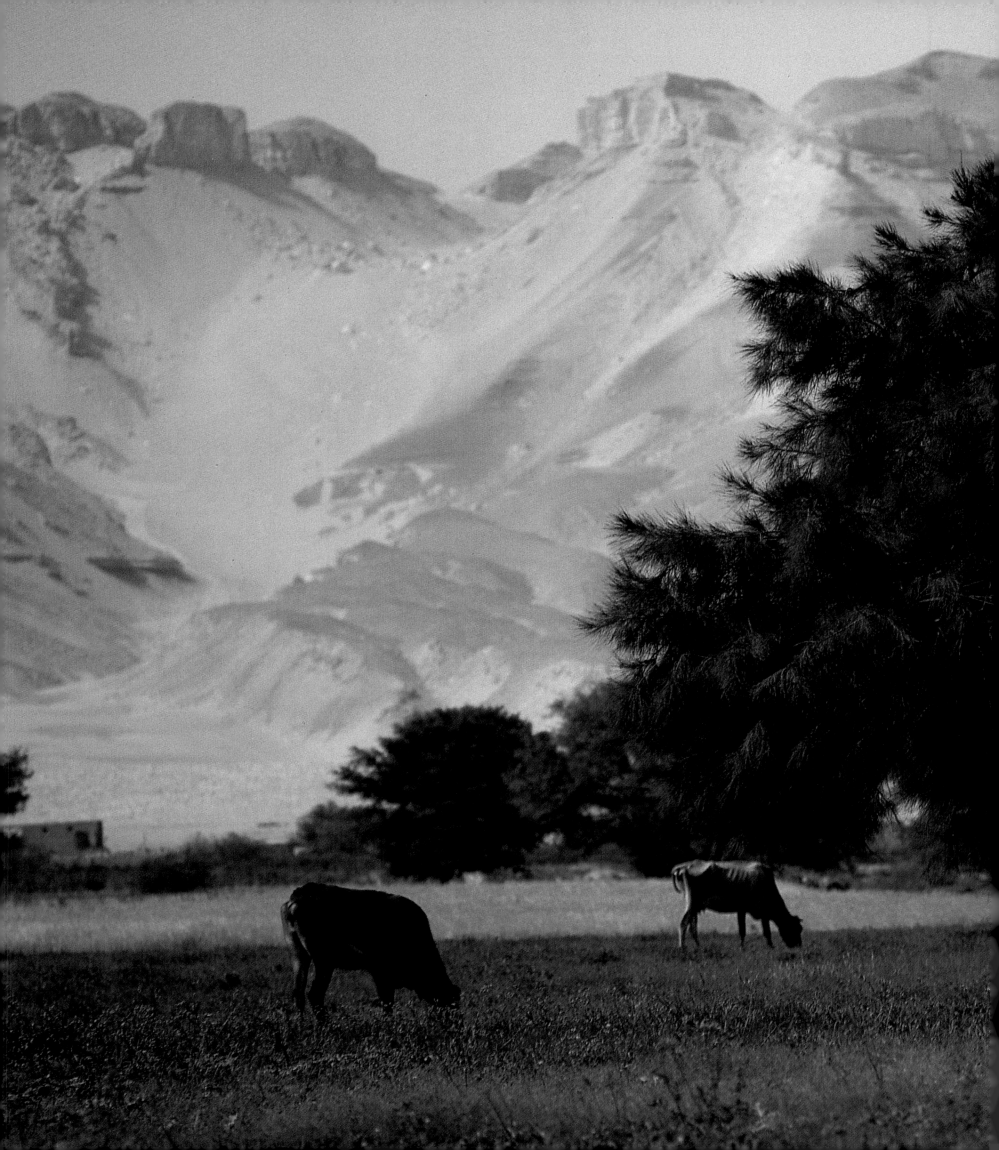

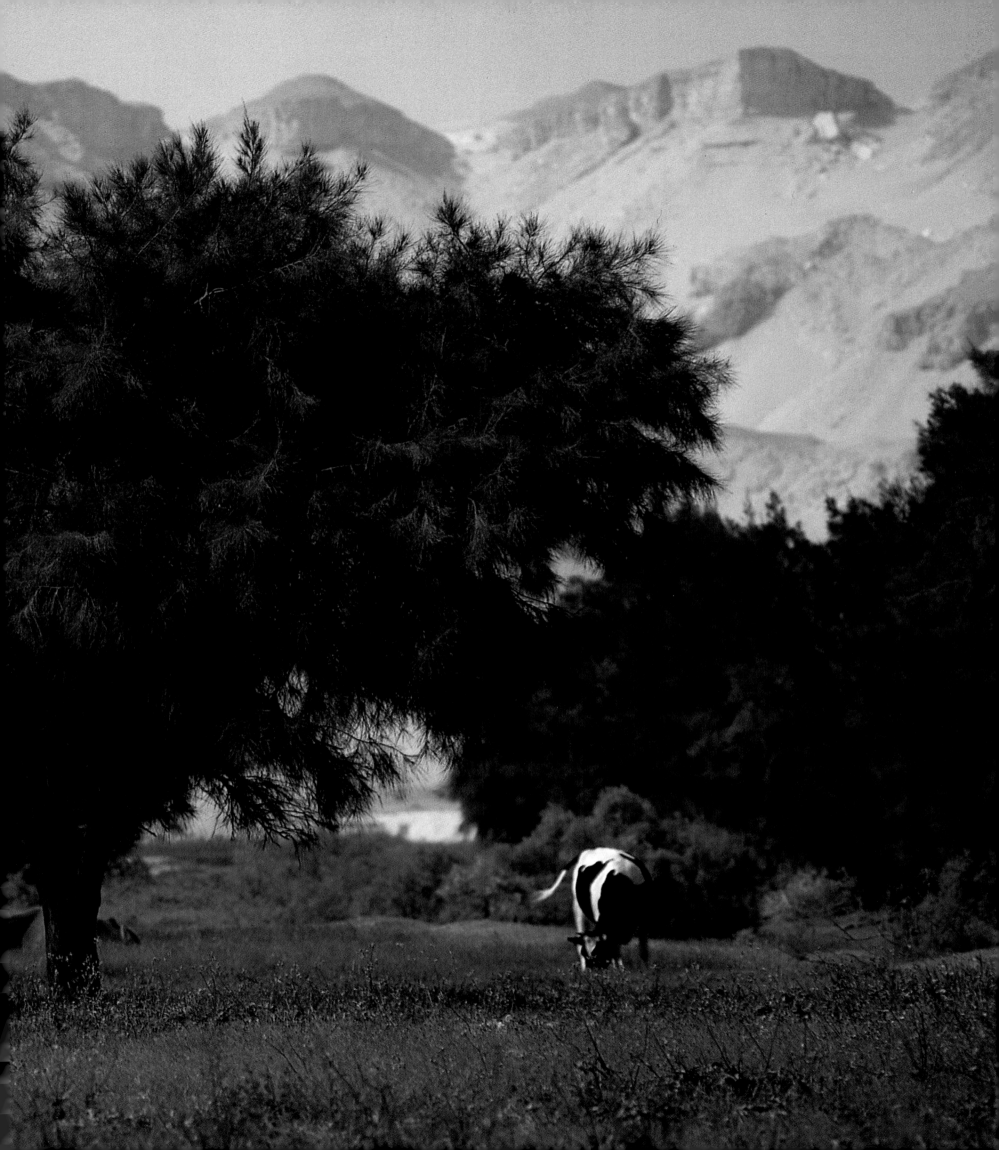

»Pasture« at Bahariya oasis
»Almwiese«, Oase Bahariya
«Alpage», oasis de Bahariéh

»The fight for survival«, Libyan desert
»Kampf ums Überleben«, Lybische Wüste
«Lutte pour la survie», désert libyque

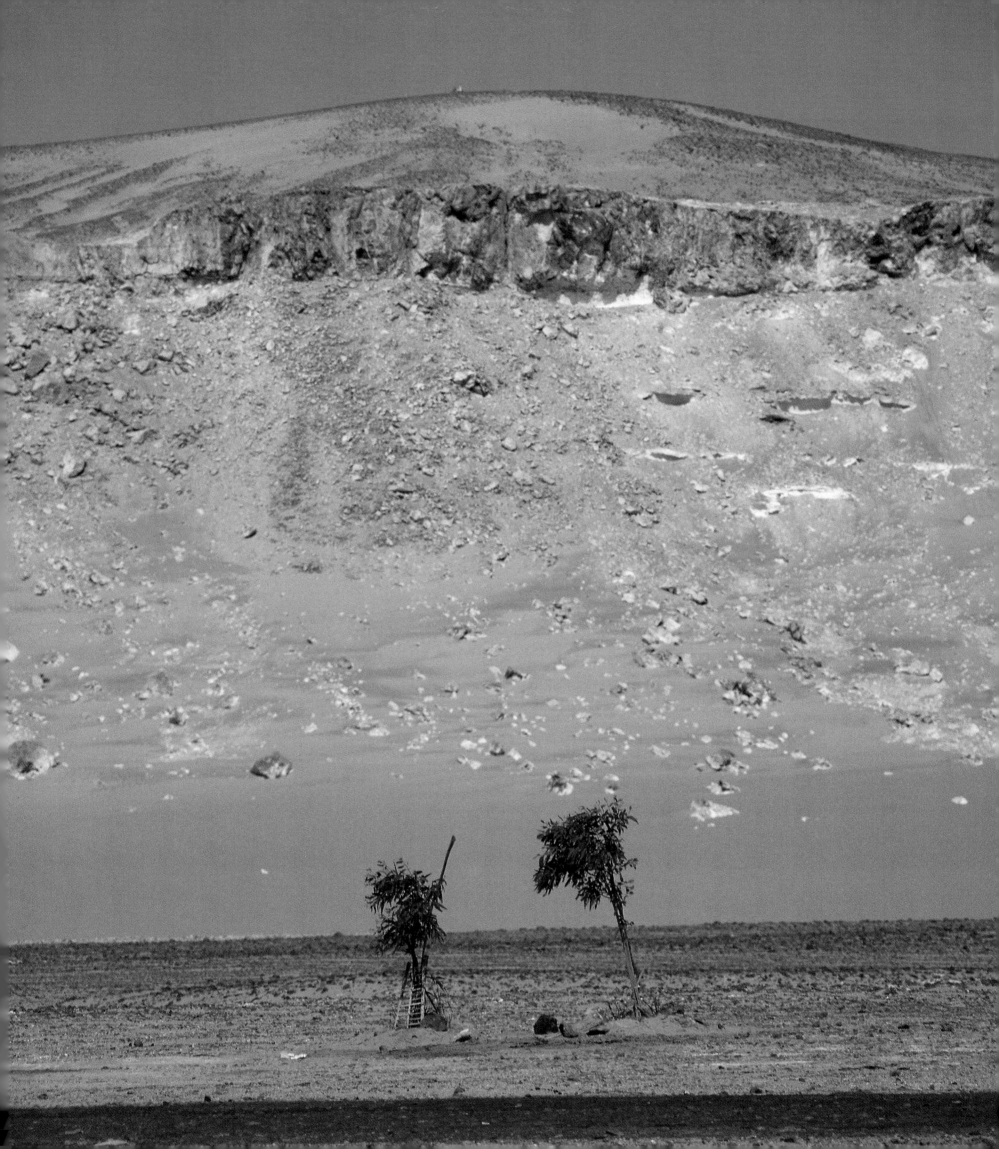

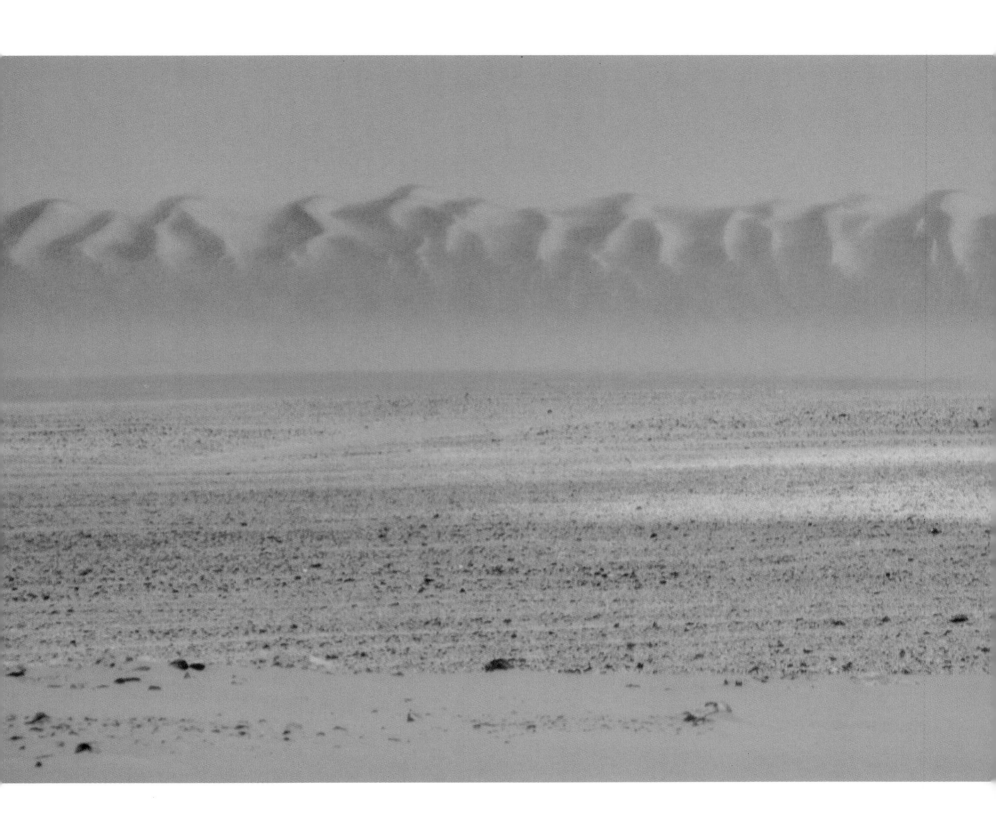

The dune perimeter in the Libyan desert
Dünensaum in der Lybischen Wüste
Bordure de dunes dans le désert de Libye

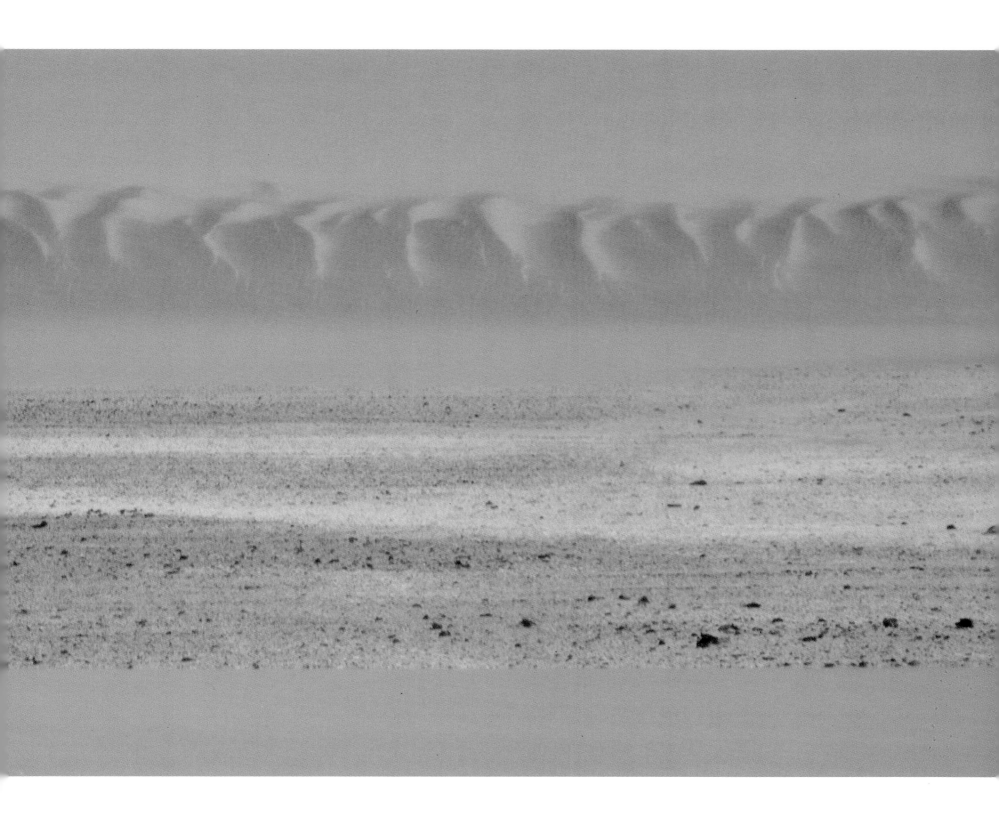

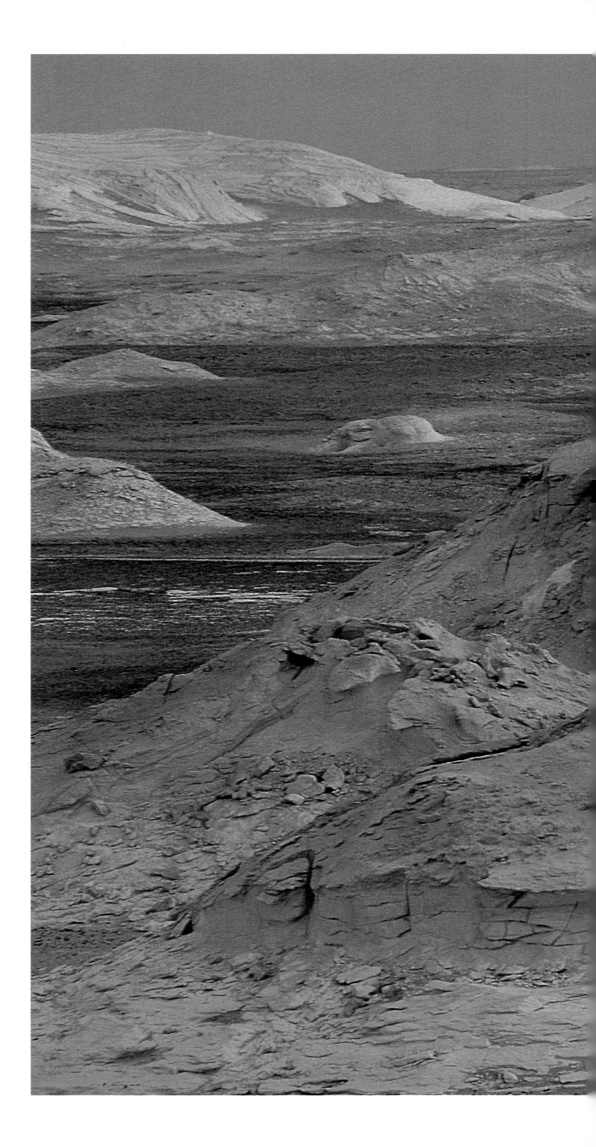

Limestone crags in the *White Desert*
near Farafra
Kalksteinfelsen in der *Weißen Wüste*,
nahe Farafra
Falaise de craie dans le *désert blanc*,
près de Farafréh

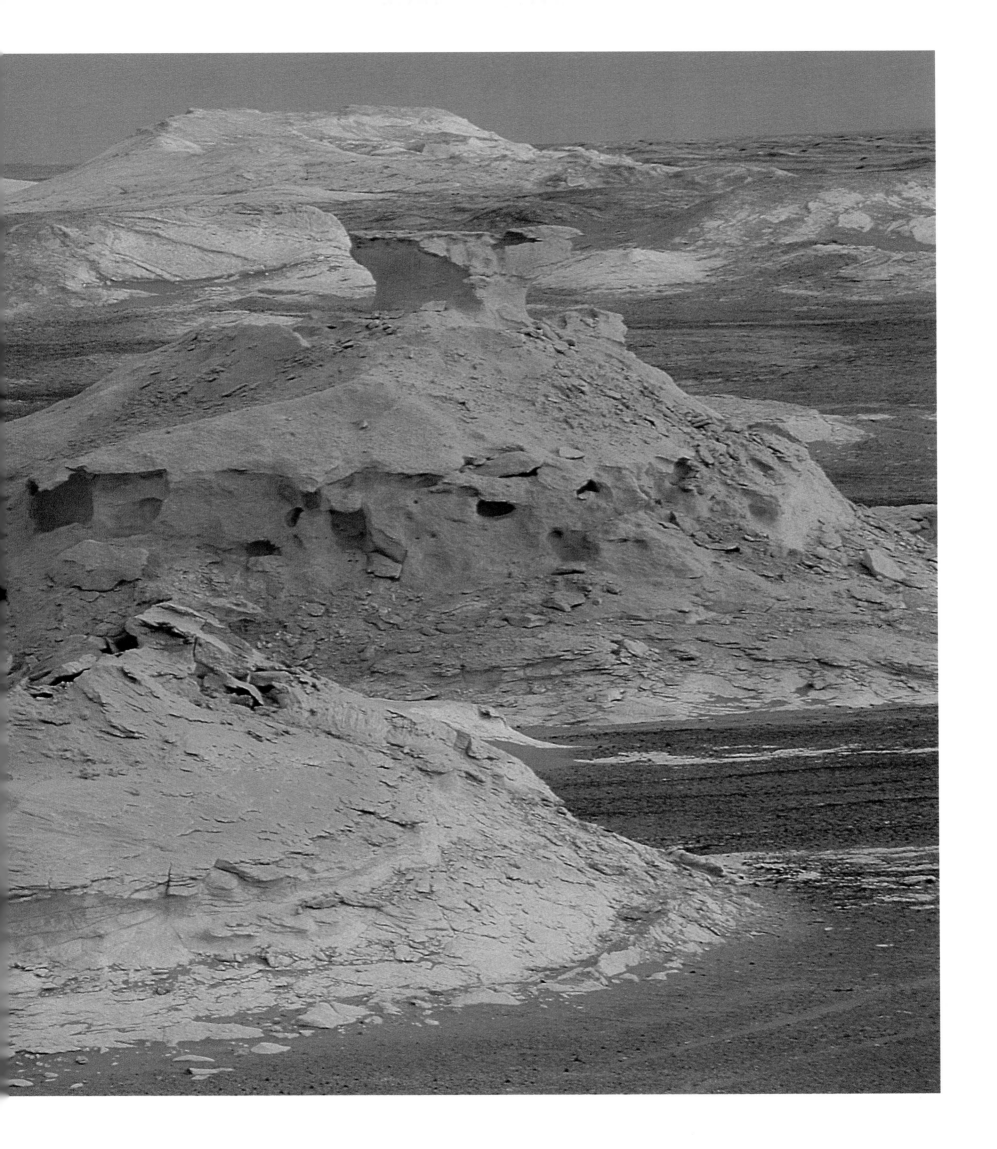

Rock sculpture in the *White Desert*
The *White Desert* lies north of Farafra oasis.
Erosion has worn bizarre works of art into
the landscape, and the wind and sand
together have sculpted the strangest of lime-
stone shapes. It is a natural garden (as it
were) of unparalleled beauty, radiant with
yellow, ochre and white – a landscape experi-
ence that makes an unforgettable impression
on the traveller in the Libyan desert.

Felsskulptur in der *Weißen Wüste*
Nördlich der Oase Farafra trifft man auf die
sogenannte *Weiße Wüste*, in der die Erosion
bizarre Kunstwerke entstehen ließ. Wind und
Sand schufen hier Kalksteingebilde in wun-
dersamen Formen und ließen einen Natur-
»Garten« von unvergleichlicher Schönheit
entstehen, der in den Farben Gelb, Ocker
und Weiß erstrahlt und in der endlosen Weite
der Lybischen Wüste ein besonders ein-
drucksvolles landschaftliches Erlebnis ist.

Sculpture rupestre dans le *désert blanc*
Au Nord de l'oasis de Farafréh, on rencontre
le désert dit *blanc,* où l'érosion a engendré de
bizarres œuvres d'art. Le vent et le sable y
ont créé des formations calcaires aux formes
les plus étranges, faisant ainsi naître un
«jardin» naturel d'une beauté incomparable,
dont les tons jaunes, ocres et blancs resplen-
dissent; c'est là un paysage fort impression-
nant dans la vaste étendue du désert de
Libye.

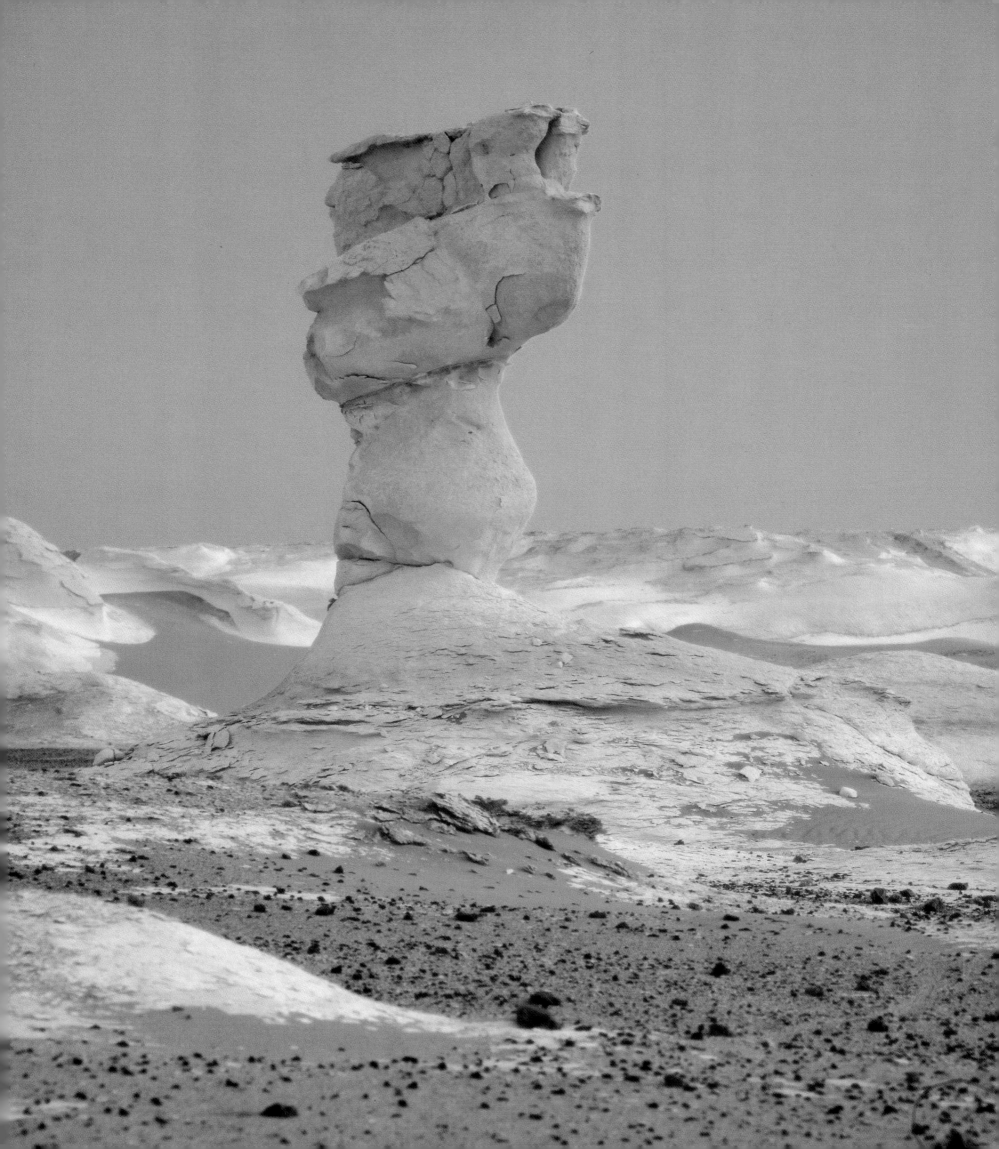

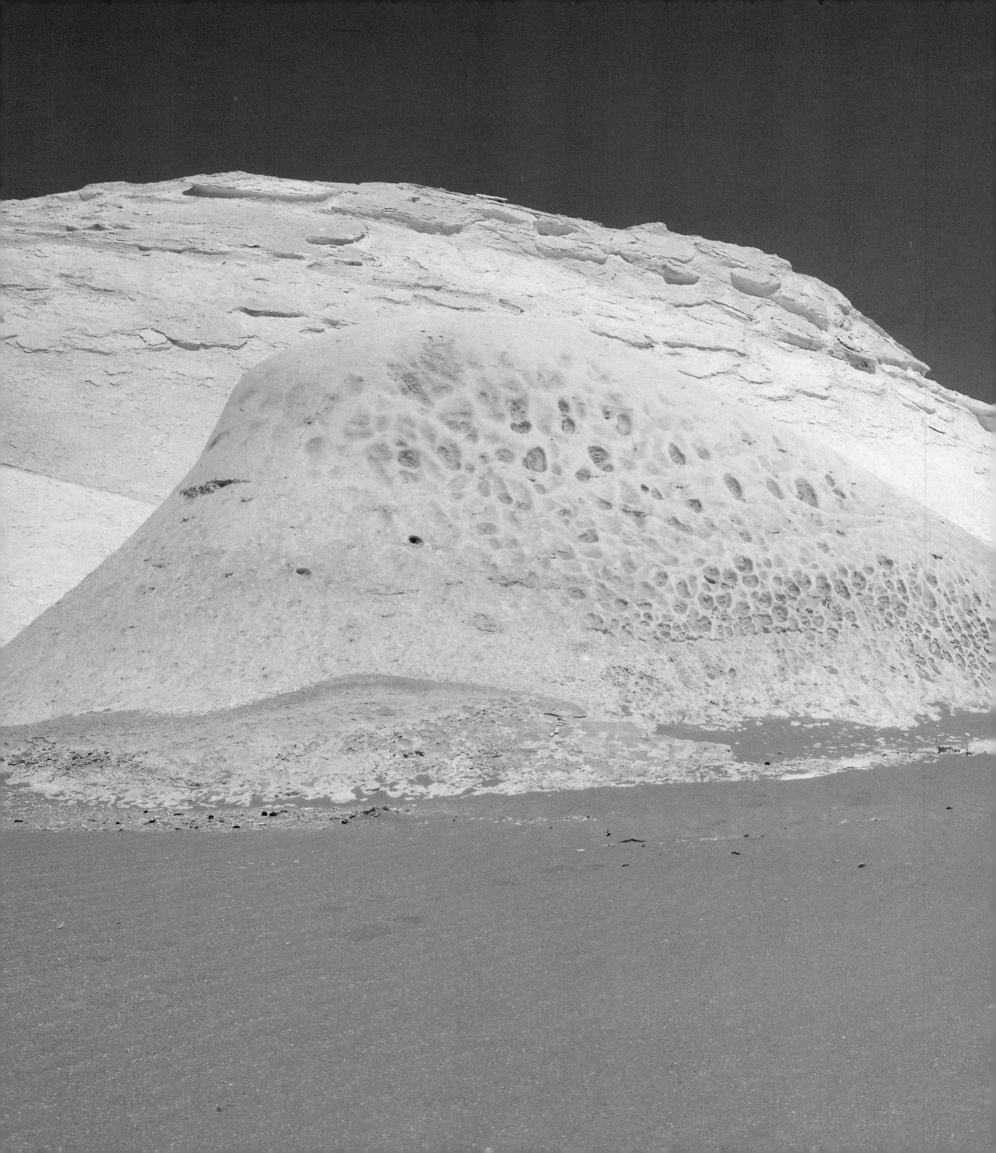

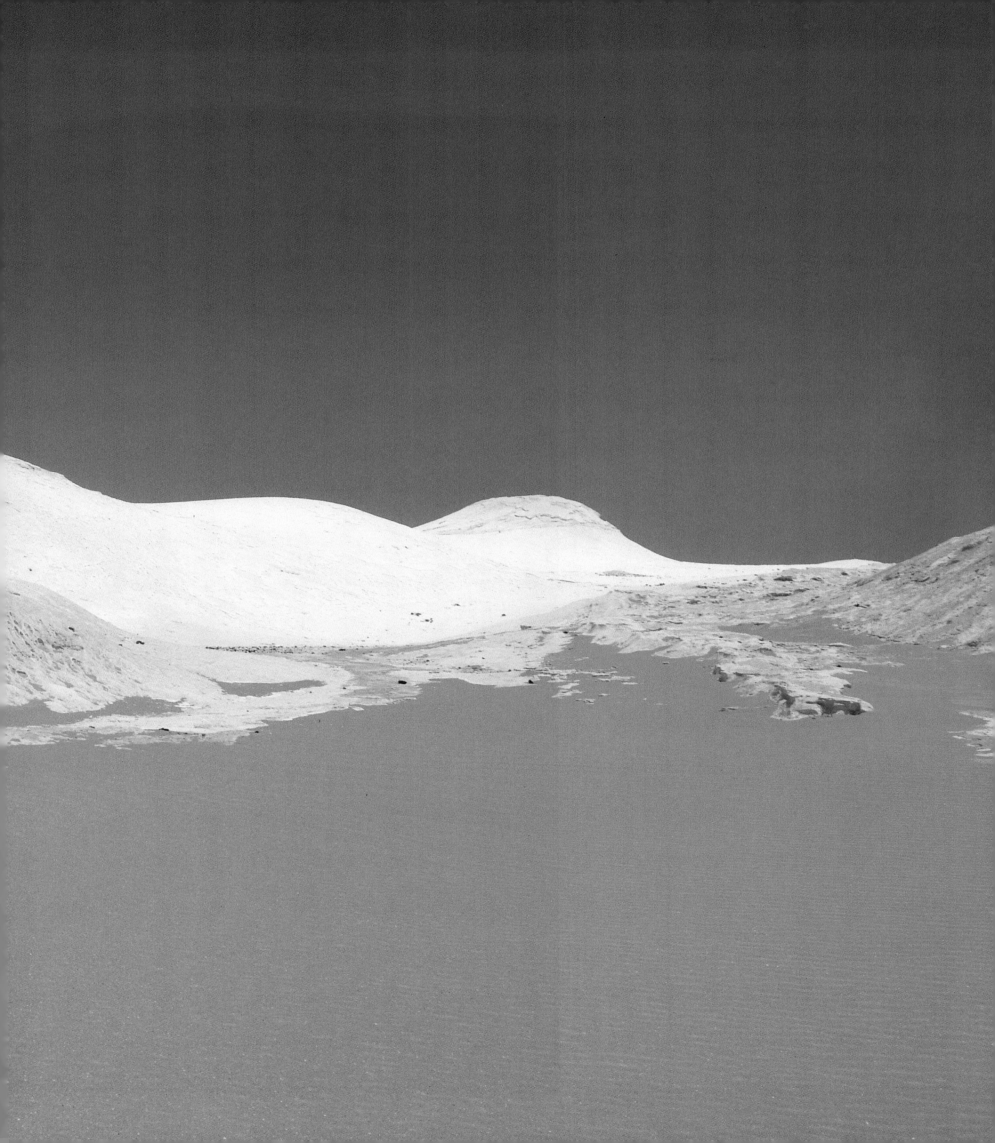

The *White Desert* near Farafra
Die *Weiße Wüste,* nahe Farafra
Le *désert blanc,* près de Farafréh

Dunes in the southerly Libyan desert
The Libyan desert is one of the driest desert regions on earth. Rainfall is almost entirely unknown. In its southerly reaches, the desert is dominated by the sweeping majesty of mighty crescent dunes. The ribbed flanks of the dunes provide an indication of which way the prevailing winds blow. In the summer months, they usually blow from the south in a westerly direction, and in the spring they cause the dreaded sandstorms.

Dünen in der südlichen Lybischen Wüste
Die Lybische Wüste zählt zu den extremsten und trockensten Wüstenregionen der Erde, in der so gut wie nie ein Tropfen Regen fällt. Majestätisch geschwungene Sicheldünen beherrschen ihr Bild im südlichen Teil. An der gerippten Struktur der Flanken dieser riesigen Sandgebilde läßt sich die vorherrschende Windrichtung ablesen, die im Sommer von Süd nach West verläuft und besonders im Frühjahr die gefürchteten Sandstürme entstehen läßt.

Dunes dans le sud du désert de Libye
Le désert de Libye est l'une des zones désertiques les plus extraordinaires et les plus sèches de la Terre, où la pluie est extrêmement rare. De majestueuses dunes en forme de croissant dominent au Sud. La structure cannelée des flancs de cette immense formation de sable permet de déterminer la direction des vents dominants, du Sud vers l'Ouest en été, qui occasionnent des tempêtes de sable redoutées, surtout au printemps.

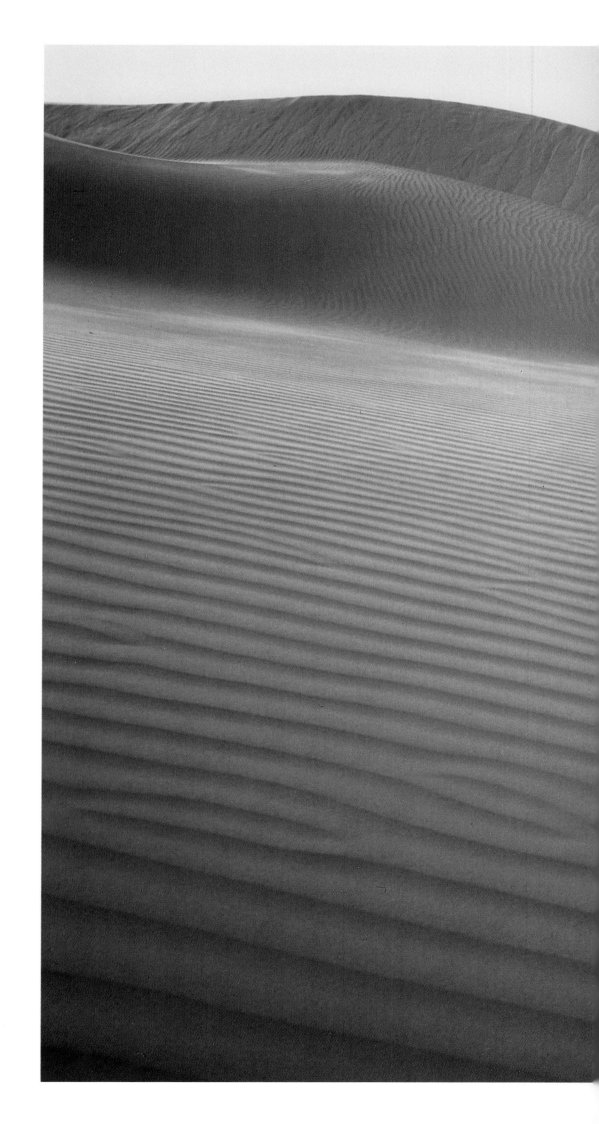

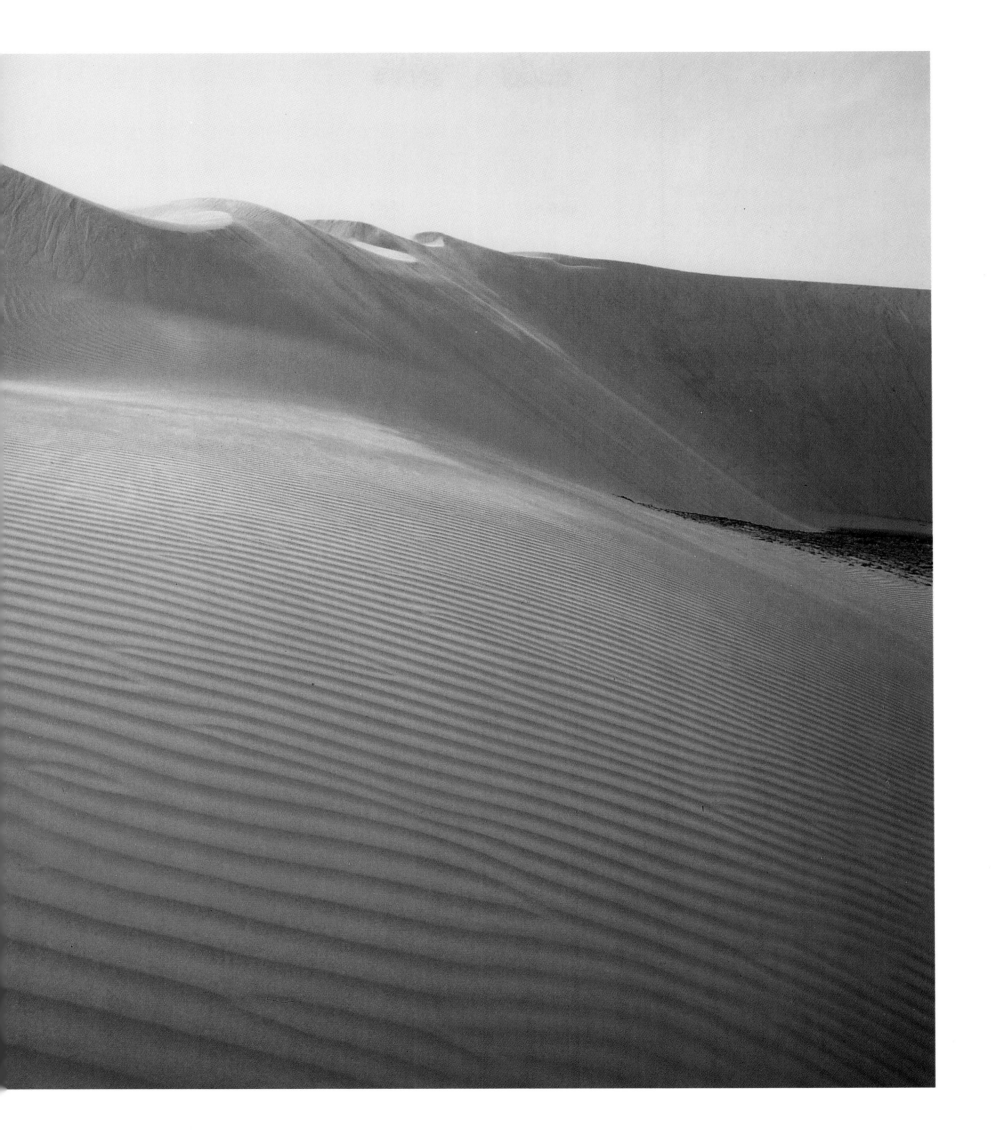

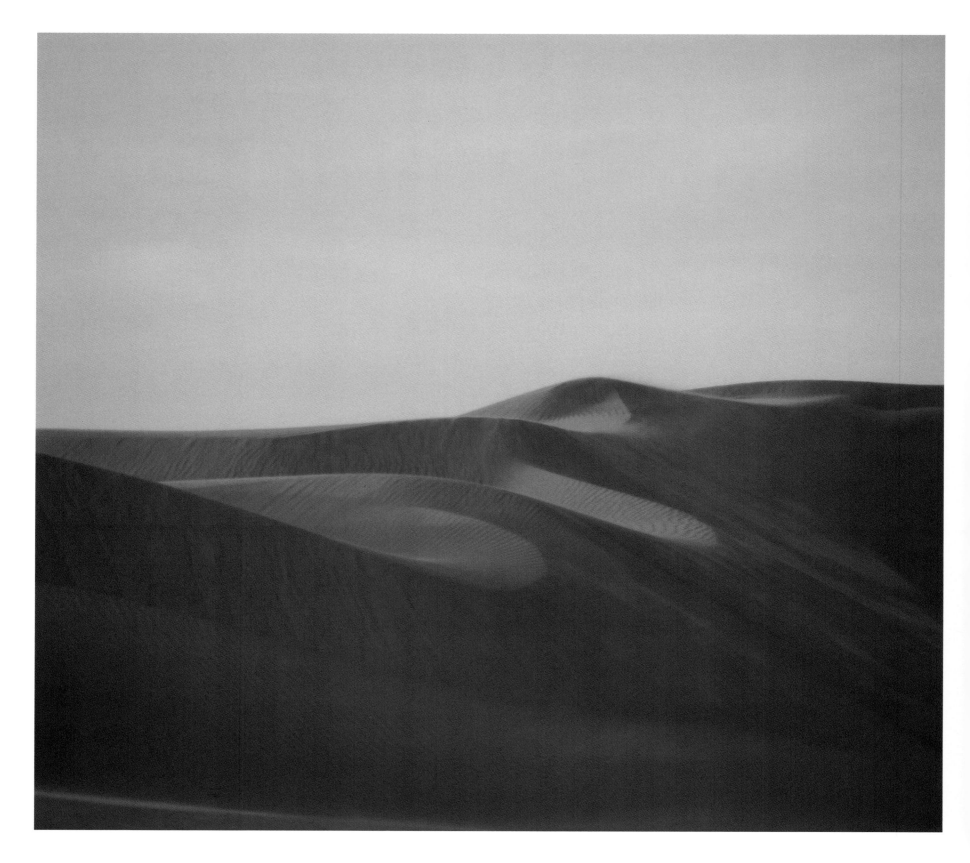

Shifting dunes, southern Libyan desert
Wanderdünen, südliche Lybische Wüste
Dunes mouvantes, Sud du désert libyque

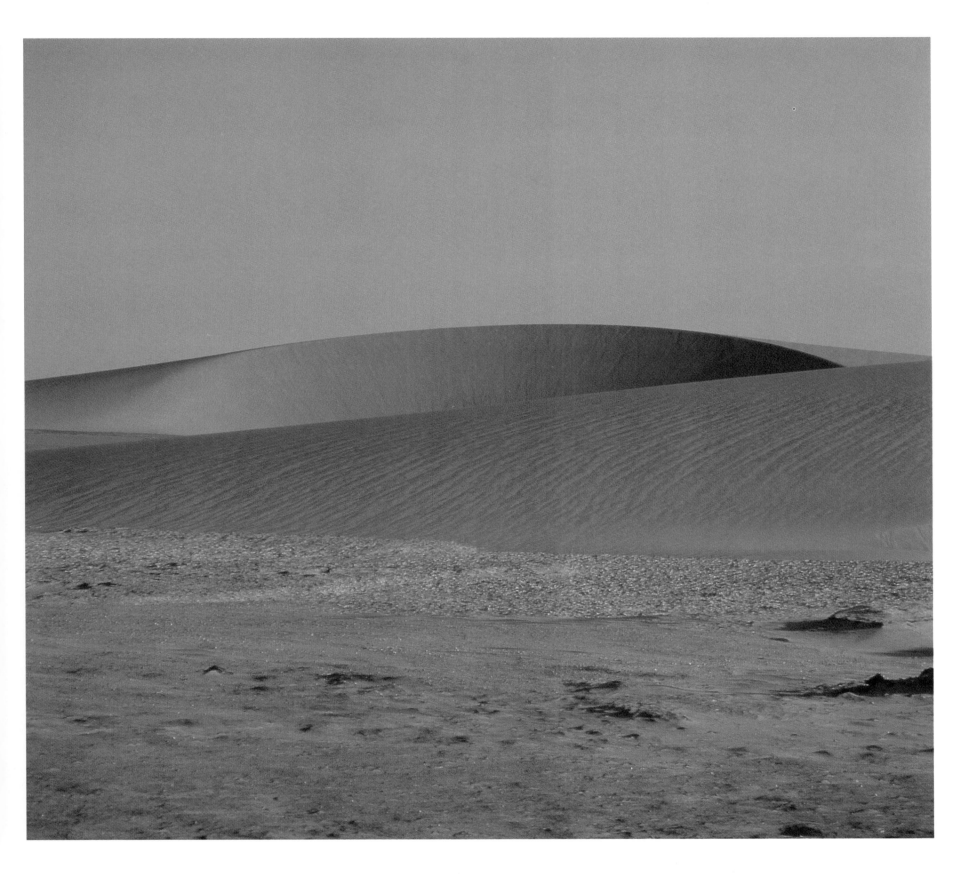

Crescent dune near El Kharga, Libyan desert
Sicheldüne nahe El Kharga, Lybische Wüste
Dune mouvante près de Khargéh, désert libyque

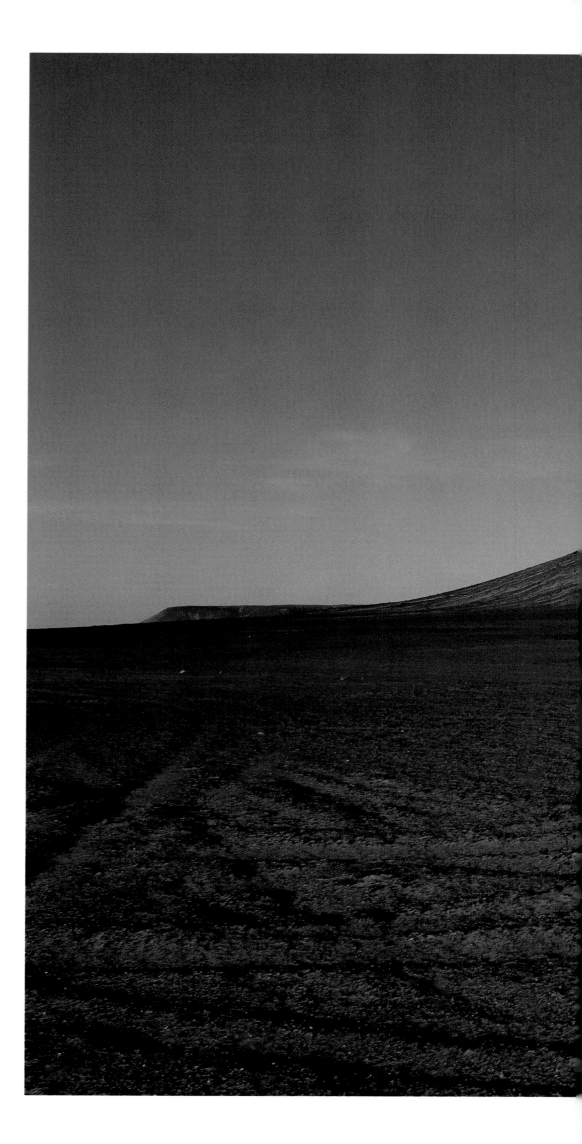

Pyramidal mountain in the southern
Libyan desert
Kegelberg in der südlichen
Lybischen Wüste
Montagne conique, Sud du
désert libyque

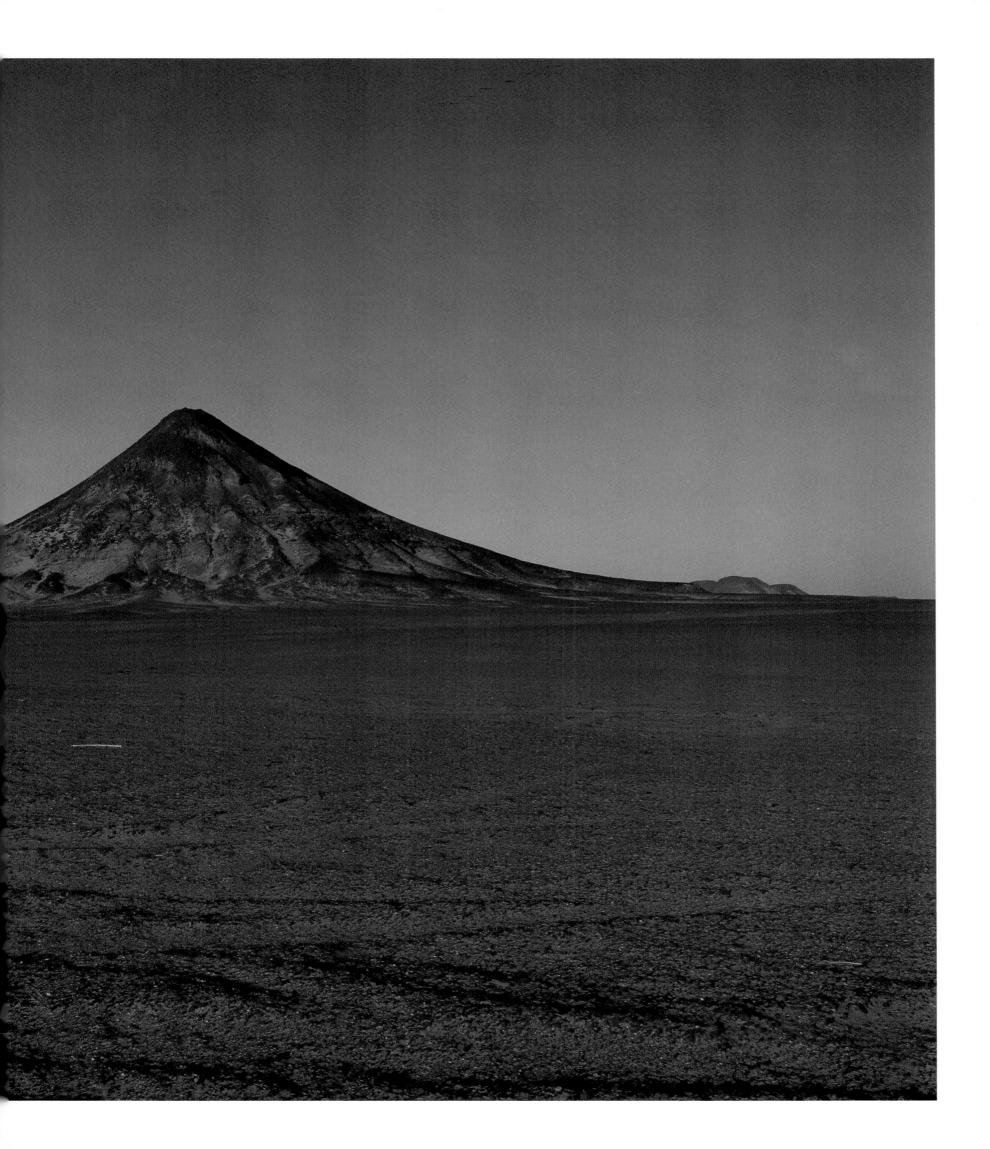

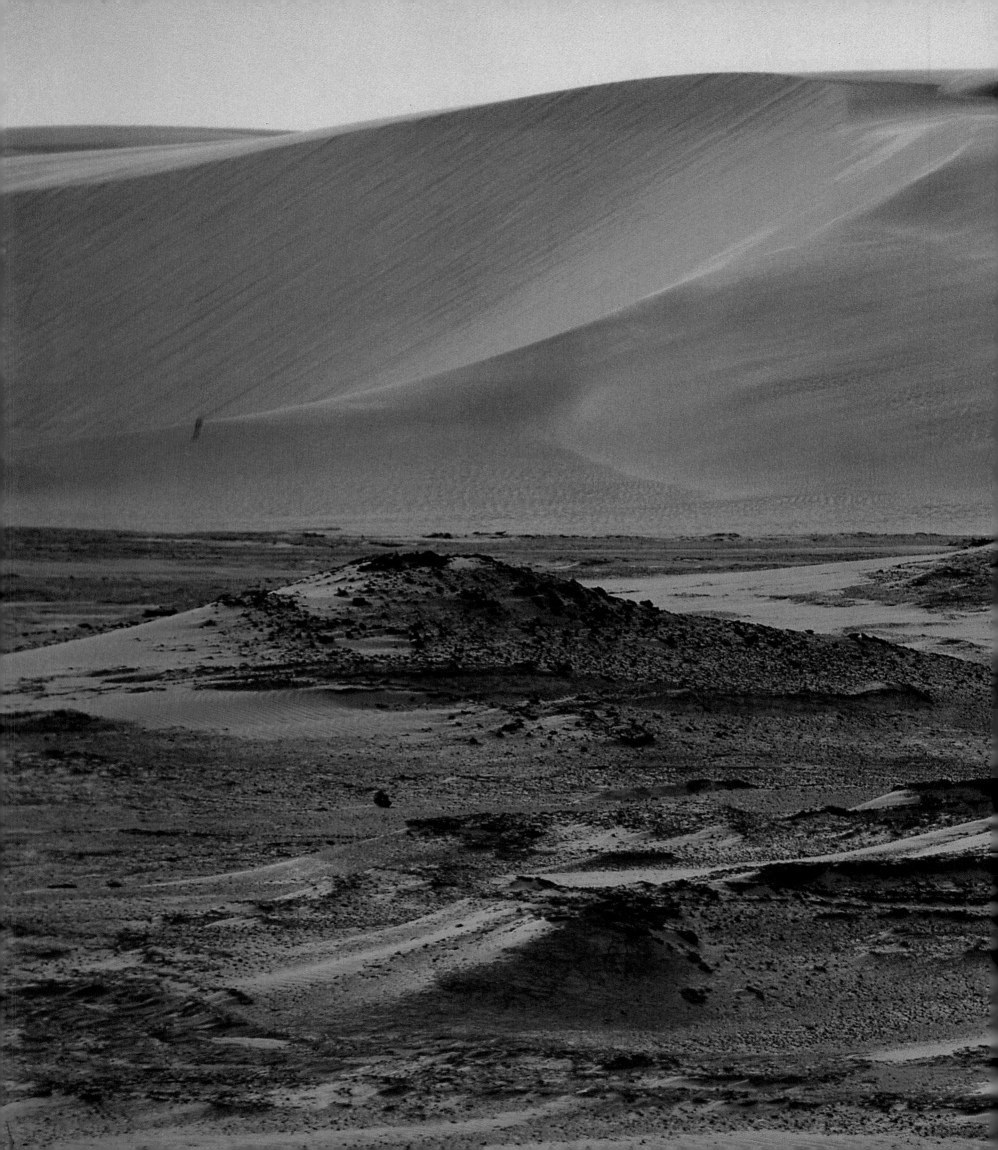

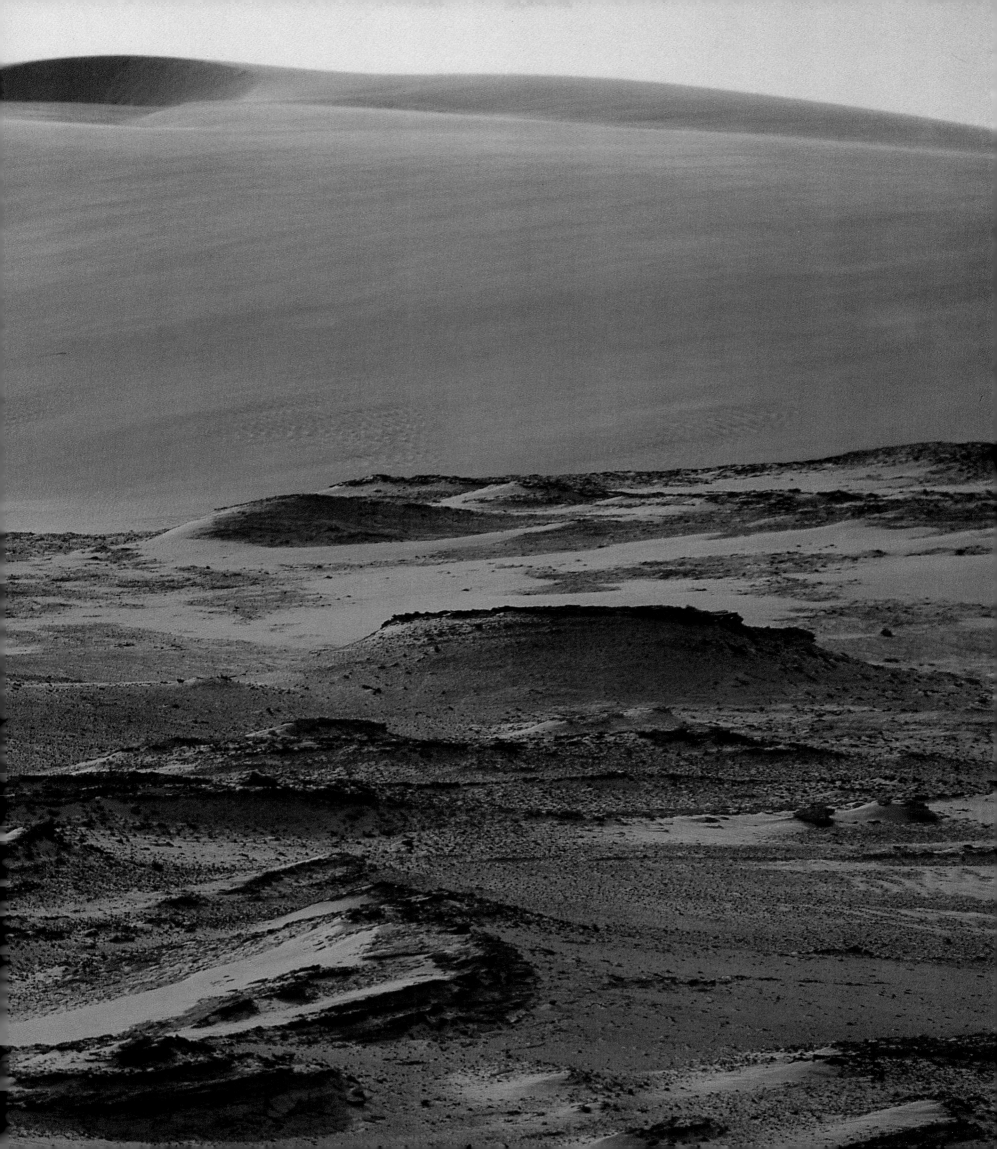

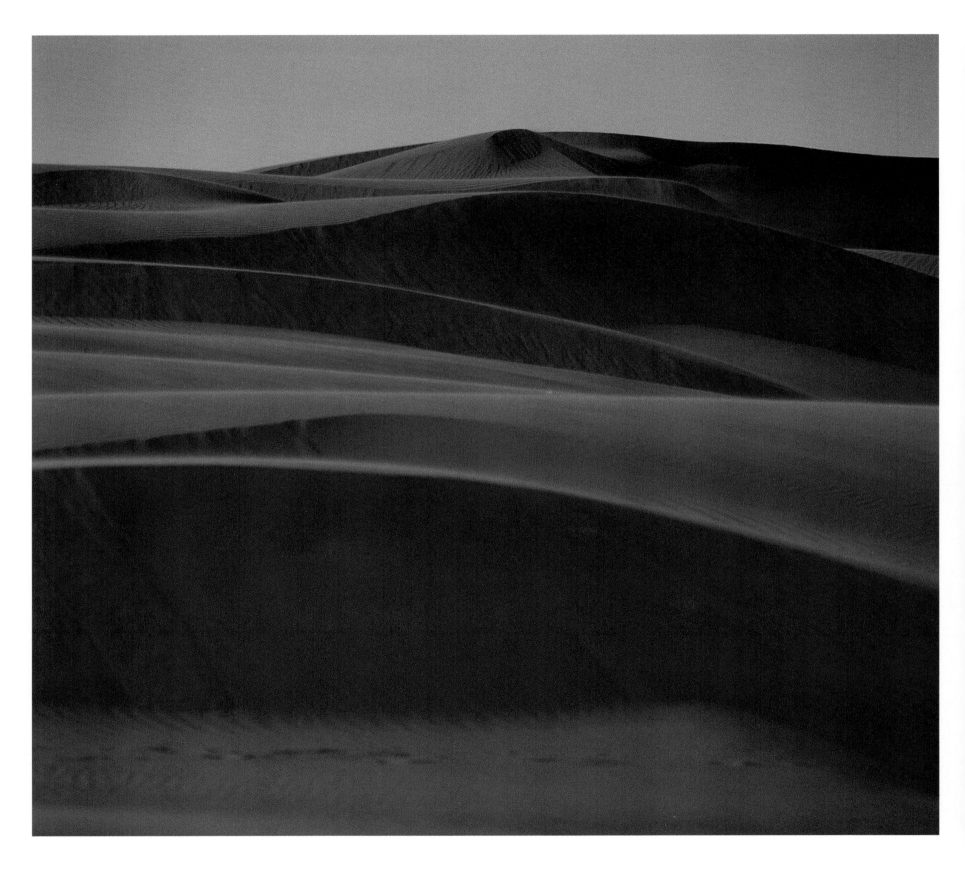

Shifting dunes, southern Libyan desert
Wanderdünen, südliche Lybische Wüste
Dunes mouvantes, Sud du désert libyque

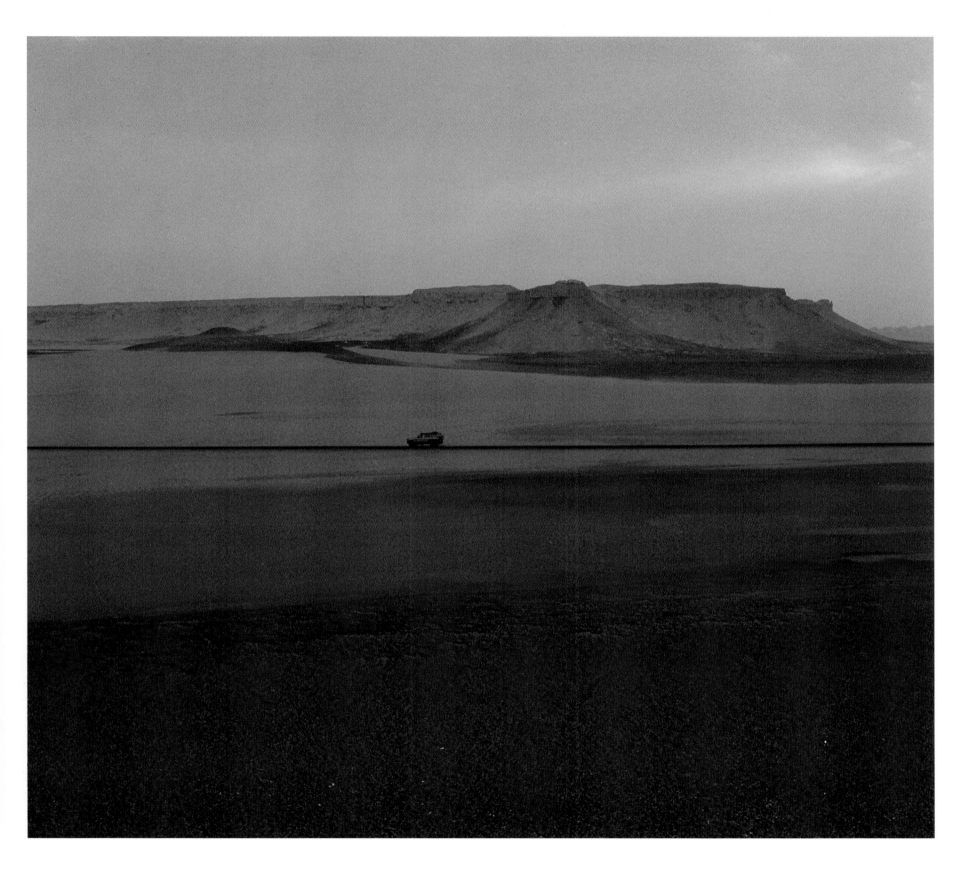

Desert Road, Libyan desert
Desert Road, Lybische Wüste
Desert Road, désert libyque

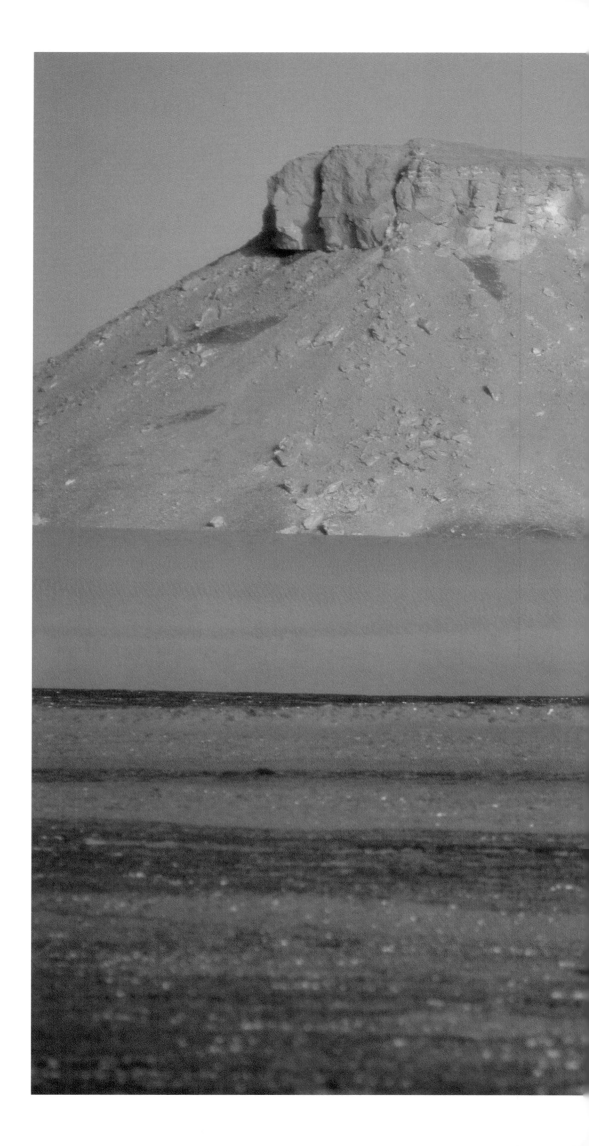

Dune and table mountain, Libyan desert
Düne und Tafelberg, Lybische Wüste
Dune et montagne à plateau, désert libyque

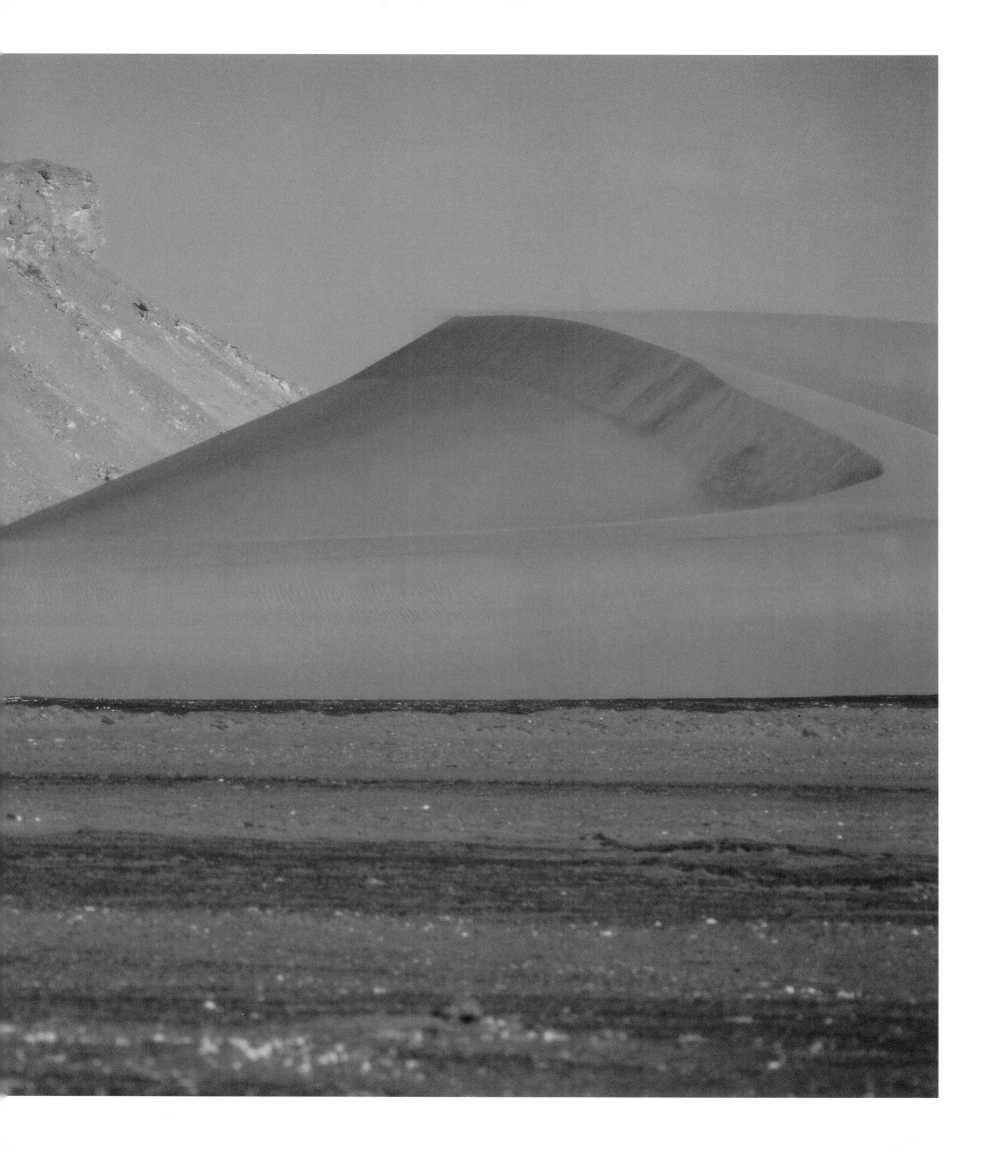

The banks of the Nile

Die Ufer des Nils

Les Rives du Nil

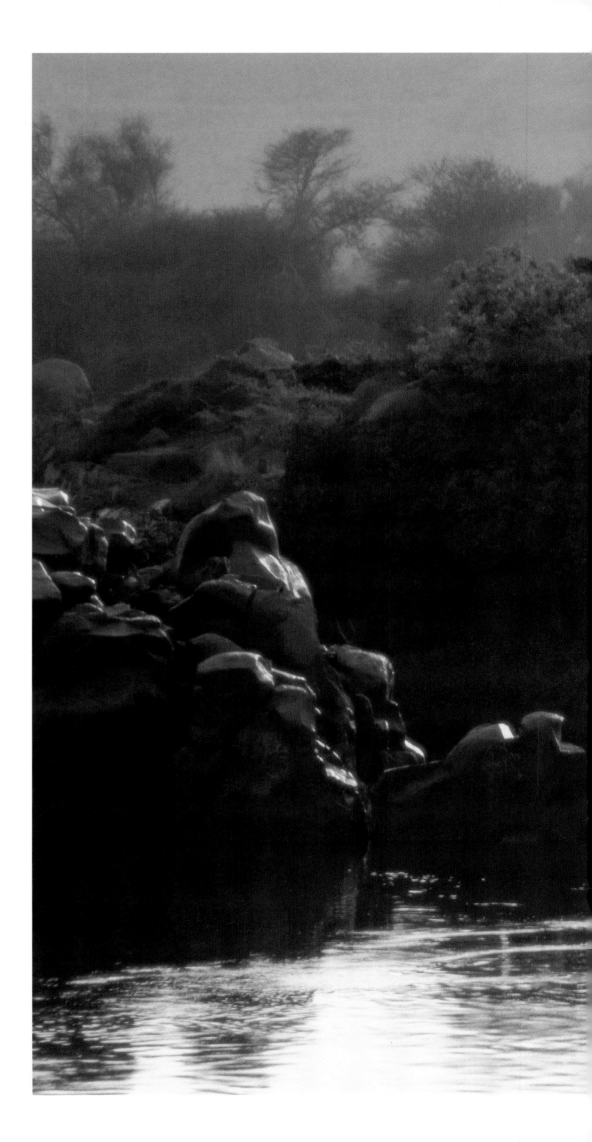

Morning on the Nile
Morgenstimmung am Nil
Atmosphère matinale au bord du Nil

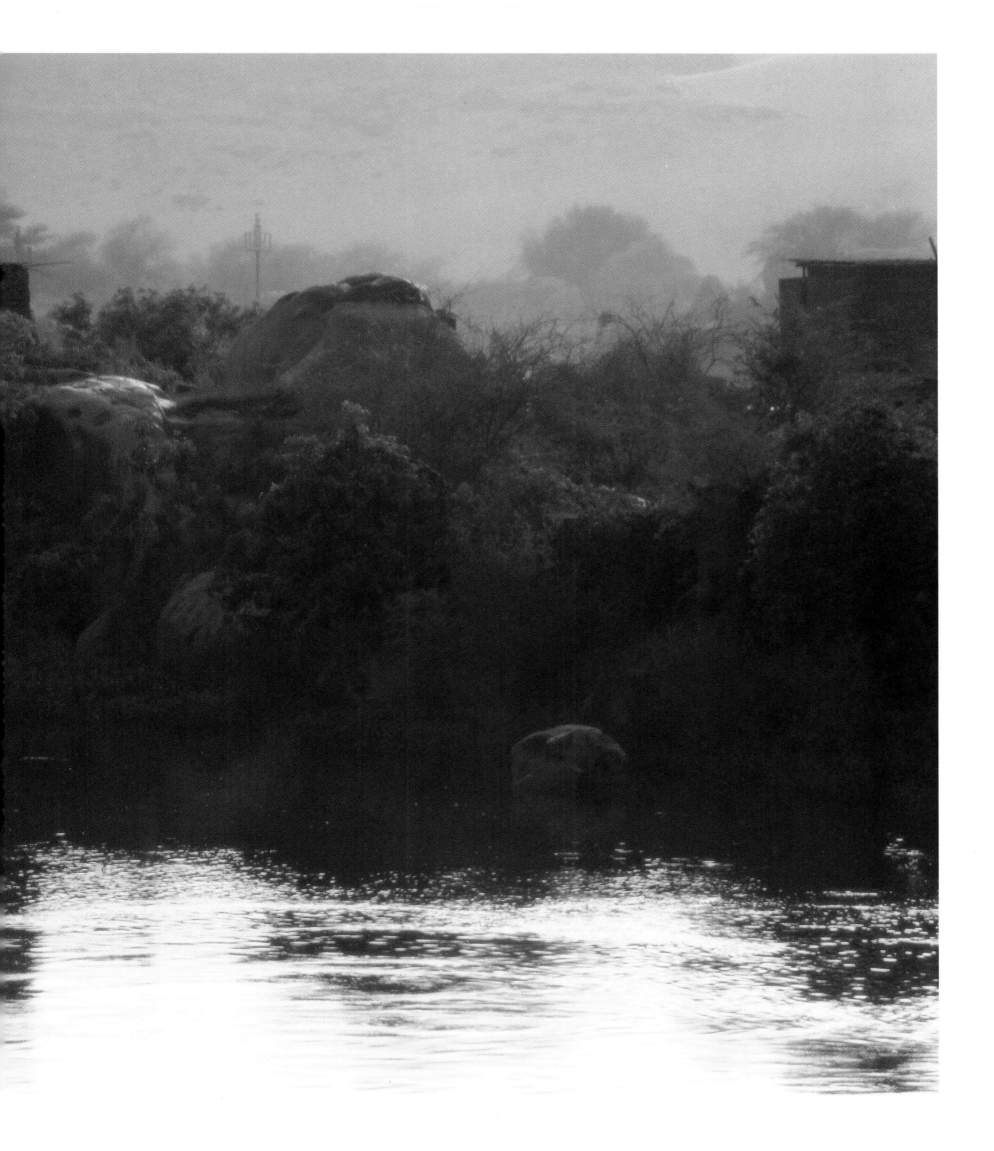

Felucca off the Aswan desert barrier
Feluccas are merchant vessels used on the
Nile and the Mediterranean, small but
spacious, with lateen sails. For Nile dwellers
they are the ideal way of getting about – per-
fect for fishing, and ideal too, in the season,
for hooking a different, lucrative catch: the
tourist.

Feluka vor der Wüstenbarriere in Assuan
Die Felukas (Nil-Barken), zum Teil groß-
räumige Holzplankenboote mit den typischen
Schrägsegeln, sind das ideale Fortbewegungs-
mittel der Nil-Anwohner. Sie dienen ebenso
zum Fischfang wie zur Beförderung von
Touristen, ein lukrativer Nebenverdienst
während der Saison.

**Felouque devant la barrière désertique à
Assouan**
Les felouques (barques sur le Nil), en partie
vastes bateaux en planches aux typiques
voiles obliques, sont le moyen de transport
idéal pour les riverains du Nil. Elles servent
aussi bien à pêcher qu'à transporter les
touristes pendant la saison, constitnant ainsi
un gain supplémentaire.

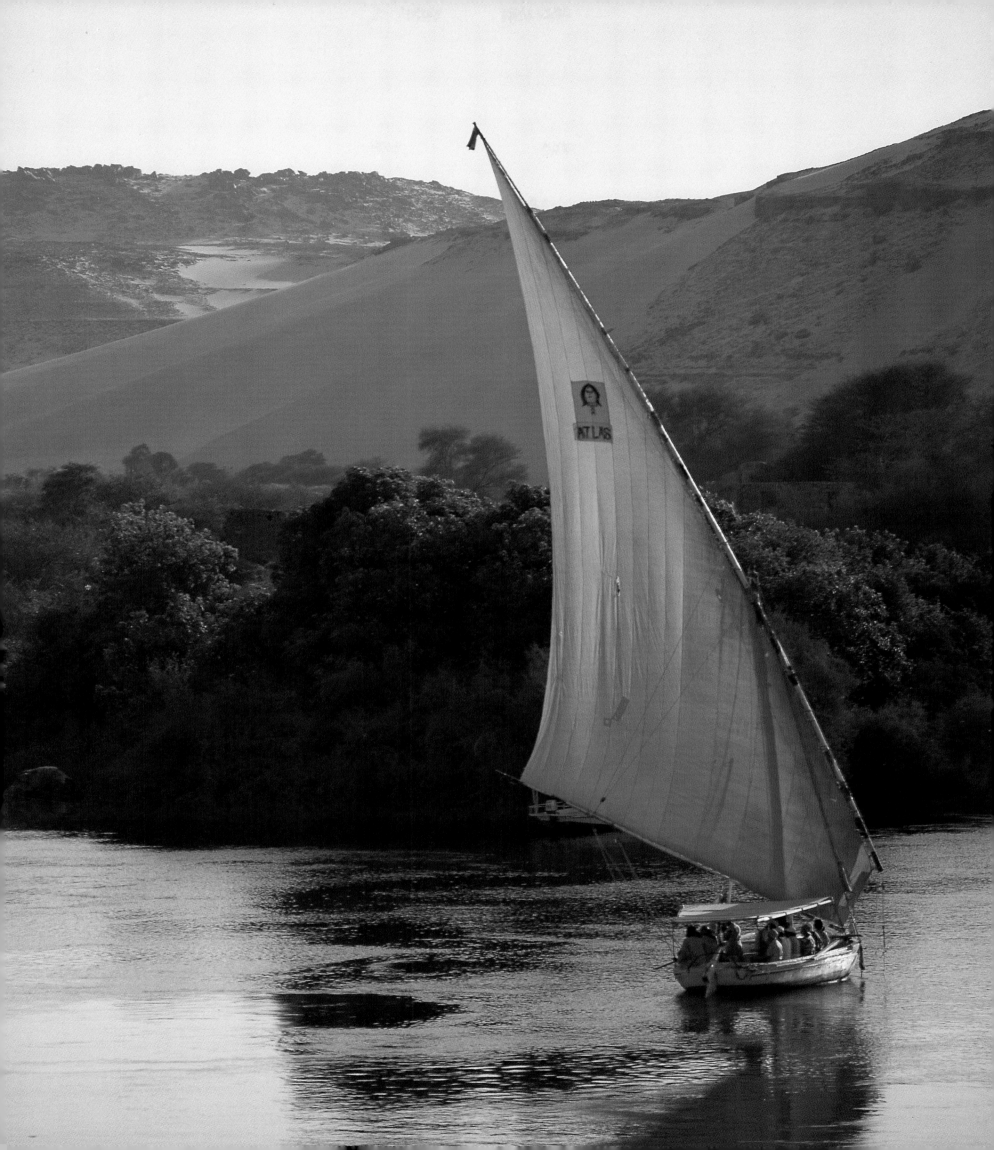

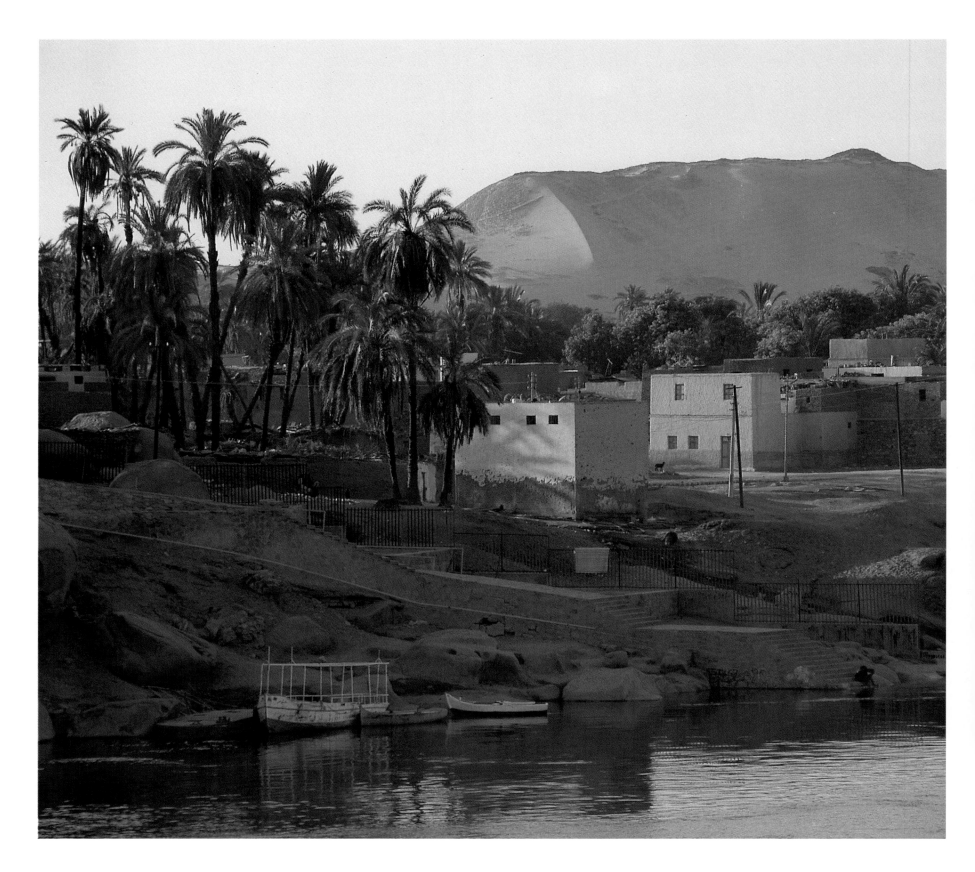

Elephantine Island, evening
Elephantine-Island im Abendlicht
L'Ile Eléphantine au couchant

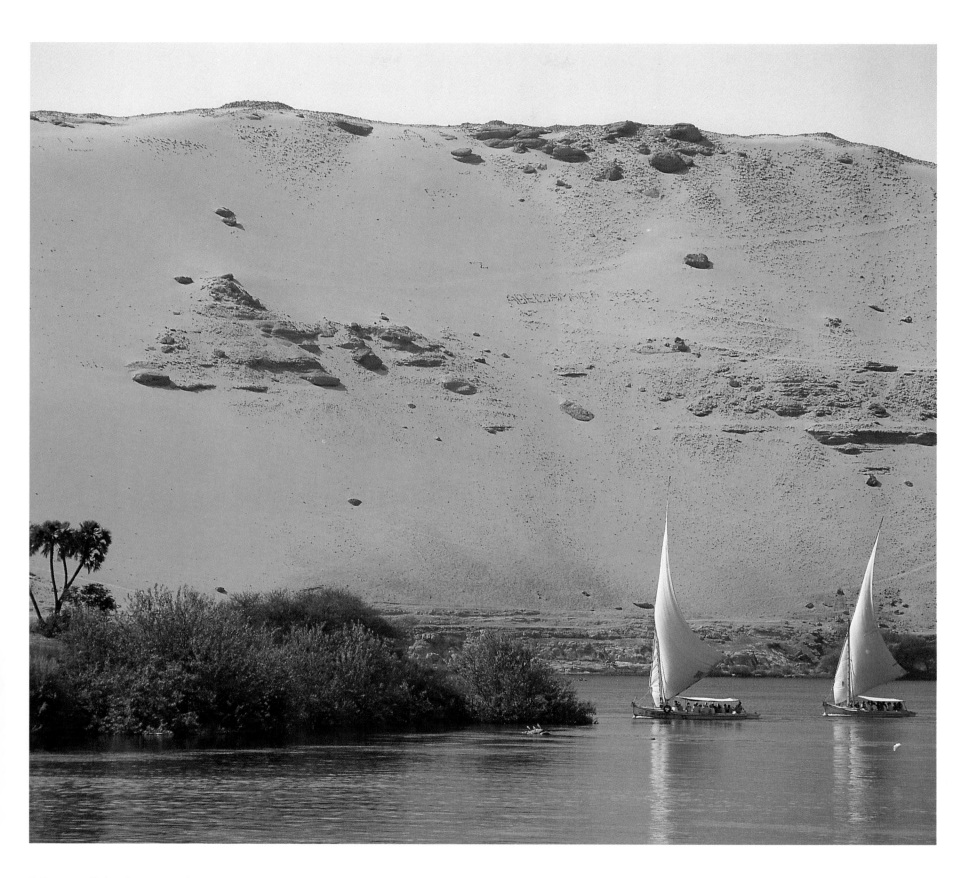

Feluccas off the desert barrier, Aswan
Felukas vor der Wüstenbarriere, Assuan
Felouques devant la barrière désertique, Assouan

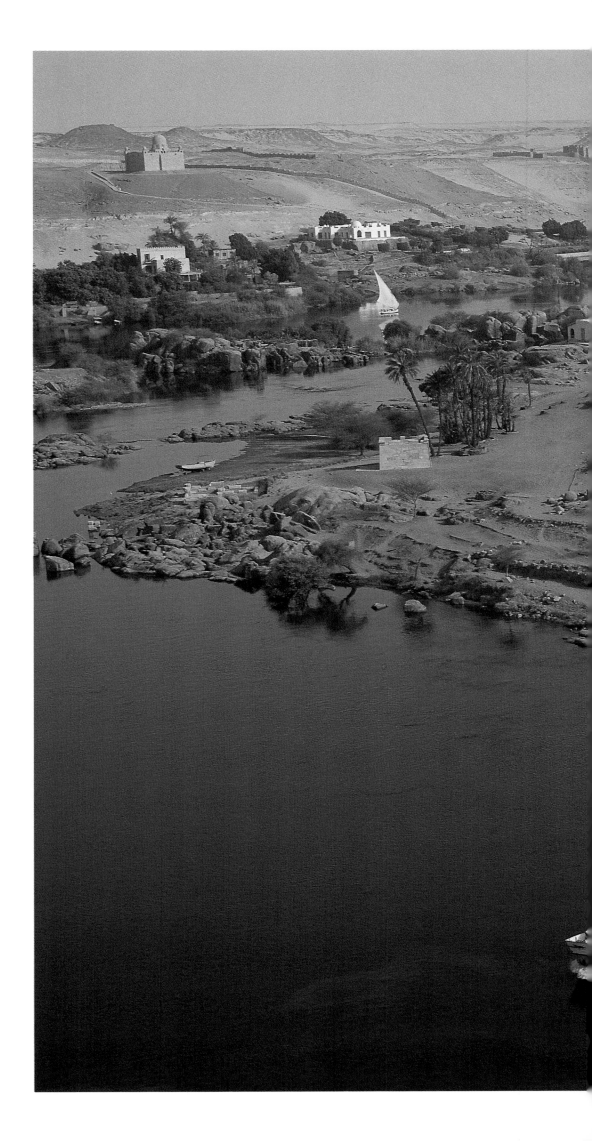

Aswan, Elephantine Island

Aswan is the southernmost and most pictur-
esque town in Egypt. The very first settle-
ments were established on Elephantine Island
in mid-river. At this point the Libyan desert
reaches right up to the banks of the Nile, as if
it planned to engulf the narrow valley in its
vast masses of sand.

Assuan, Elephantine-Island

Assuan ist die südlichste Stadt Ägyptens
mit malerischem Flair. Auf der Elephantine-
Insel in der Mitte des Stroms entstanden die
ersten Ansiedlungen. Hier rückt die Lybische
Wüste bis unmittelbar an das Nilufer heran
und scheint das enge Tal mit ihren Sand-
massen erdrücken zu wollen.

Assouan, Ile Eléphantine

Assouan est la ville la plus méridionale et la
plus pittoresque de l'Egypte. Les premières
colonies se sont installées sur l'île Eléphan-
tine, au milieu du fleuve. Ici, le désert libyque
s'approche de la rive du Nil et semble vouloir
écraser l'étroite vallée avec ses masses de
sable.

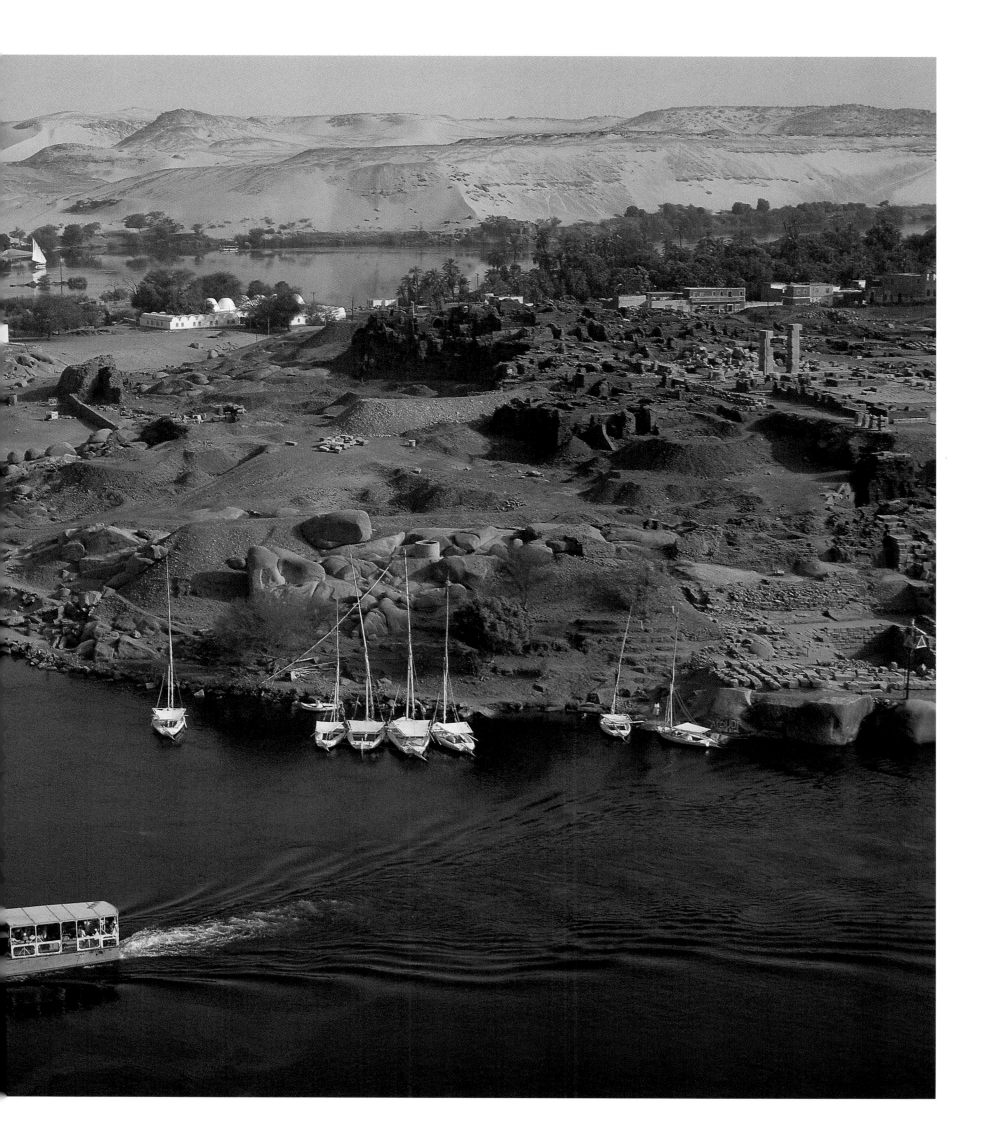

page 88/89

The Valley of the Kings
The Valley of the Kings was the Theban
Pharaohs' great necropolis on the west bank
of the Nile, and is one of Egypt's most import-
ant historic sites. The mighty tombs were
hewn deep into the rock, in the hope that this
would afford protection against intruders; but
in fact they were all – with the sole exception
of Tutankhamen's tomb – looted by grave
robbers at an early date.

Seite 88/89

Das Tal der Könige
Das Tal der Könige, die Totenstadt des
pharaonischen Theben auf der Westseite des
Nils, zählt zu den bedeutendsten kulturhisto-
rischen Stätten Ägyptens. Die gewaltigen
Grabanlagen wurden zum Schutz vor Ein-
dringlingen tief in den Fuß des Bergmassivs
getrieben, sind jedoch, mit Ausnahme der
Nekropole Tut-ench-Amuns, bereits früh von
Grabräubern geplündert worden.

page 88/89

La Vallée des Rois
La Vallée des Rois, la nécropole de la Thèbes
des pharaons, à l'ouest du Nil, fait partie
des sites les plus importants de l'histoire de la
civilisation égyptienne. Les prodigieux
tombeaux creusés en profondeur au pied du
massif montagneux pour se protéger contre
les intrus, ont toutefois, exception faite de la
nécropole de Tout-Ankh-Hamon, été pillés
très tôt par les violeurs de sépultures.

Contrasts on the west bank at Thebes
Kontraste, Westbank von Theben
Contrastes, Ouest de Thèbes

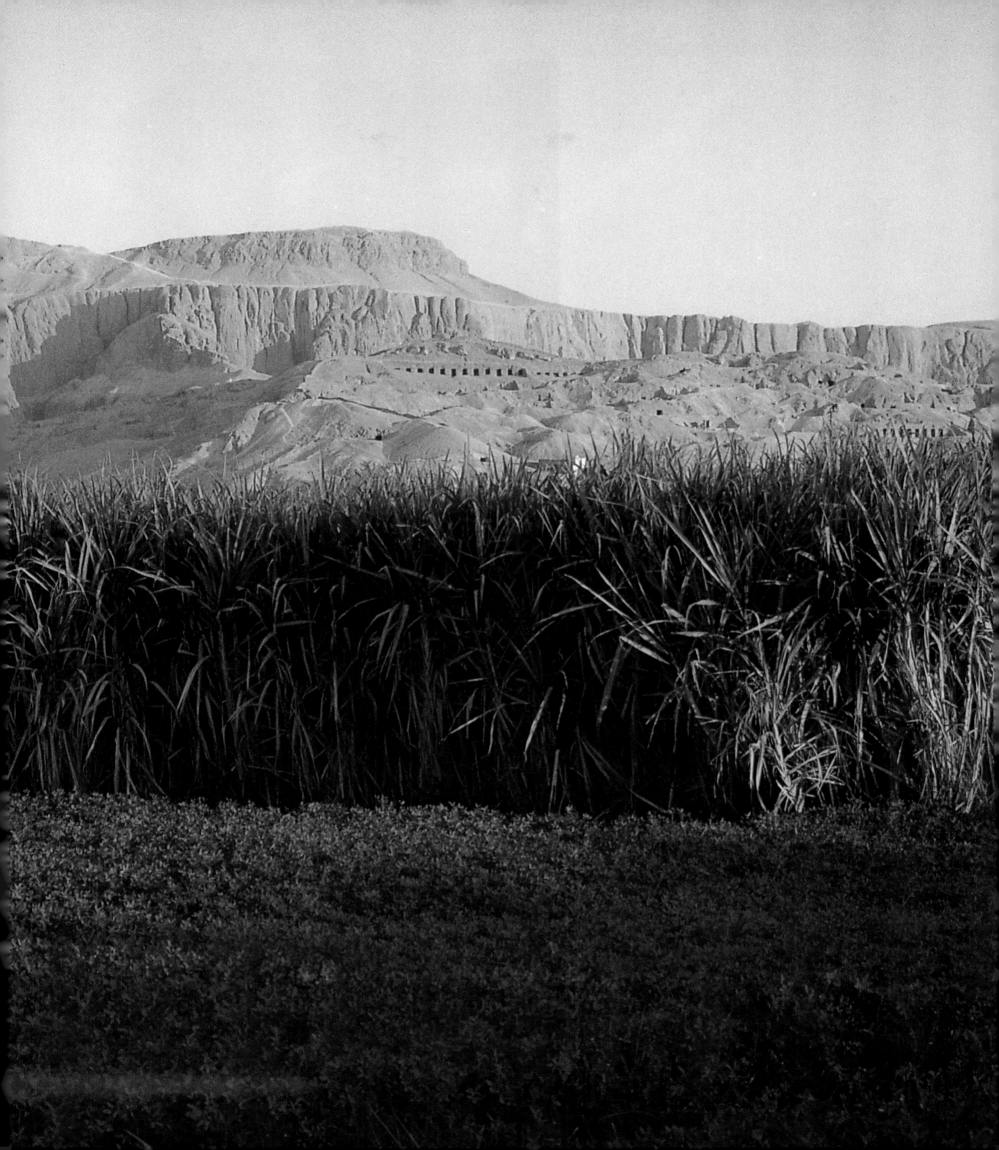

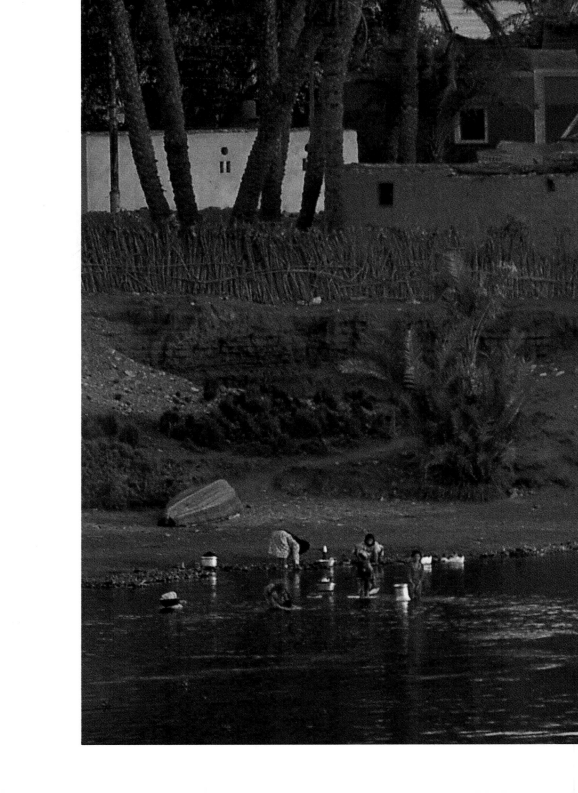

Village on the southern reaches of the Nile
Dorf am südlichen Nil
Village, partie Sud du Nil

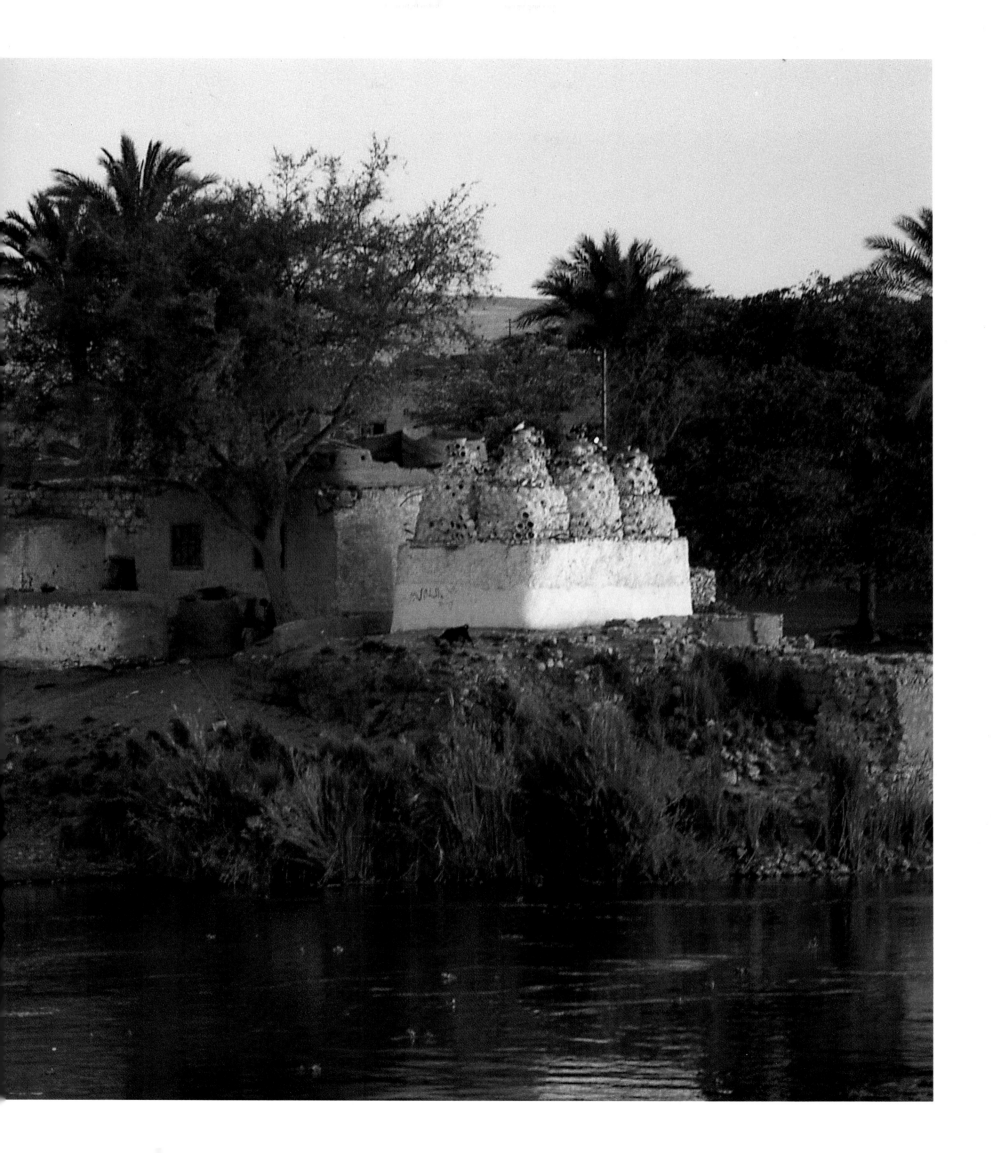

Village on the southern reaches of the Nile

Dorf im Abendlicht, südlicher Nil

Village au couchant, partie Sud du Nil

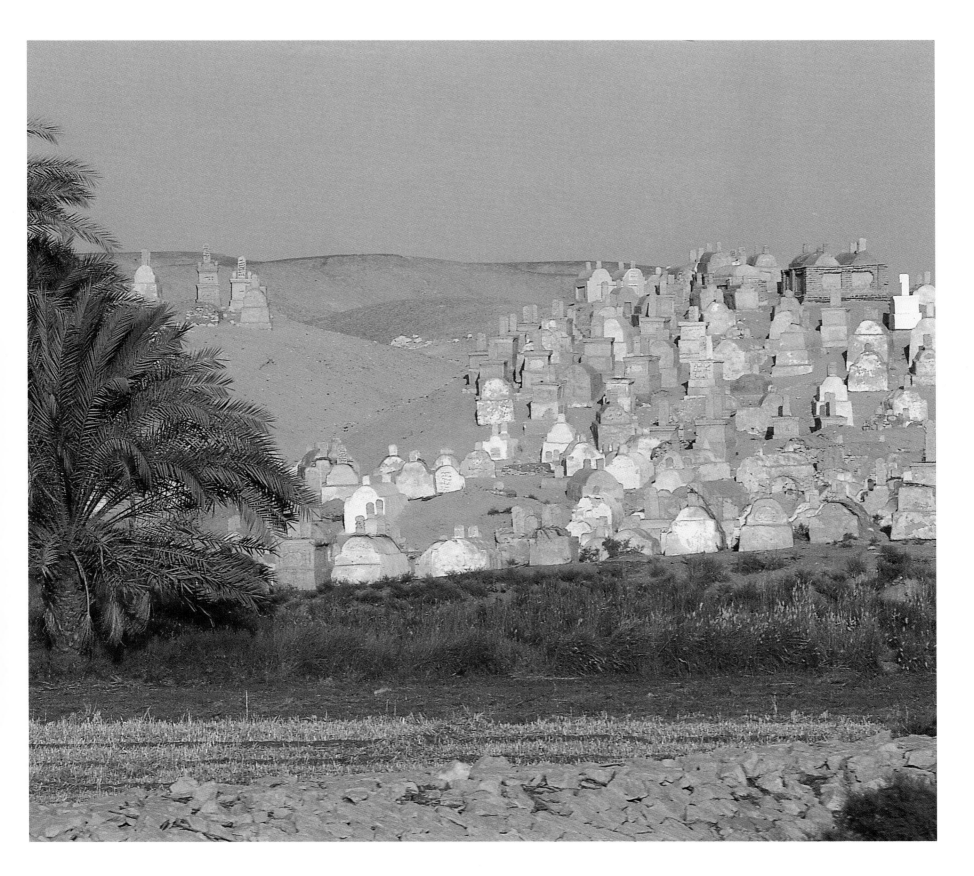

Desert cemetery south of Asyut
Wüstenfriedhof, südlich von Asyut
Cimetière du désert, Sud d'Assiout

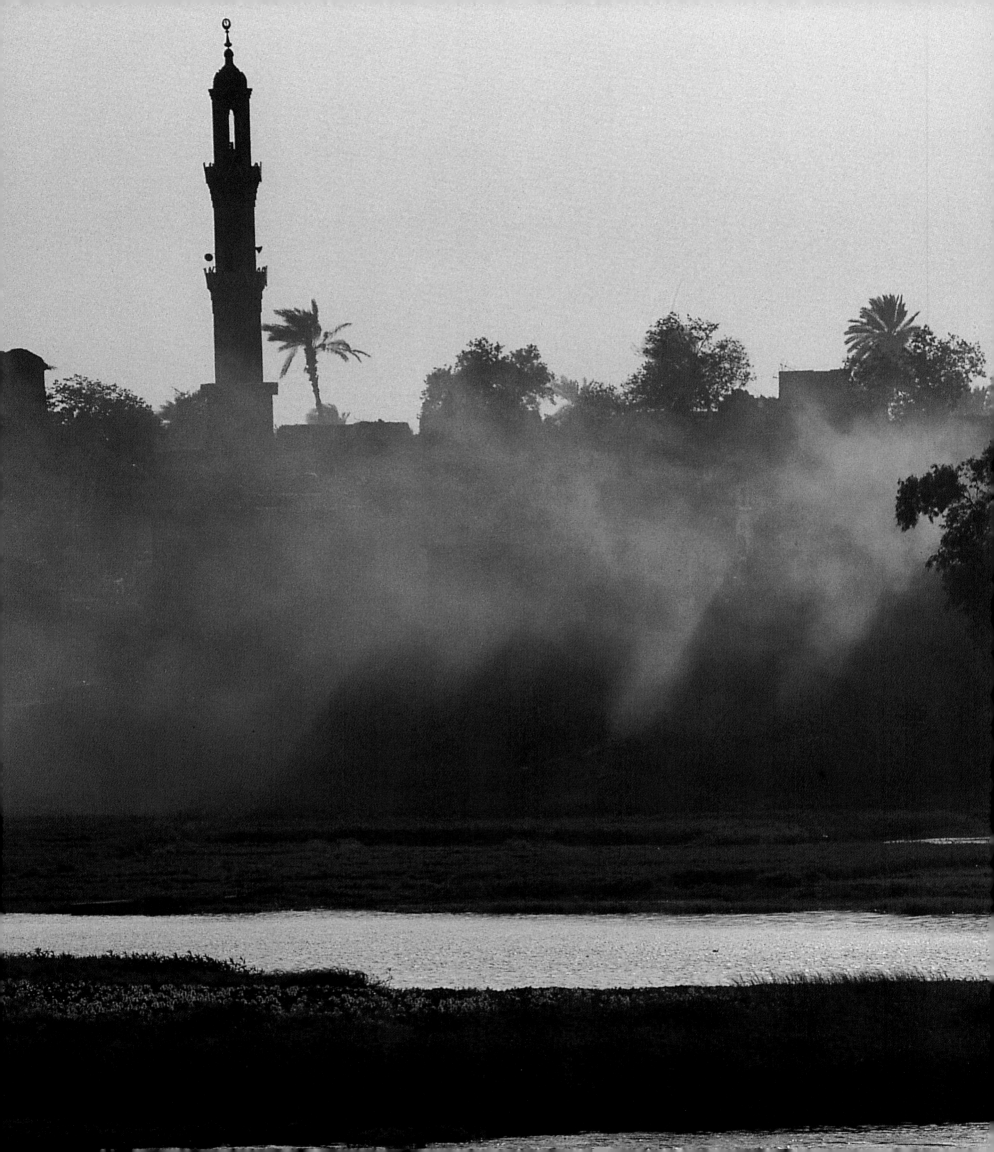

Morning on the Nile
Morgenstimmung am Nil
Atmosphère matinale au bord du Nil

Home of the fellahin on the Upper Nile
Fellachen-Hütte am oberen Nil
Hutte de fellah au bord Nil

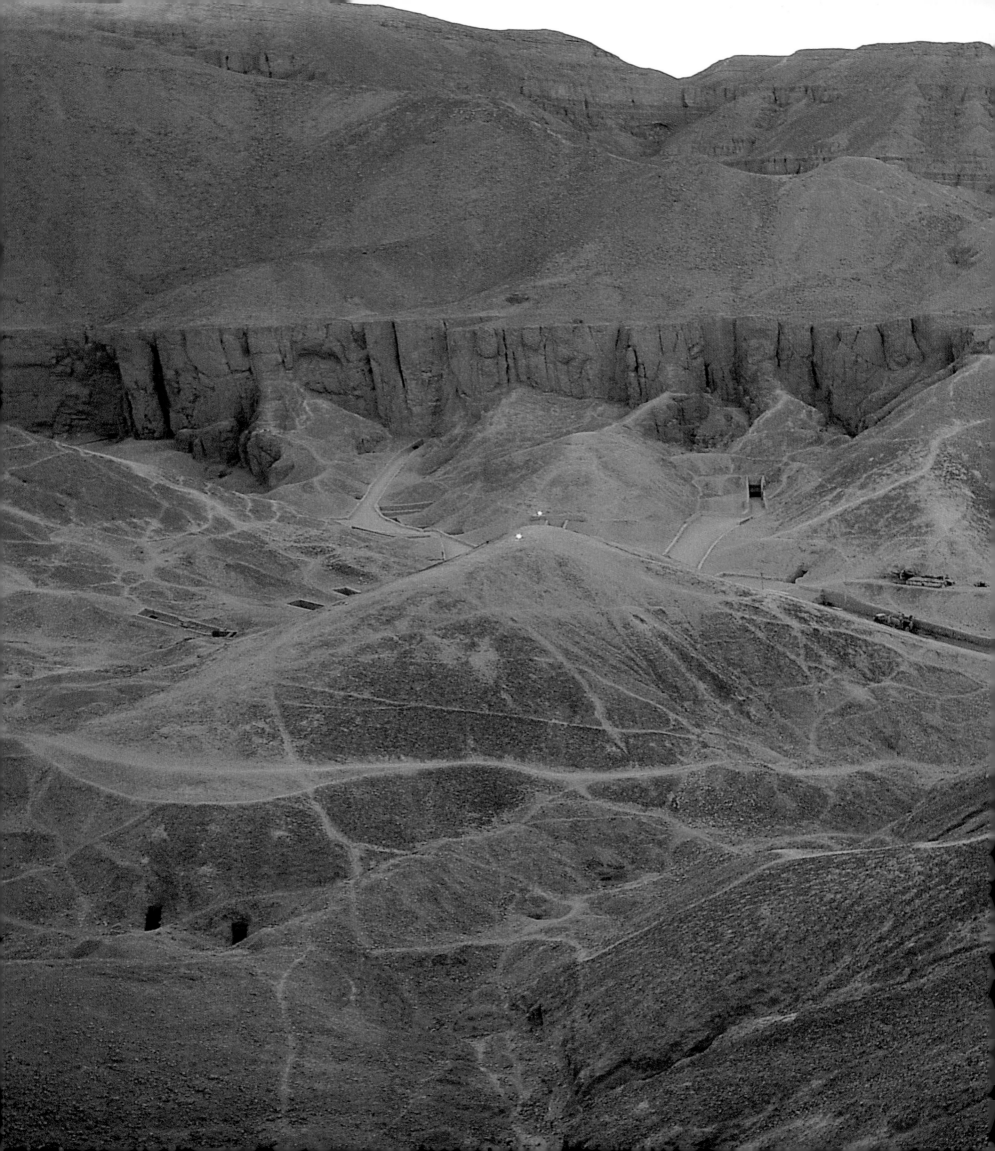

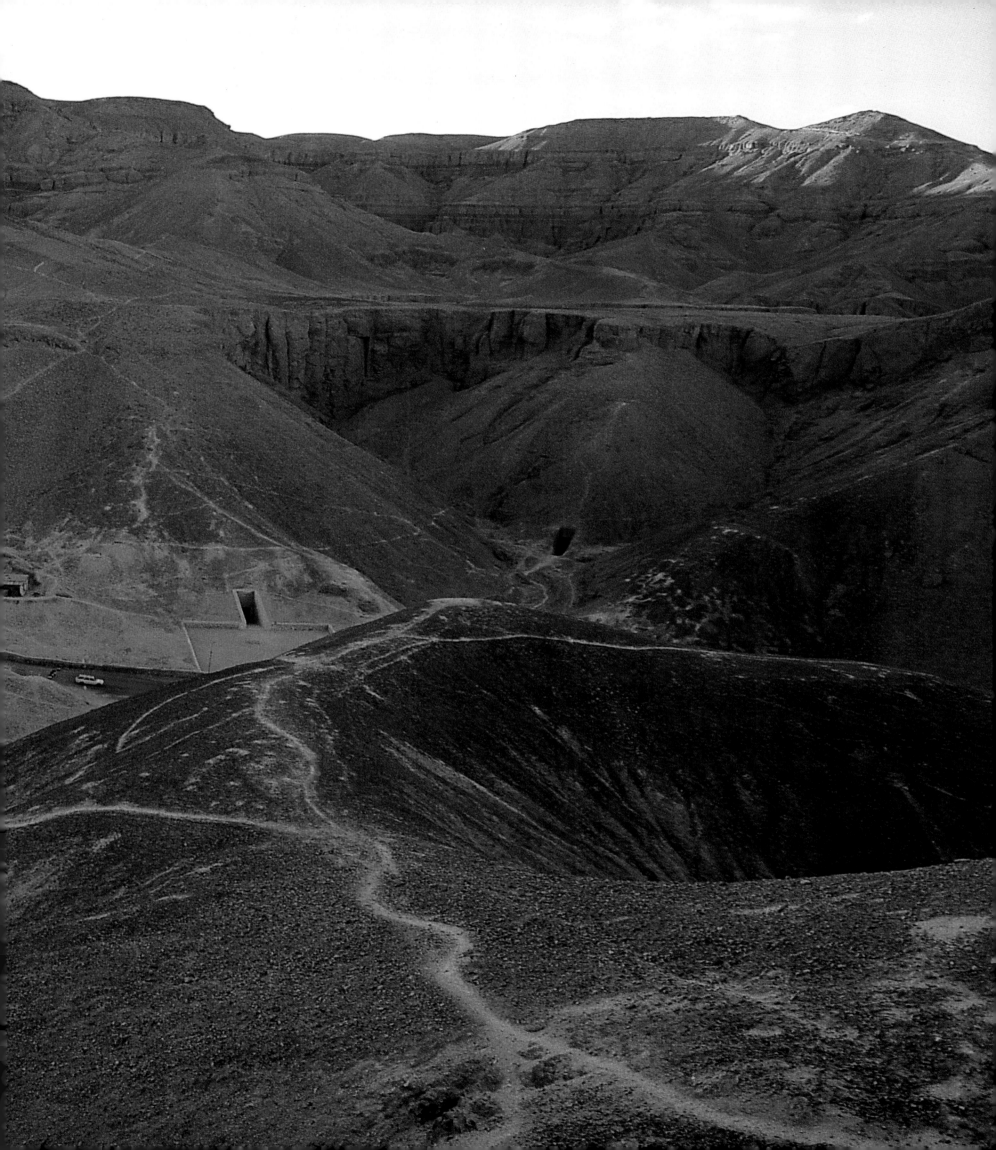

The Sinai

Der Sinai

Le Sinaï

Pyramidal mountain in central Sinai, evening
Kegelberg im Abendlicht, Zentral-Sinai
Montagne conique au couchant, centre du Sinaï

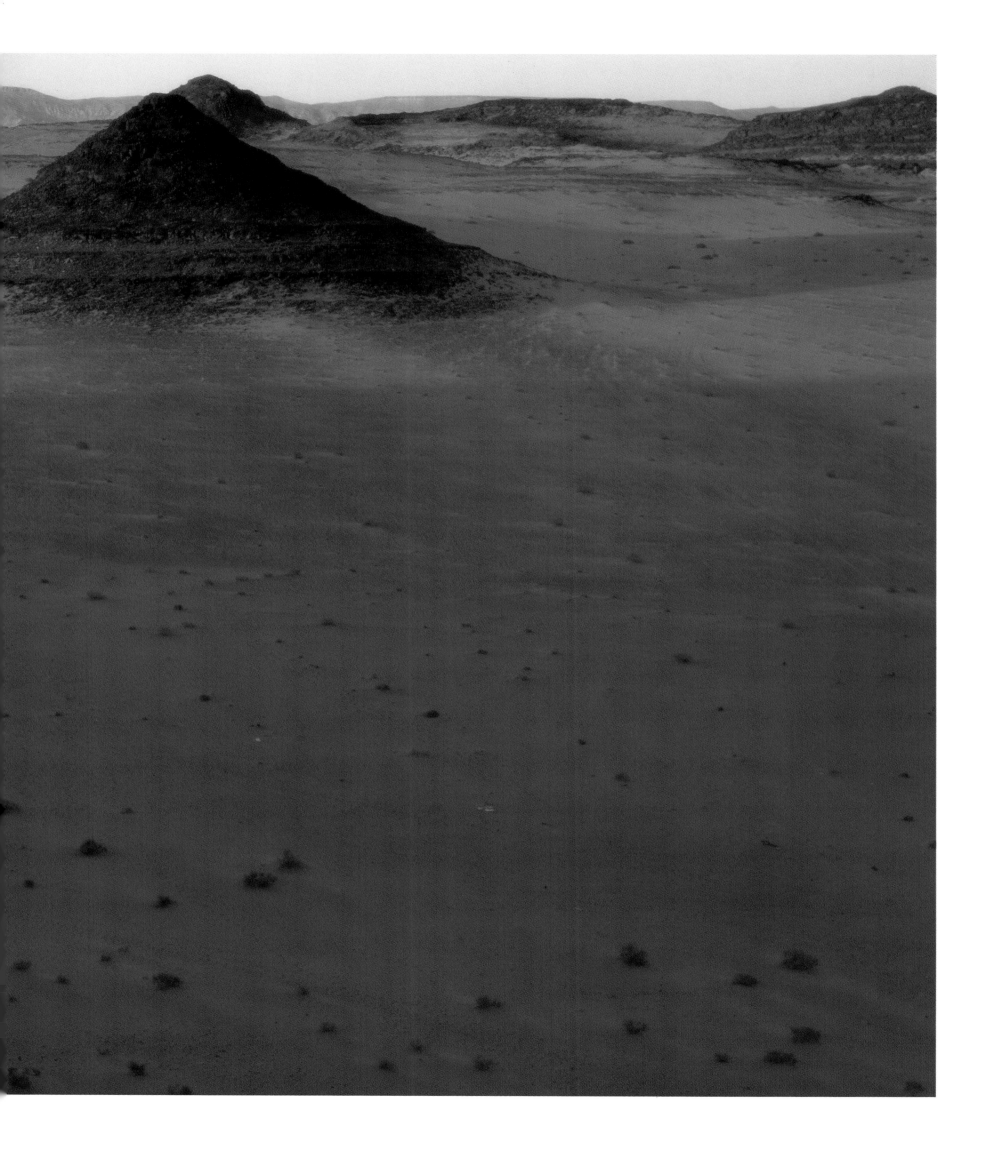

A spring in the mountains of central Sinai
Quelle im Bergmassiv des Zentral-Sinai
Source dans le massif montagneux au centre du Sinaï

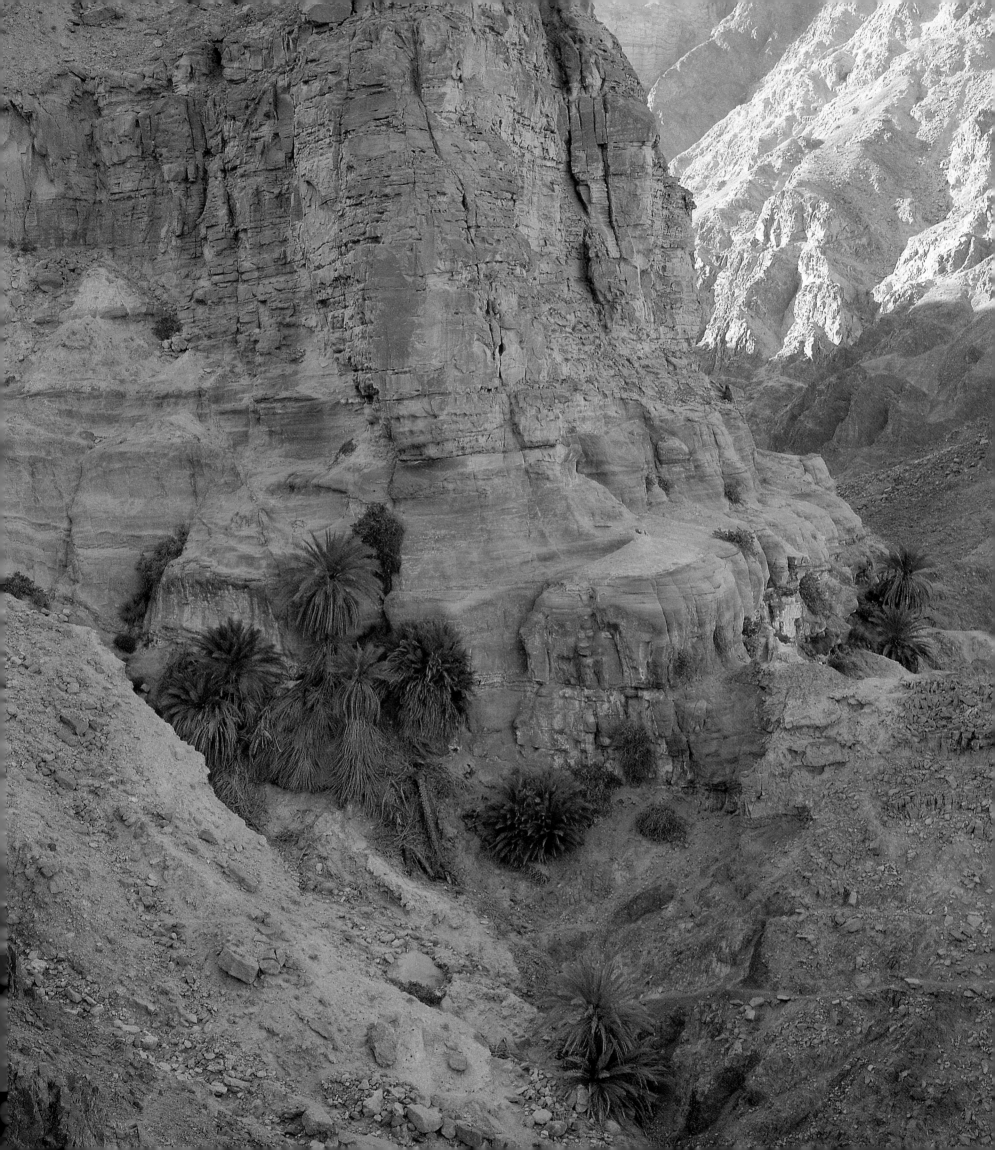

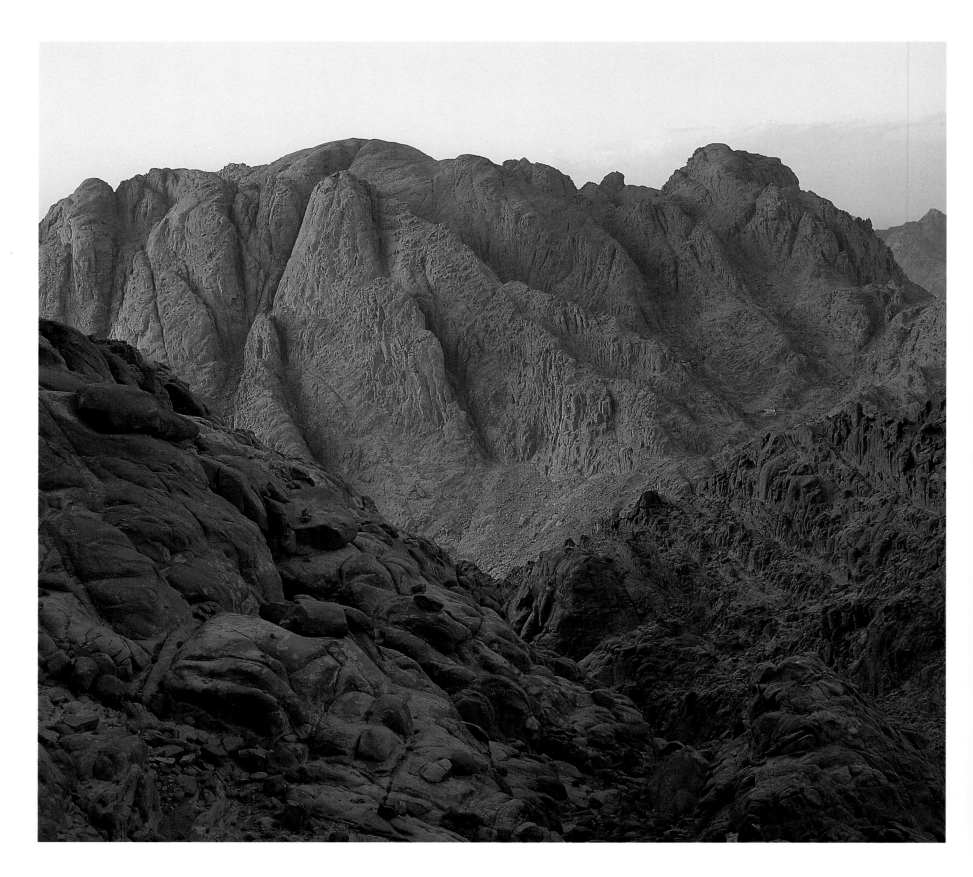

A sea of rock, coming down Mount Sinai
Felsenmeer, beim Abstieg vom Moses-Berg
Mer de rochers, pendant l'escalade du mont Moïse

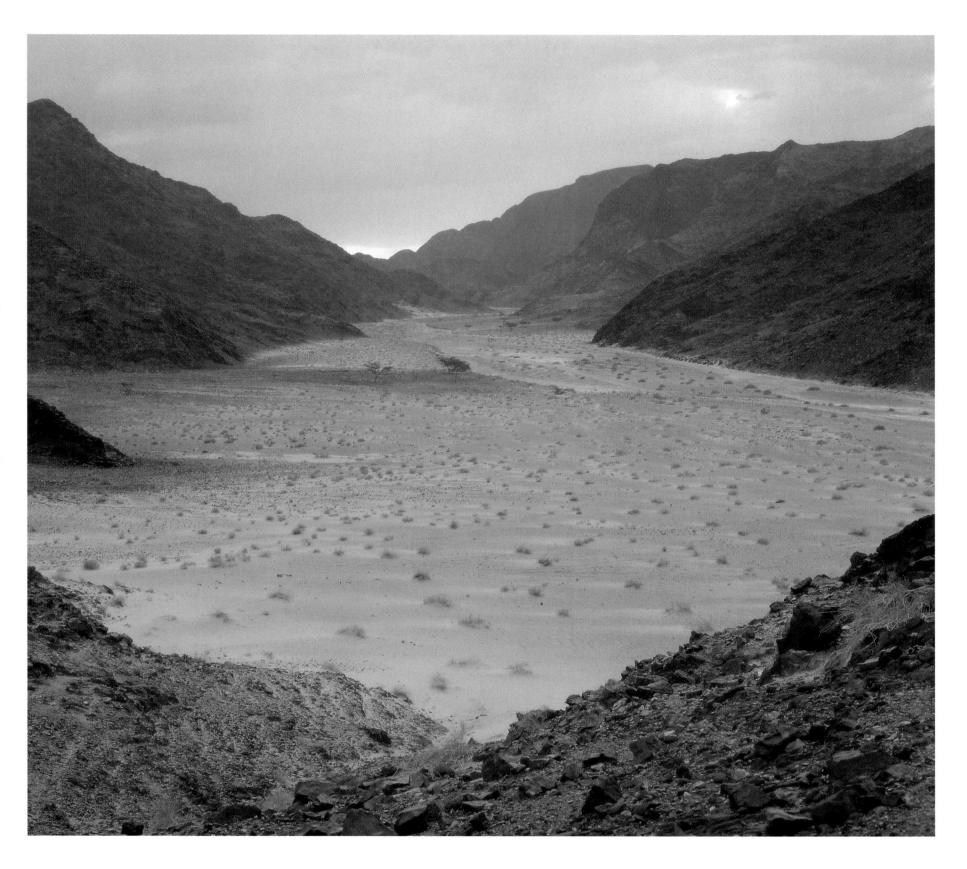

Morning at Wadi Seih, central Sinai

Morgenstimmung im Wadi Seih, Zentral-Sinai

Atmosphère matinale dans l'oued Seih, centre du Sinaï

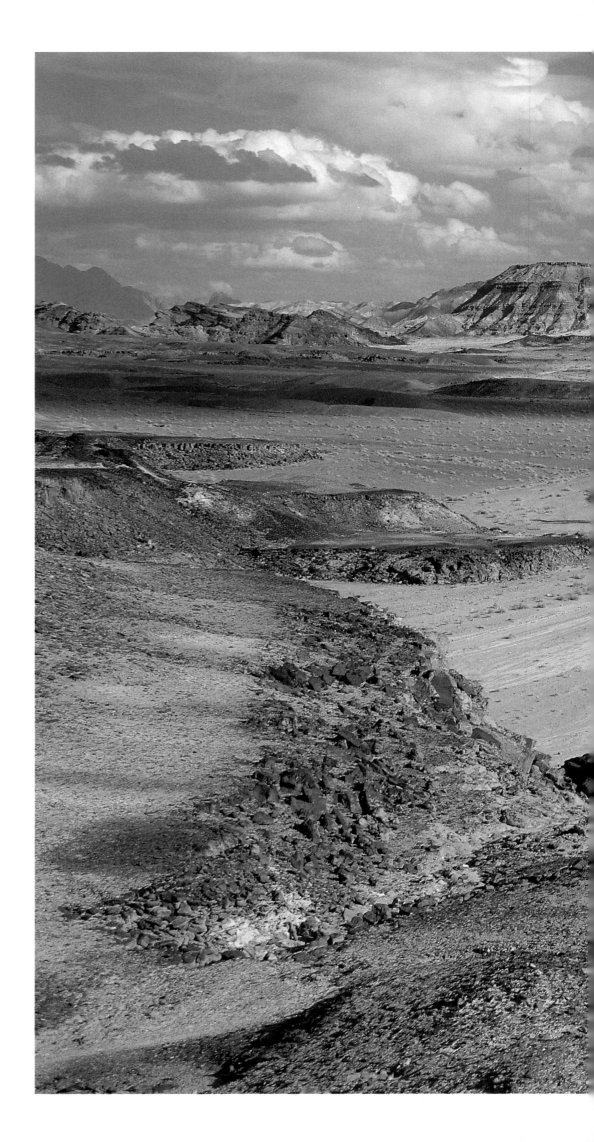

Wadi Muktap

The name, loosely translated, means Valley
of the Signs. On the rocks there are ancient
Semitic inscriptions dating from the second
millennium BC, as well as signs cut by Cru-
saders on their way to Jerusalem, to help
them find their way home.

Das Wadi Muktap

Frei übersetzt bedeutet der Name Wadi
Muktap soviel wie »Tal der Zeichen«. Auf
den Felsen finden sich alte semitische Schrift-
zeichen aus dem 2. vorchristlichen Jahr-
tausend, sowie in den Stein geritzte Symbole,
die Kreuzritter auf ihrem Weg nach Jerusalem
als Markierung für den Rückweg hinter-
ließen.

L'oued Muktap

La traduction libre de Oued Muktap
signifie «Vallée des signes». Les roches sont
en effet pourvues de vieux signes graphiques
sémitiques datant du second millénaire avant
J.-C. et de symboles gravés dans la pierre, qui
furent laissés par des Croisés en route pour
Jérusalem, comme repères pour le retour.

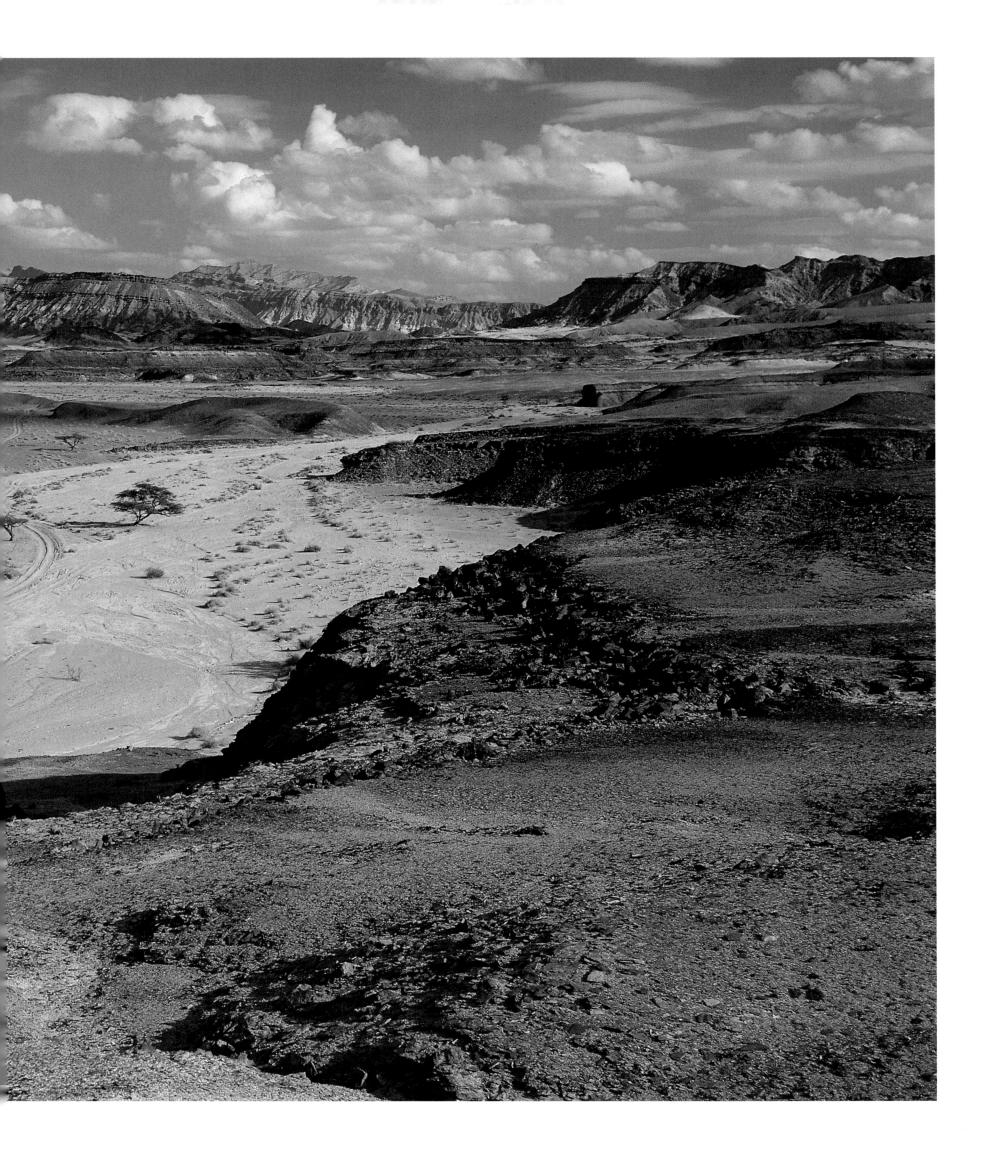

Traces of erosion, rock sculpture in Sinai
Spuren der Erosion, Felsskulptur im Sinai
Traces d'érosion, sculpture rupestre dans le Sinaï

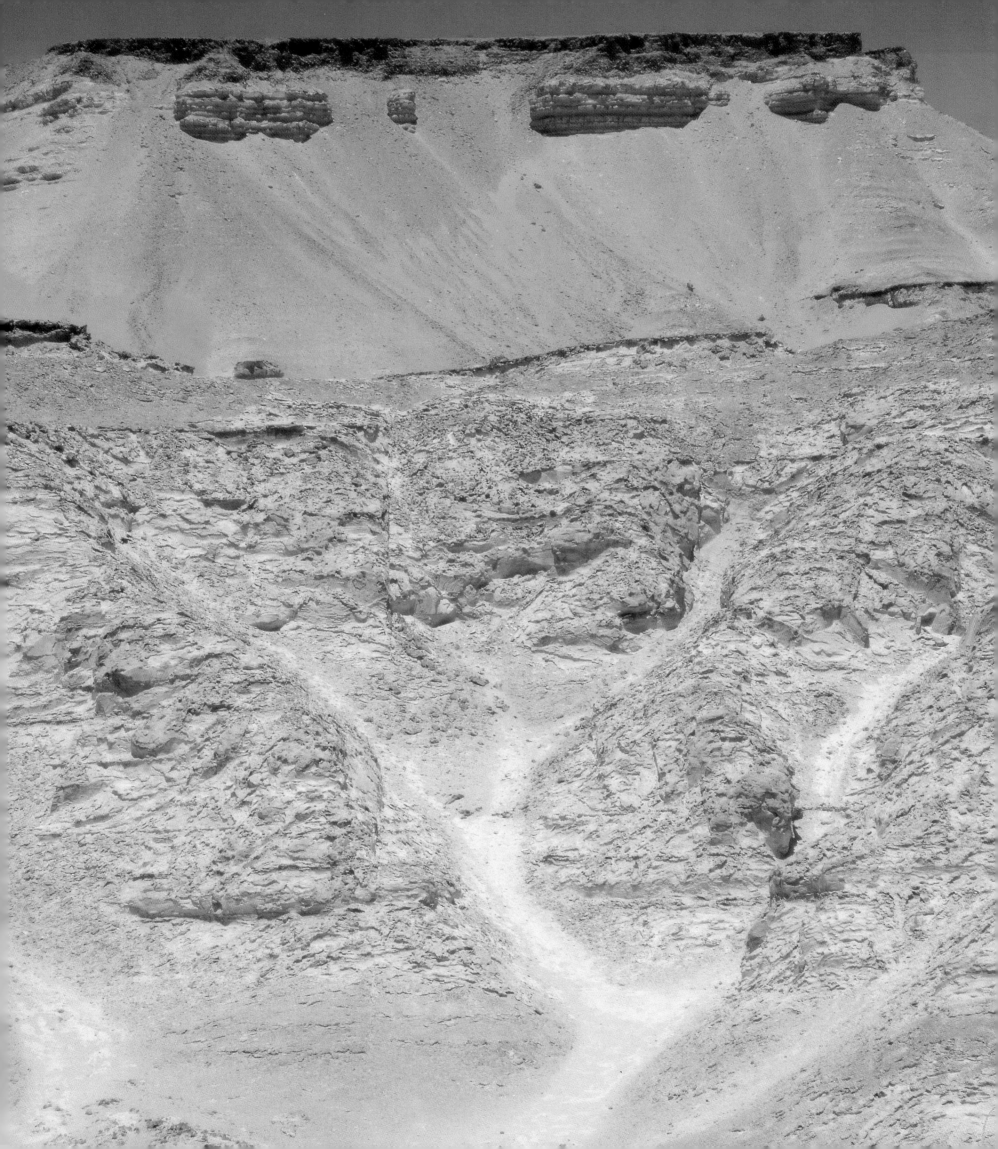

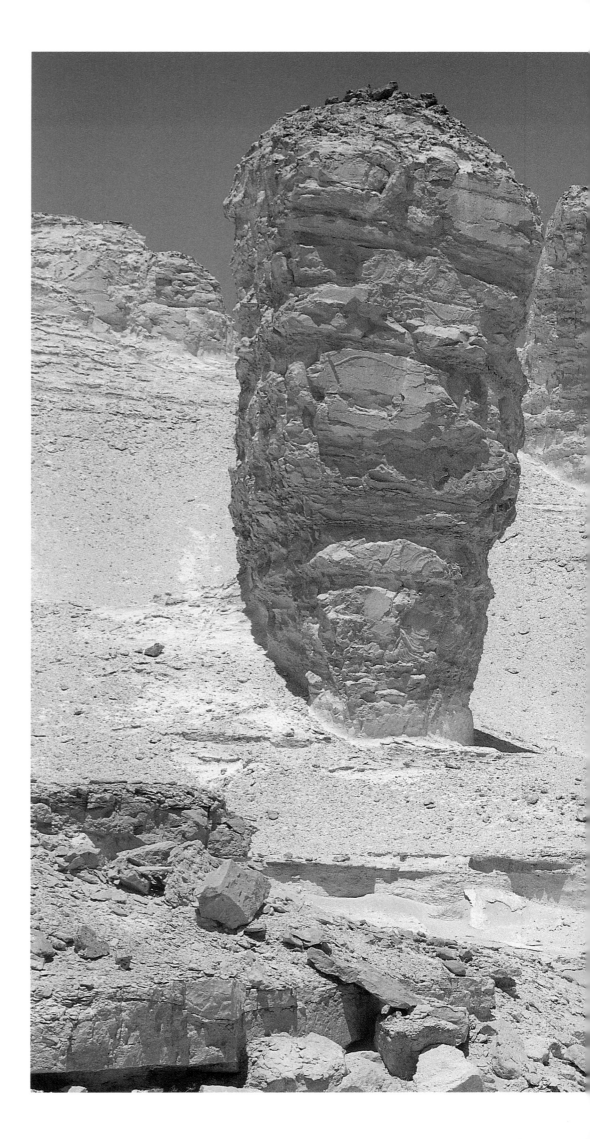

Rock sculptures, western Sinai
Felsskulpturen im West-Sinai
Sculptures rupestres, Ouest du Sinaï

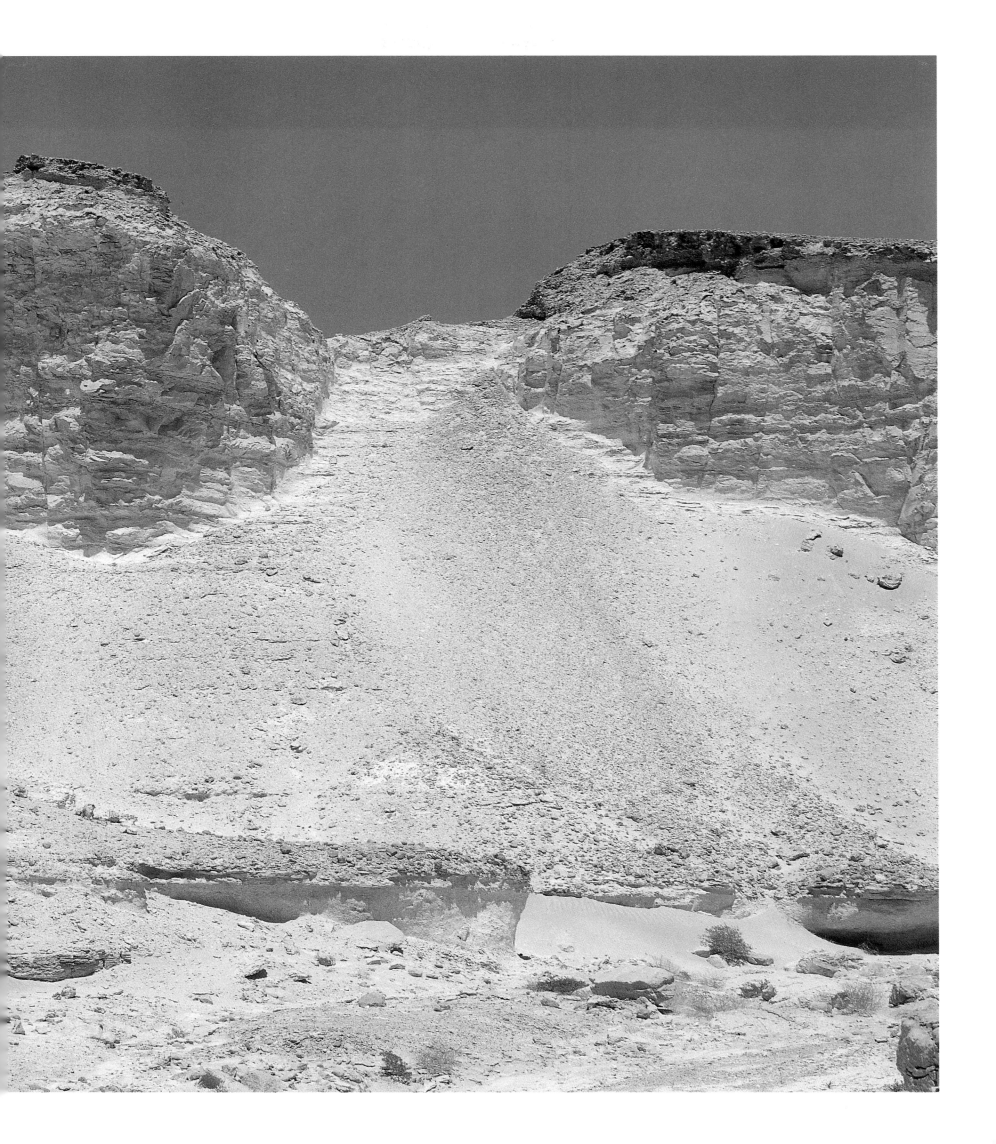

»Taking the measure of humankind«
In Sinai too, prehistoric floods, followed by
centuries of wind and drifting sand, carved
unusually shaped rock sculptures of stagger-
ing dimensions. Beside them, human beings
are mere ants.

»Von der Größe des Menschen«
Die Erosion durch Wasserfluten in prähisto-
rischer Zeit, durch Wind und Sand, schuf
auch im Sinai Felsgebilde von ungewöhn-
licher Form und beachtlicher Größe, neben
denen ein Mensch zum Winzling wird.

«De la grandeur de l'homme»
L'érosion due aux inondations des temps
préhistoriques, au vent et au sable, a égale-
ment créé dans le Sinaï des roches de taille
appréciable aux formes inhabituelles, à côté
desquelles l'être humain est minuscule.

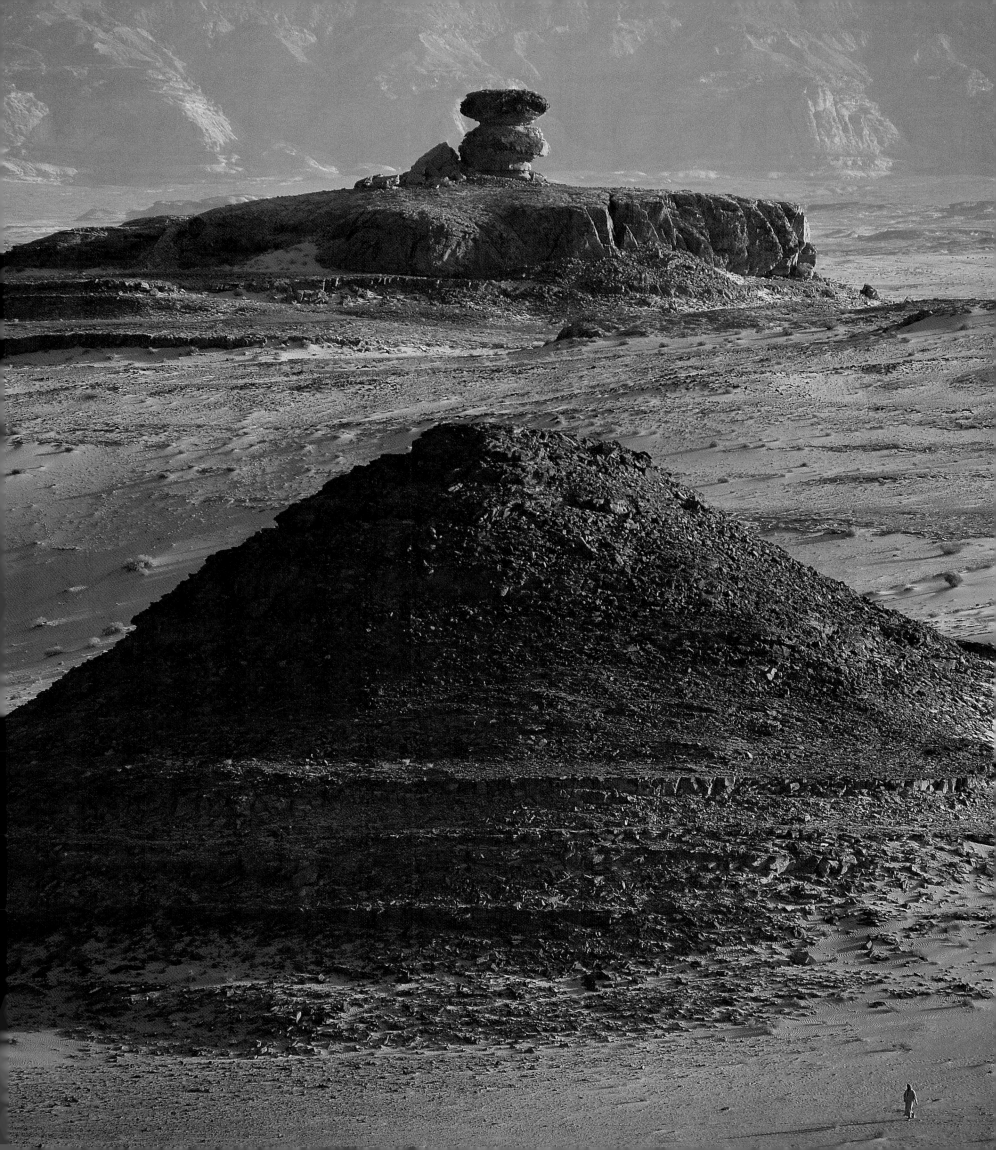

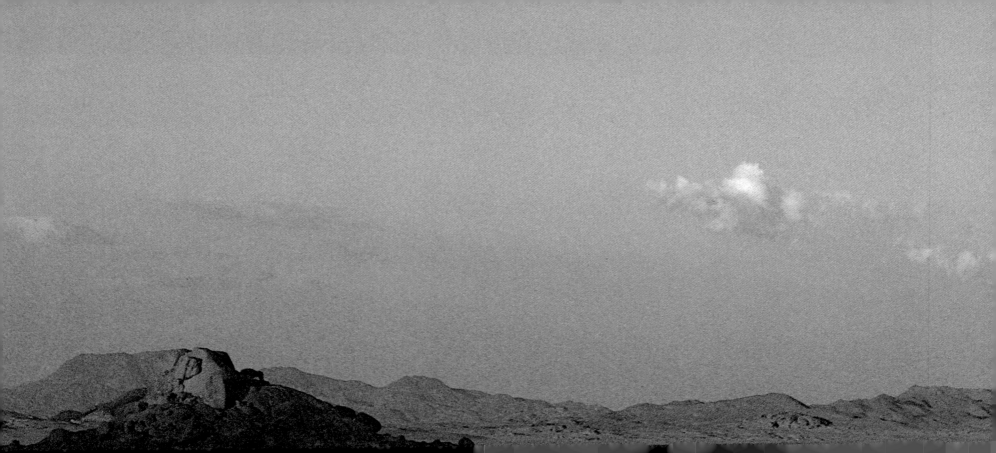

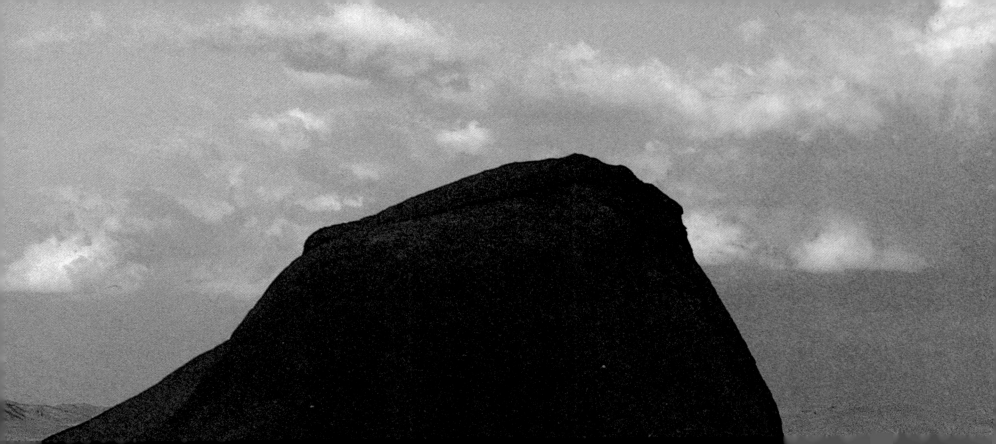

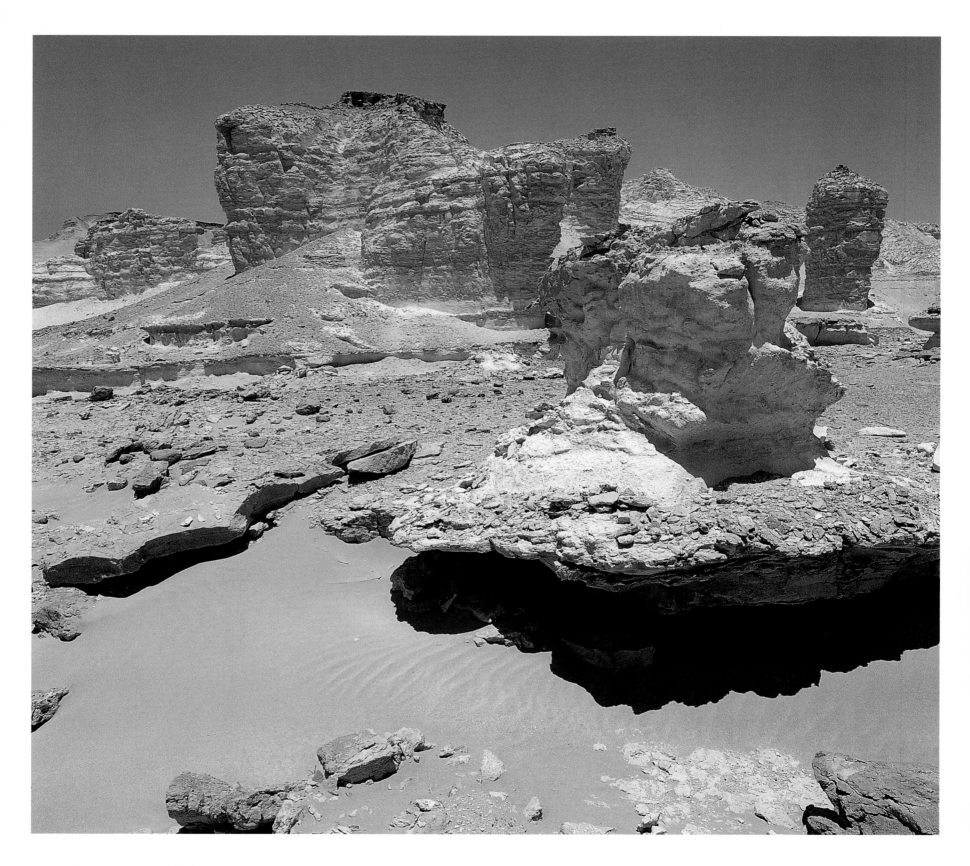

Rock columns, western Sinai

Felsentürme im West-Sinai

Tours rocheuses, Ouest du Sinaï

108

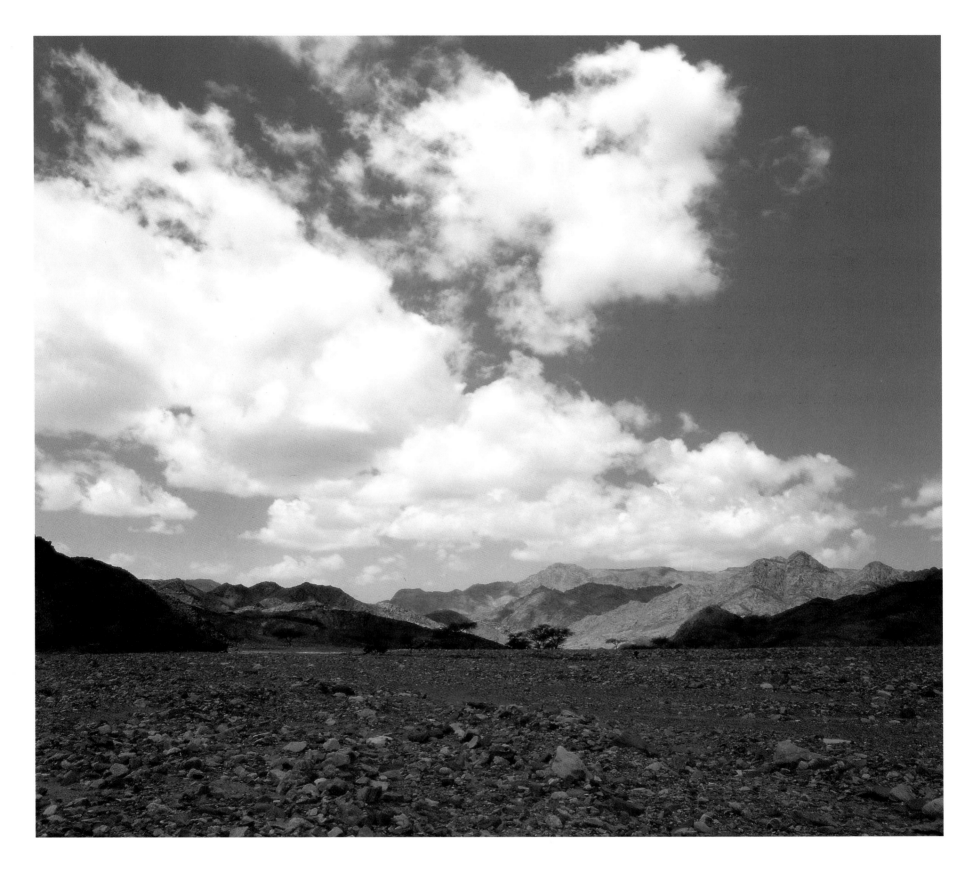

Wadi El Garf, central Sinai

Wadi El Garf, Zentral-Sinai

L'oued El Garf, centre du Sinaï

The view from Mount Sinai

Legend has it that Djebel Mousa, 2,285 metres
high, is the Mount Sinai on which, according
to Exodus, Moses received the tablets of the
Ten Commandments. From the summit, the
view across Sinai's ocean of rock is breath-
taking. This, indeed, is the rock of ages.

**Blick vom Gipfel des Moses-Berges
über den Sinai**

Der 2285 Meter hohe Gebel Musa, auf dem
Moses der Legende nach die Gesetzestafeln
empfangen haben soll, erlaubt von seinem
Gipfel einen atemberaubenden Blick über
das Felsenmeer des Sinai, einer Granit-Land-
schaft von archaischer Urwüchsigkeit.

**Vue depuis le sommet du mont Moïse
sur le Sinaï**

Le Djebel Mousa s'élève à 2285 m d'altitude
et Moïse y aurait reçu les tables de la Loi.
Depuis le sommet, on jouit d'une vue épous-
touflante sur la mer rocheuse du Sinaï,
paysage granitique naturel et archaïque.

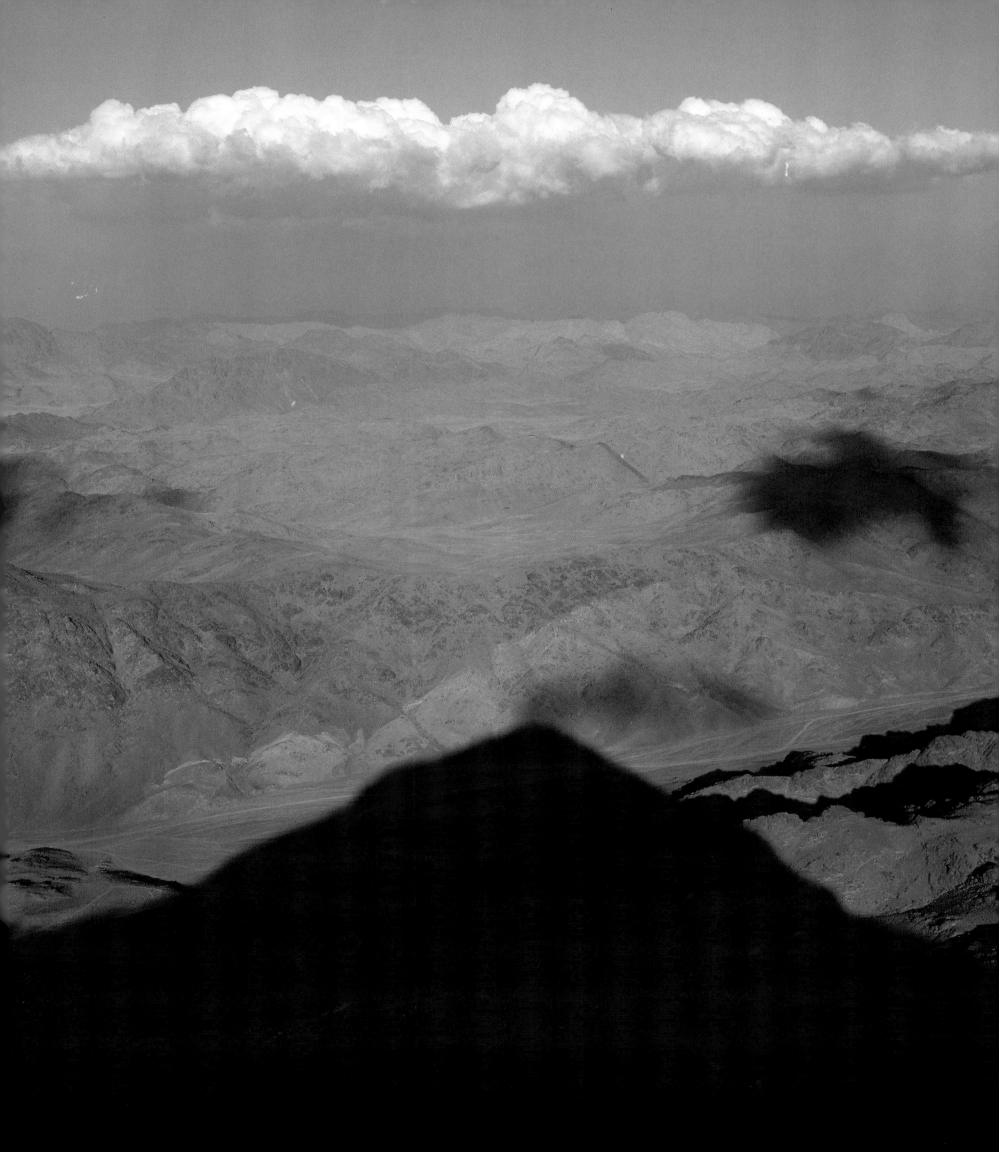

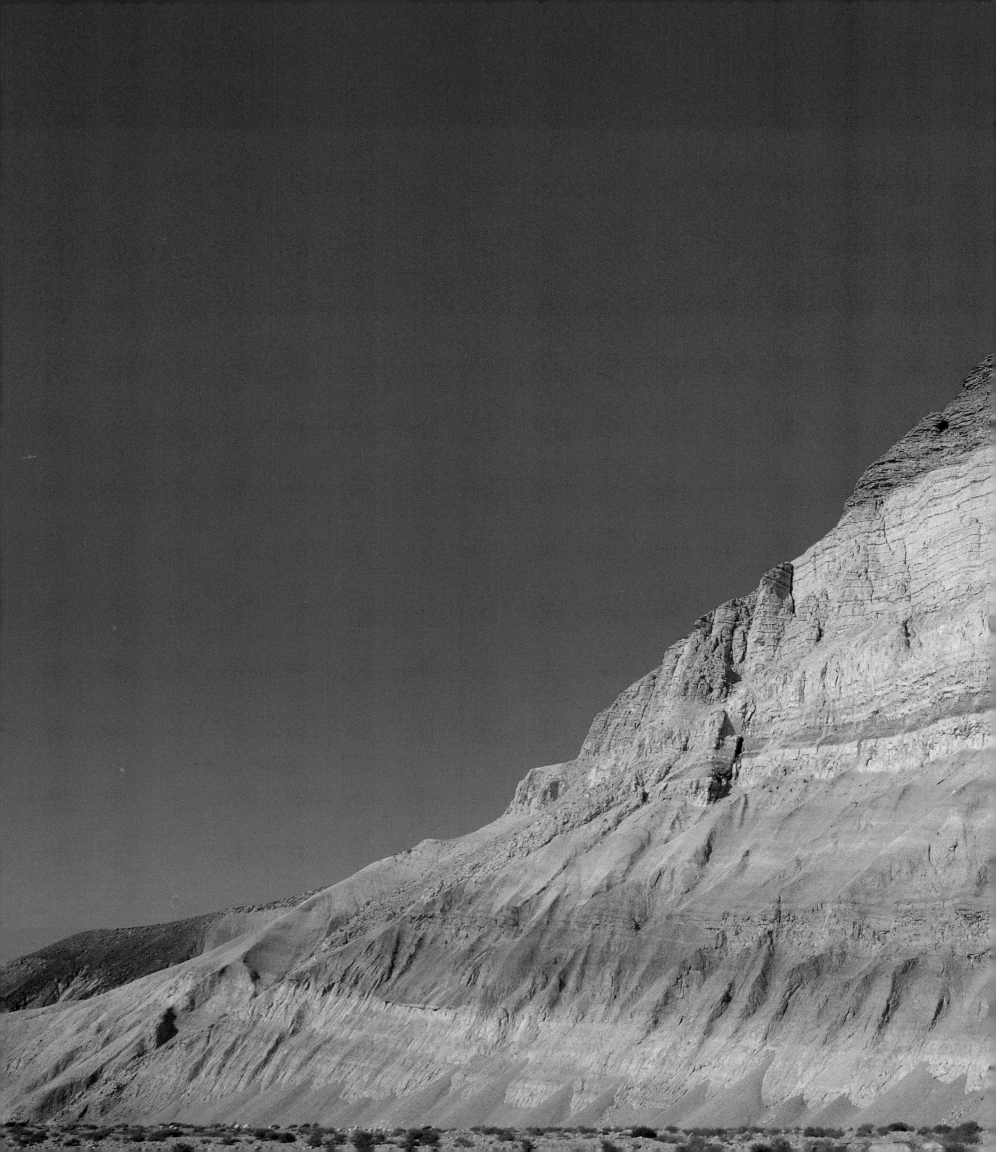

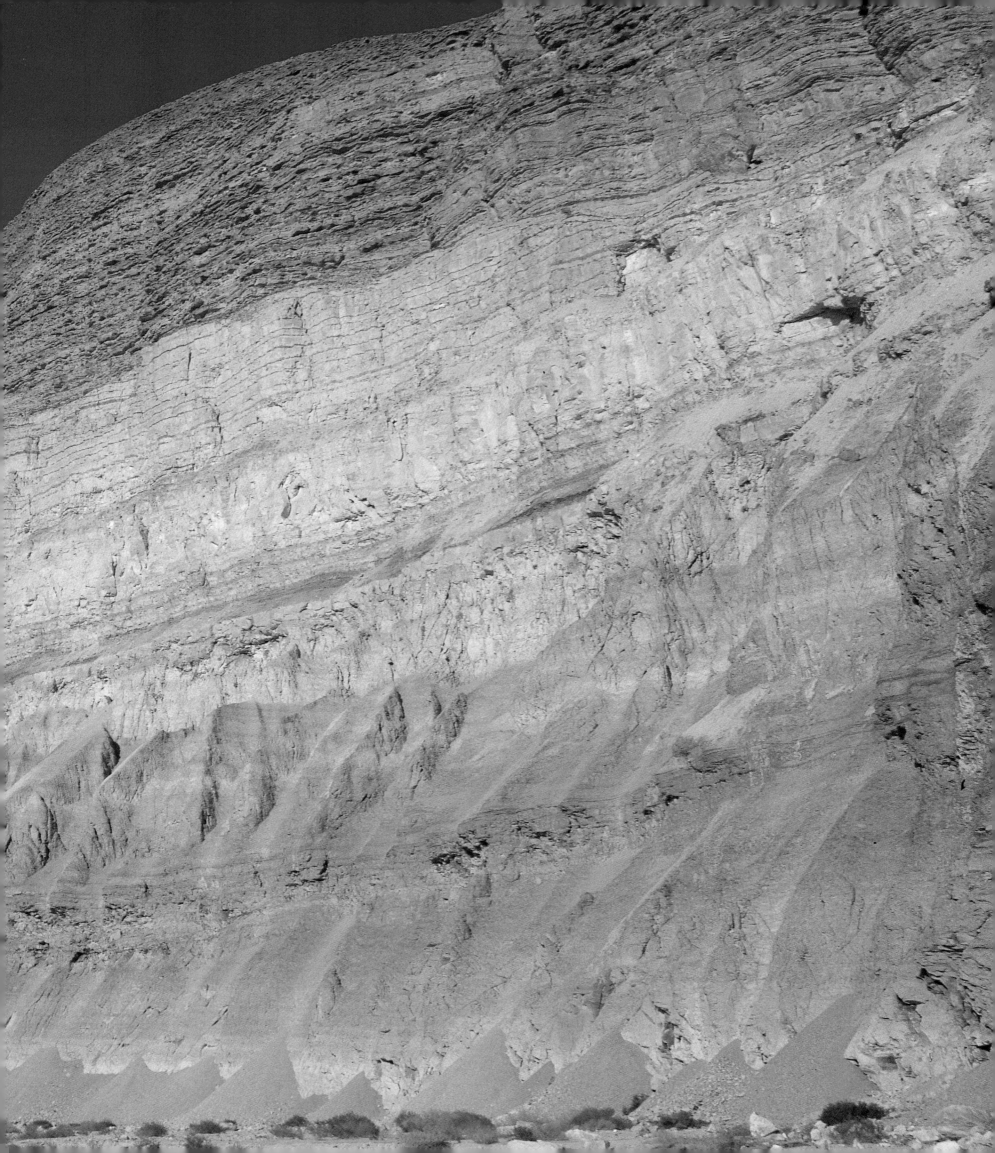

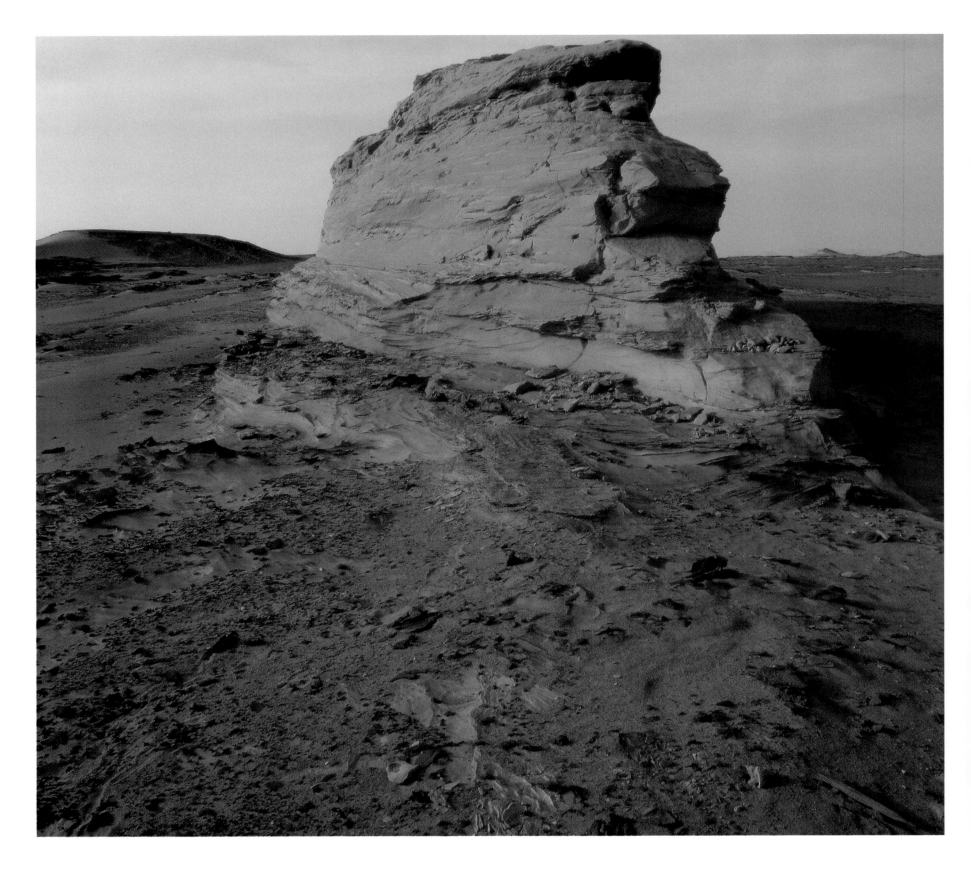

Central Sinai
Zentral-Sinai
Centre du Sinaï

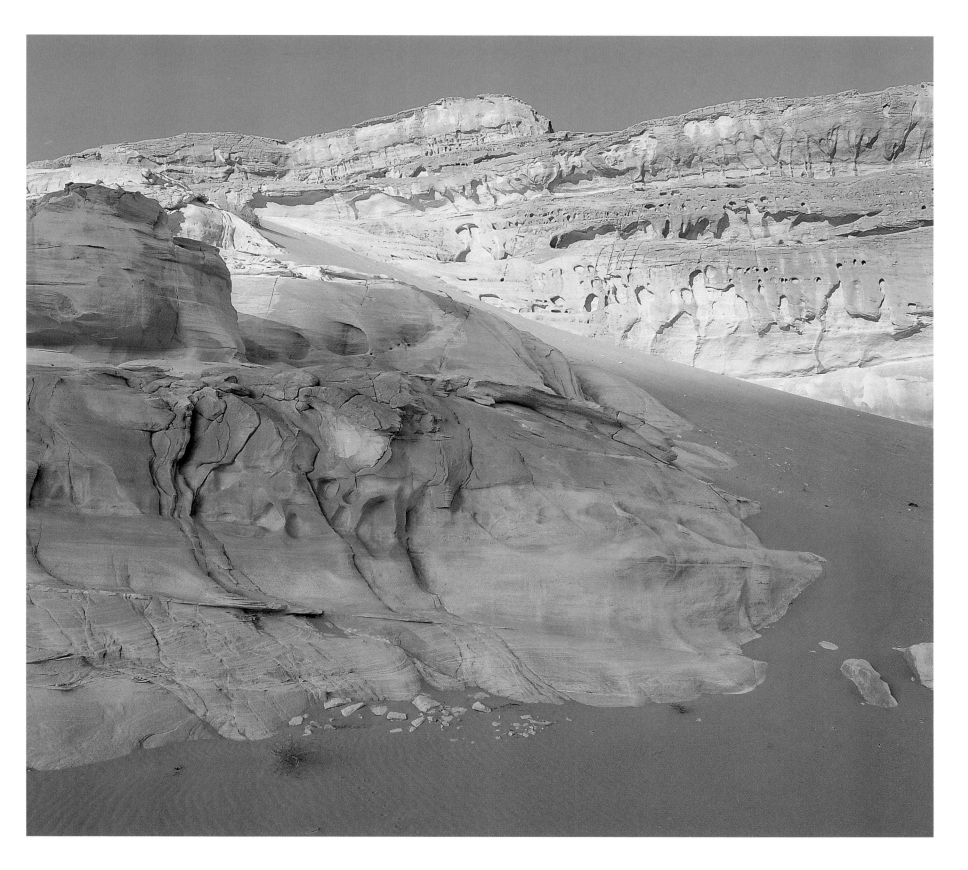

Rock sculpture, eastern Sinai
Felsskulptur im Ost-Sinai
Sculpture rupestre, Est du Sinaï

The *Blue Mountains*

The *Blue Mountains* are no whim of Creation, no freak of Nature. They are man-made. In 1980, a Belgian artist named Jean Verame spent two months transforming the plateau north of Mount Sinai into what might be called land art, using a brush and paints. Given the remoteness of the terrain, it is normally only the Bedouin who are confronted with this enigmatic sight – and they no doubt accept it with their customary phlegmatic ease.

Die *Blauen Berge*

Die *Blauen Berge* sind weder eine Laune des Universums noch das Resultat eines Naturereignisses, sondern das Werk eines Menschen. Der belgische Künstler Jean Verame hielt sich 1980 zwei Monate hier auf, um das nördlich des Moses-Berges gelegene Hochplateau mit Pinsel und Farbe in eine *land art* zu verwandeln. Da der Ort relativ abgeschieden liegt, gibt er wohl nur Beduinen Rätsel auf, die das jedoch aufgrund ihrer Art mit Gelassenheit zur Kenntnis nehmen.

Les *montagnes bleues*

Les *montagnes bleues* ne sont ni un caprice de l'univers ni le résultat d'un phénomène naturel, mais l'œuvre d'un homme. En 1980, l'artiste belge Jean Vérame y a passé deux mois pour transformer en *land art* le hautplateau situé au nord du mont Moïse, à l'aide de ses pinceaux et de ses couleurs. Comme ce site est relativement isolé, il propose une énigme aux seuls bédouins, qui le découvrent toutefois sans s'émouvoir, en raison de leur caractère.

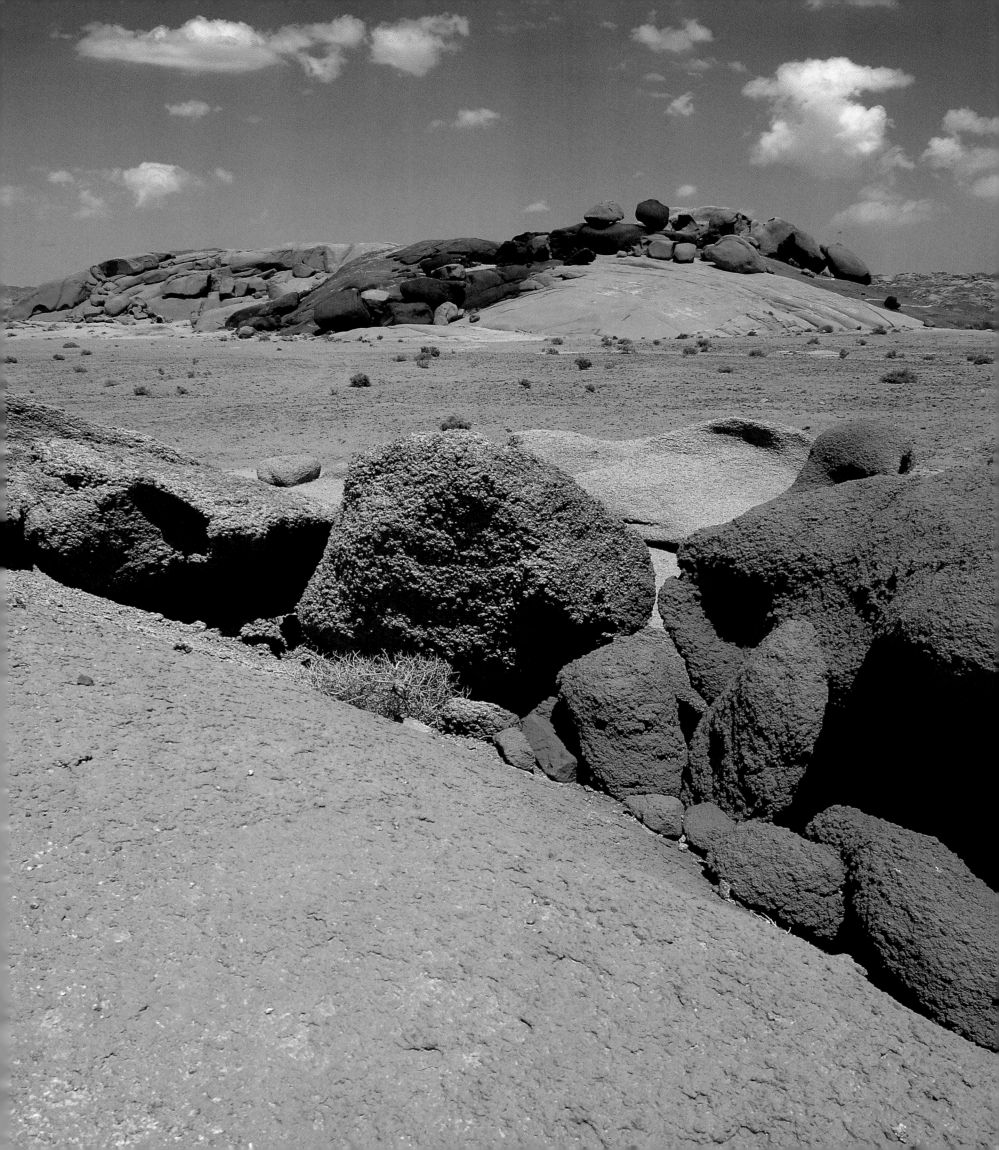

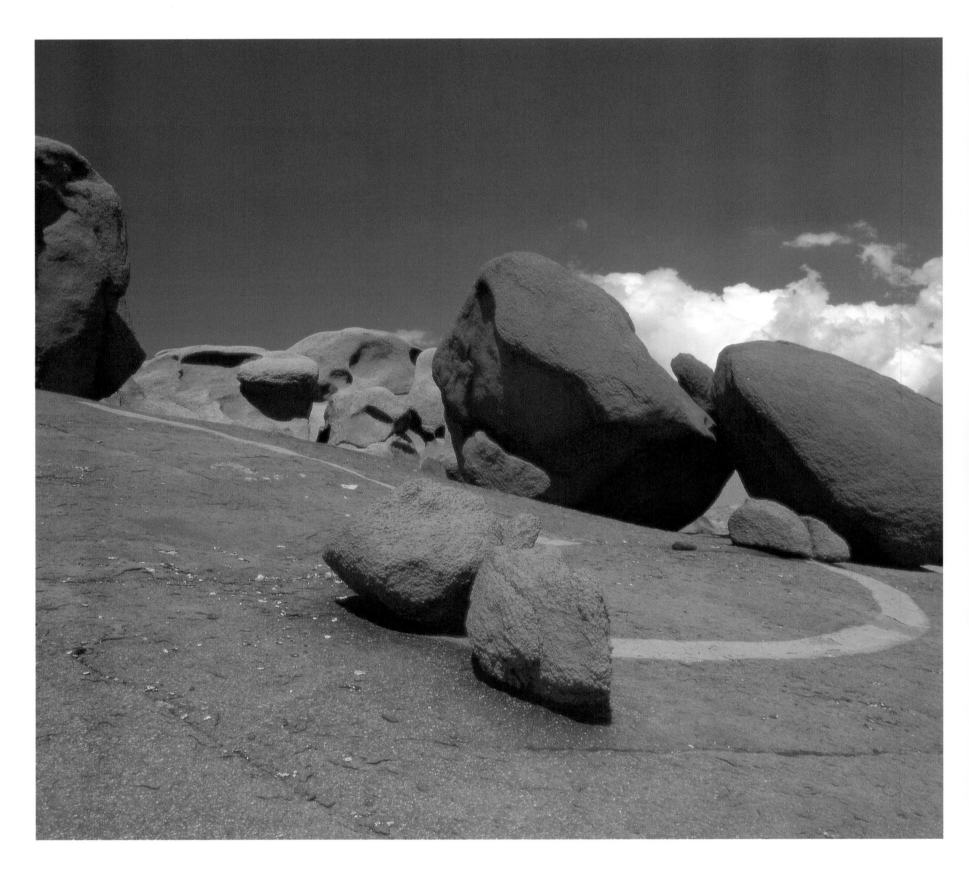

The *Blue Mountains,* land art by
Jean Verame, southern Sinai
Die *Blauen Berge,* land art von
Jean Verame, Süd-Sinai
Les *Montagnes bleues,* land art de
Jean Verame, Sud du Sinaï

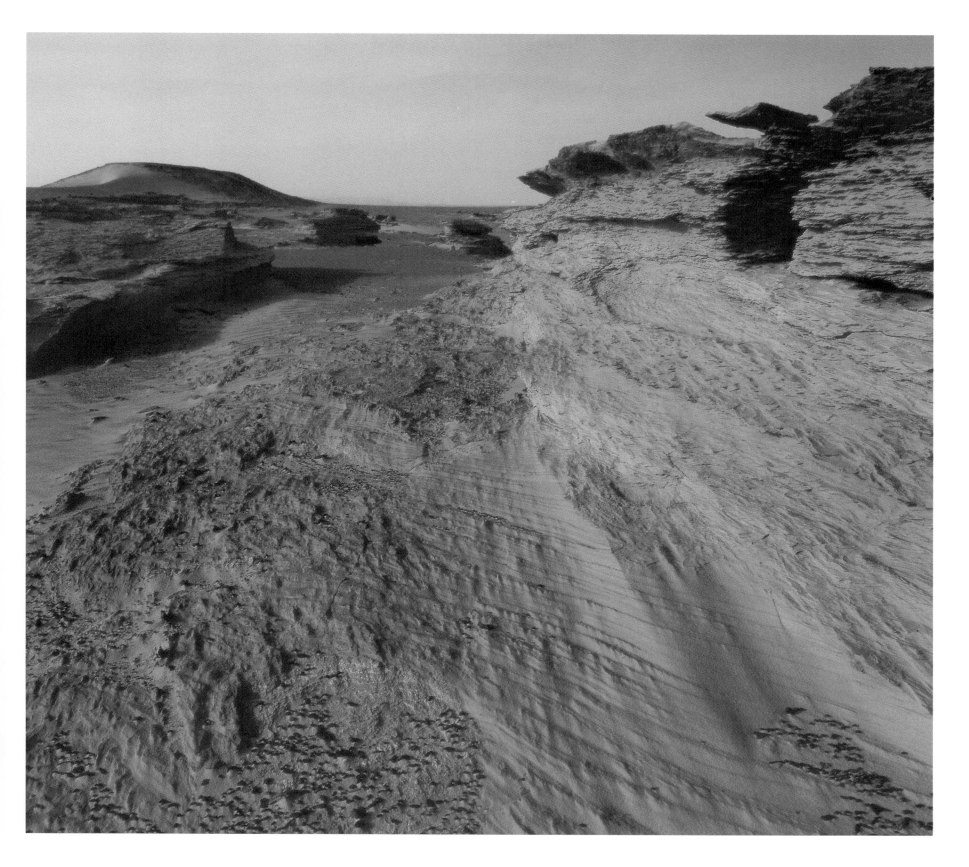

Central Sinai
Zentral-Sinai
Centre du Sinaï

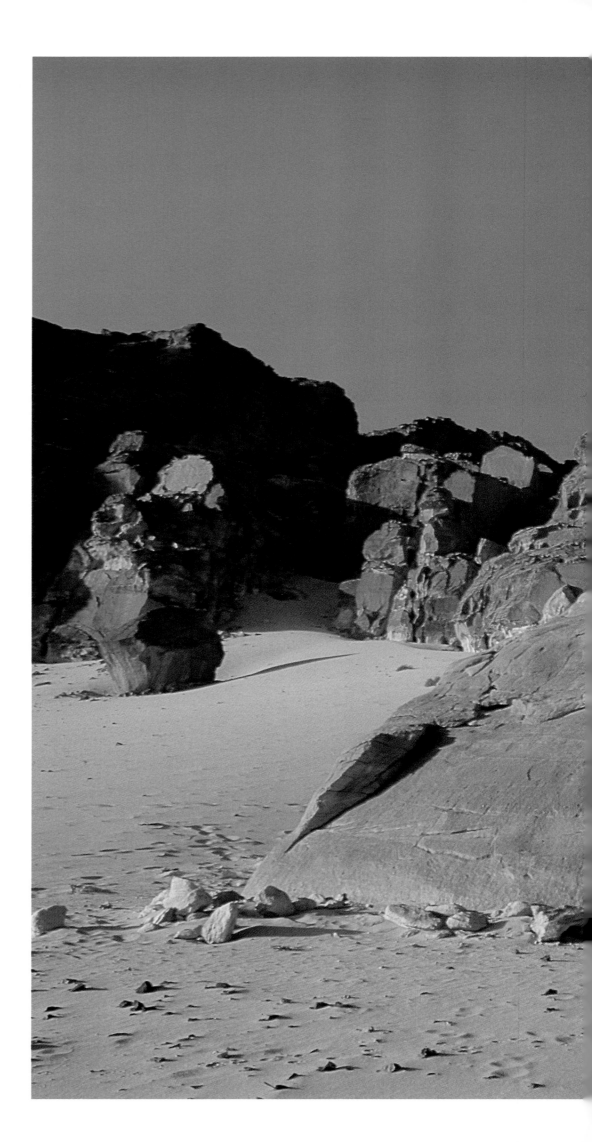

Eastern Sinai, near the Red Sea
Ost-Sinai, in der Nähe des Roten Meeres
Est du Sinaï, près de la Mer Rouge

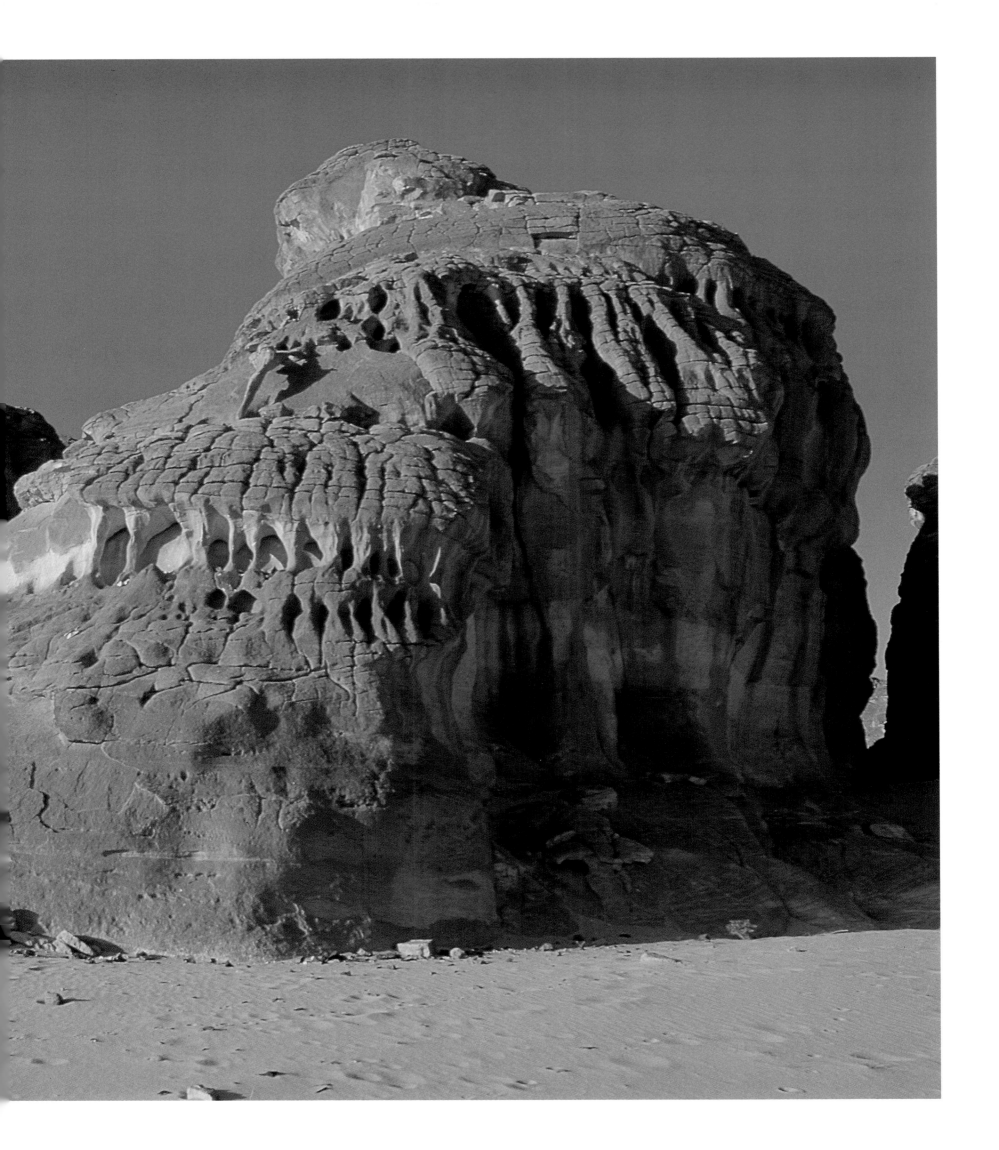

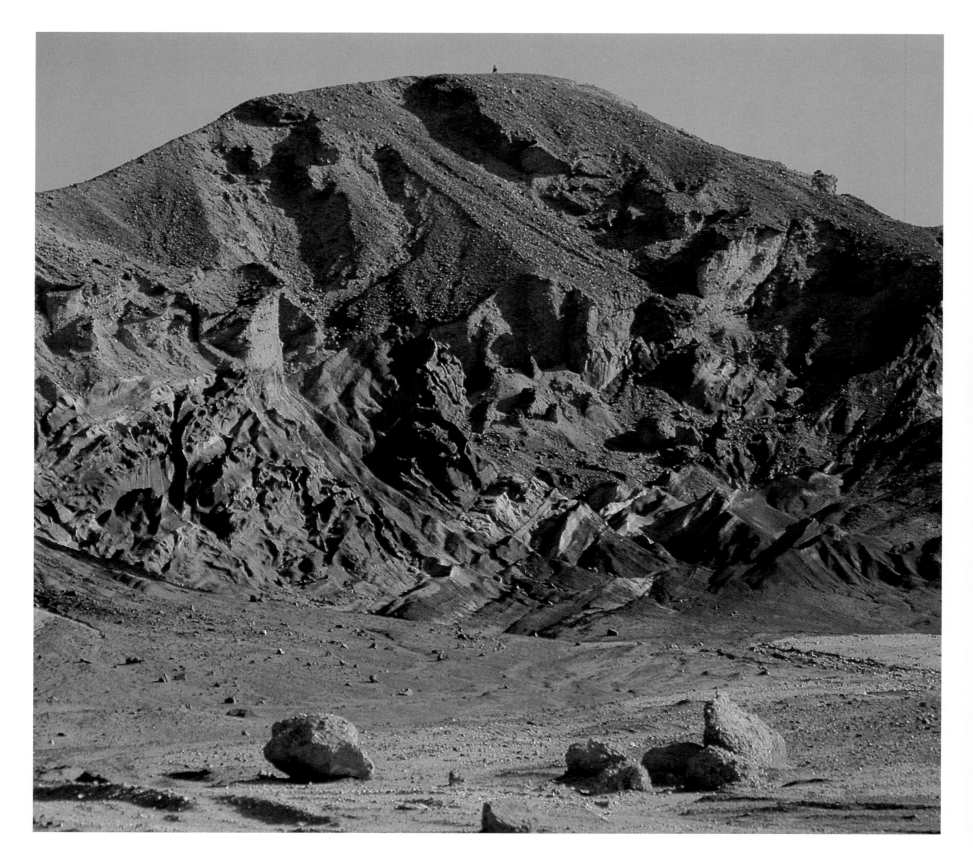

Northeast Sinai
Nordost-Sinai
Nord-est du Sinaï

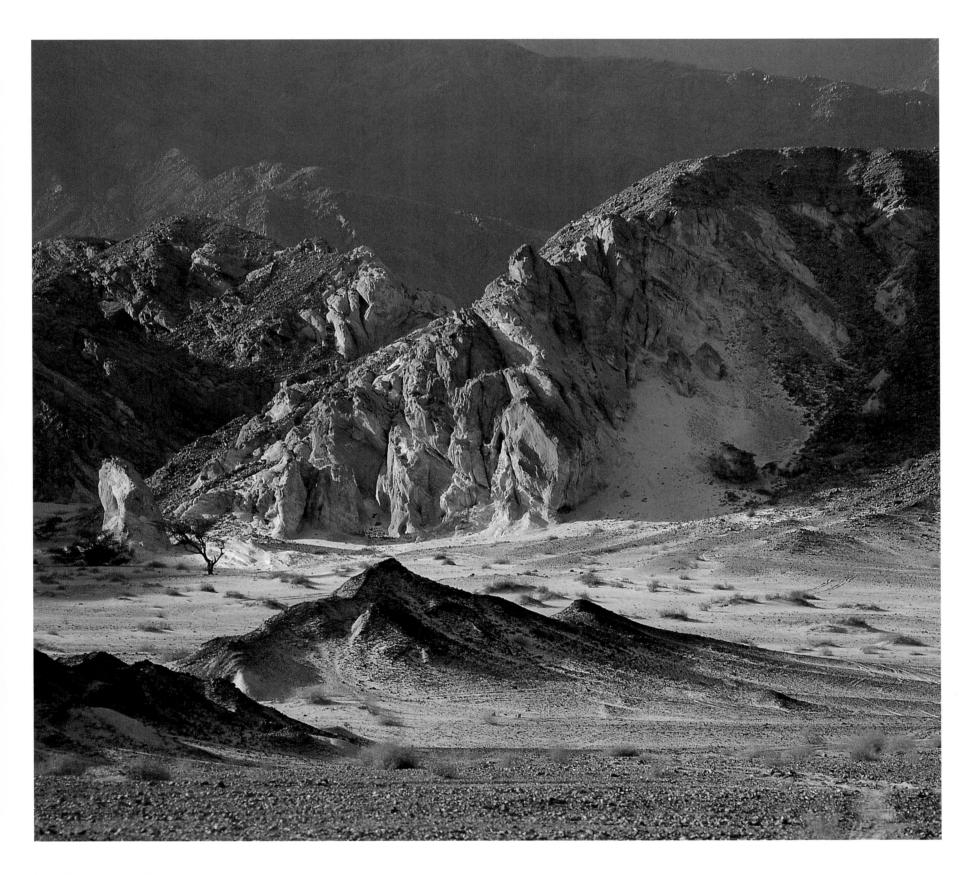

Morning, southern Sinai

Der Süd-Sinai im Morgenlicht

Le Sud du Sinaï dans la lumière matinale

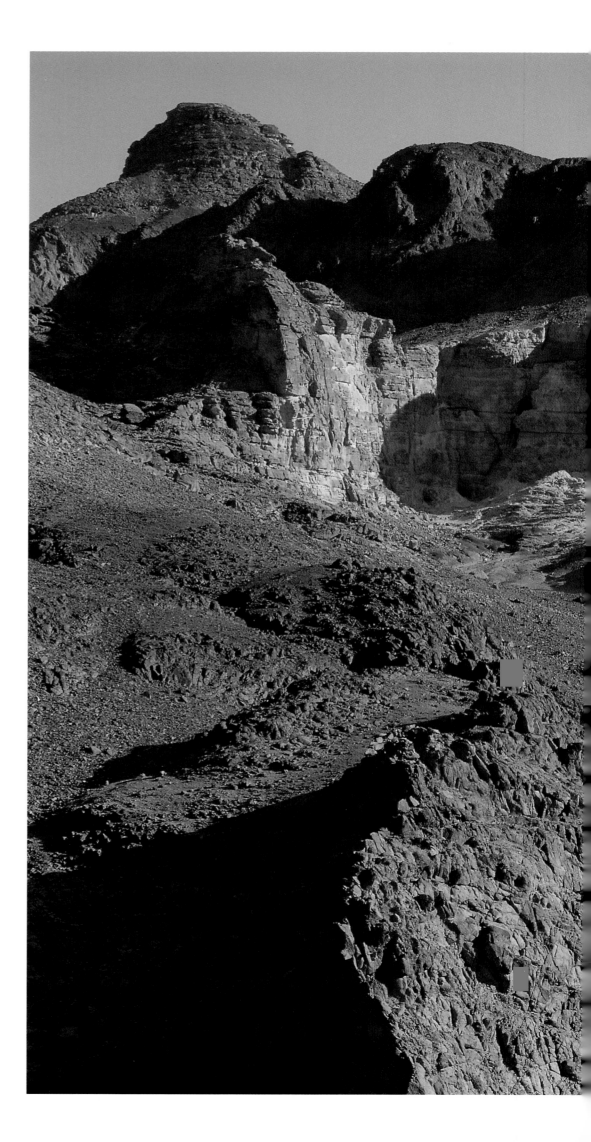

Central Sinai
Zentral-Sinai
Centre du Sinaï

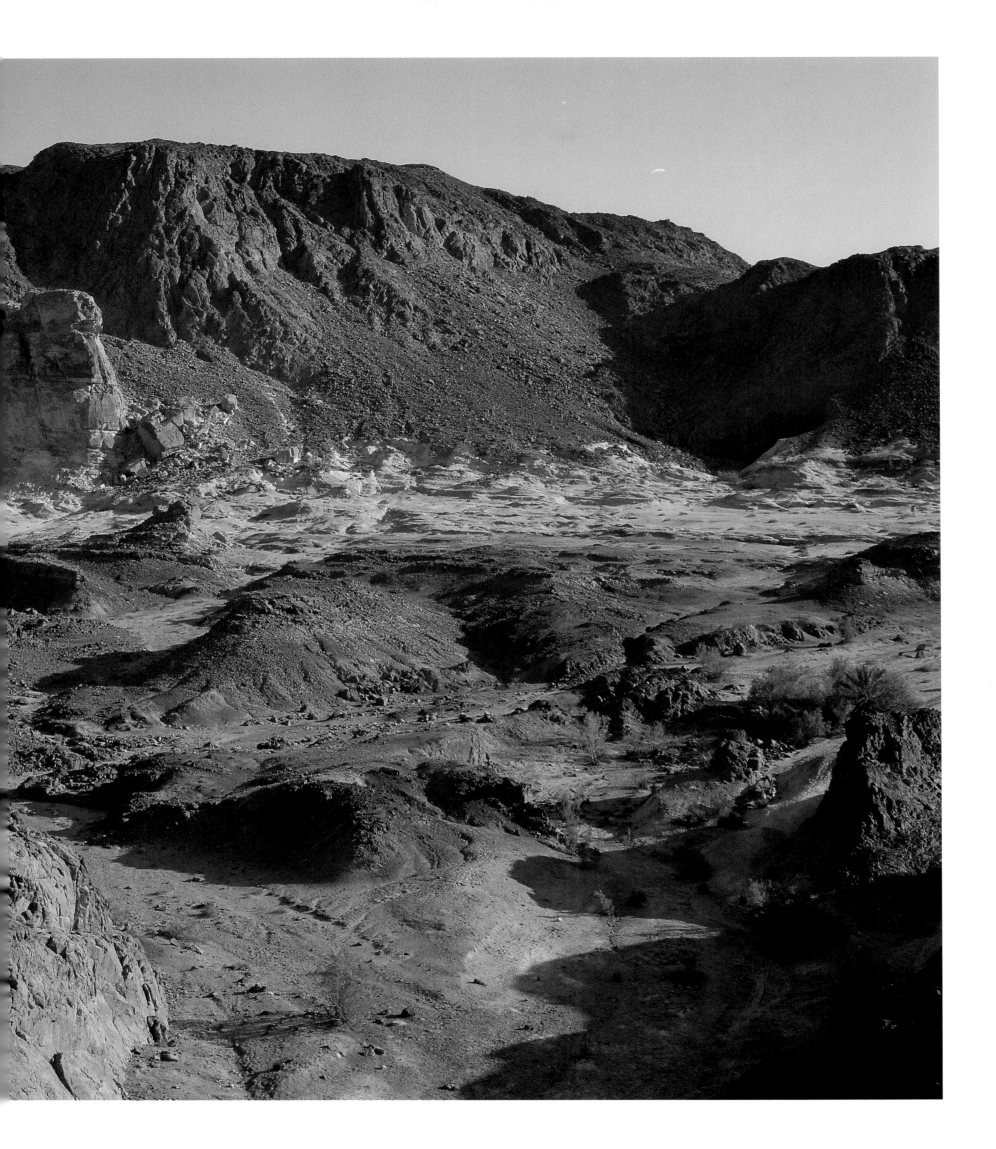

Forest of Pillars

Weird shapes like tree trunks, made of stone like volcanic tuff, rise as much as two and a half metres up from ground level. How these pillars at the end of a wadi reaching deep into the heart of Sinai came about remains an unsolved mystery.

Forest of Pillars

Ungewöhnliche und bizarre »Baumstümpfe« aus lavaähnlichem Gestein ragen hier bis zu zweieinhalb Metern Höhe aus dem Boden. Die Herkunft dieses »Säulenwaldes« am Ende eines Wadis, das sich bis tief ins Innere des Sinai erstreckt, ist bis heute ungeklärt.

Forest of Pillars

Des «souches» bizarres, insolites, faites d'une roche ressemblant à de la lave, s'élèvent à deux mètres cinquante du sol. L'origine de cette «forêt de colonnes», au bout d'un oued qui s'enfonce profondément dans l'intérieur du Sinaï, n'a pas encore été découverte.

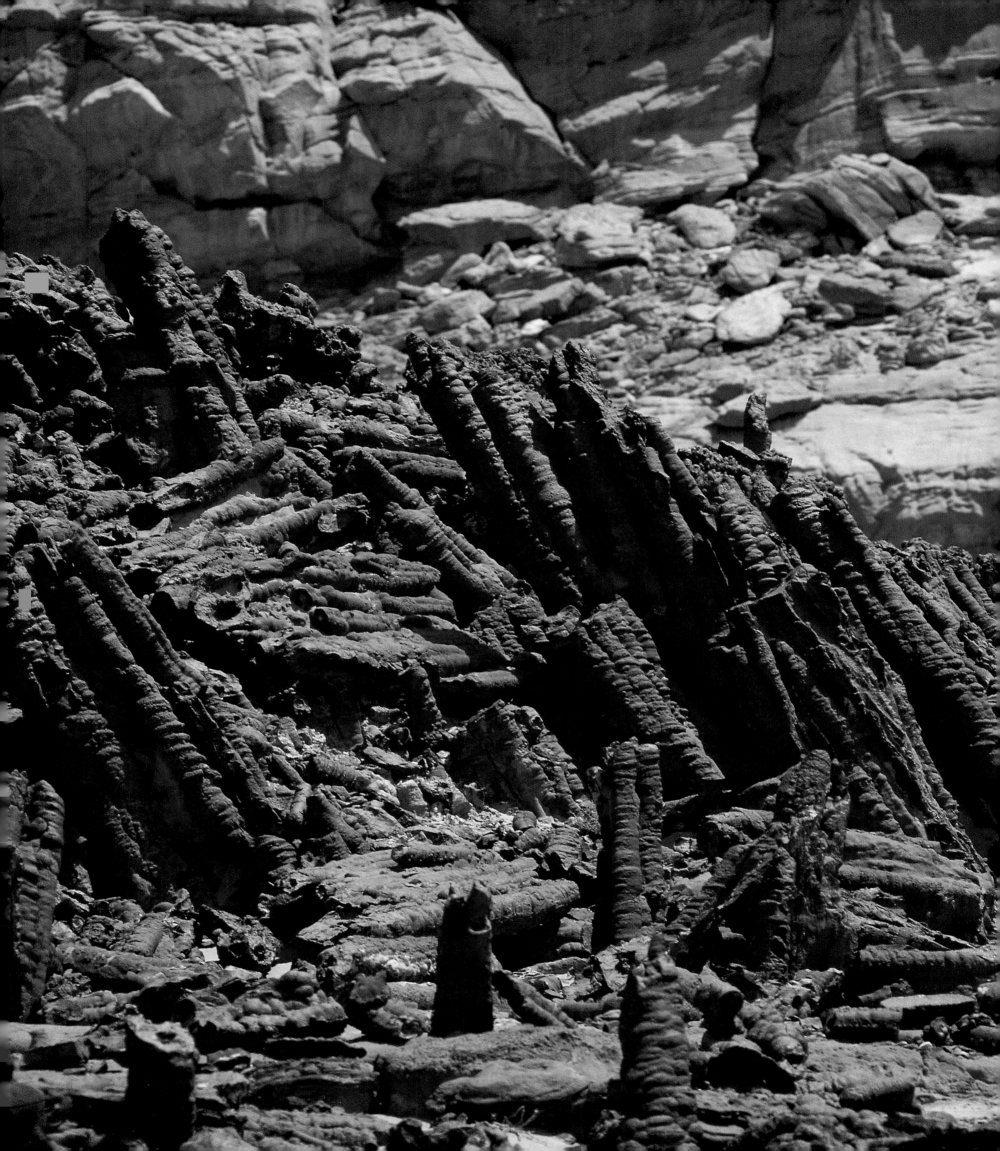

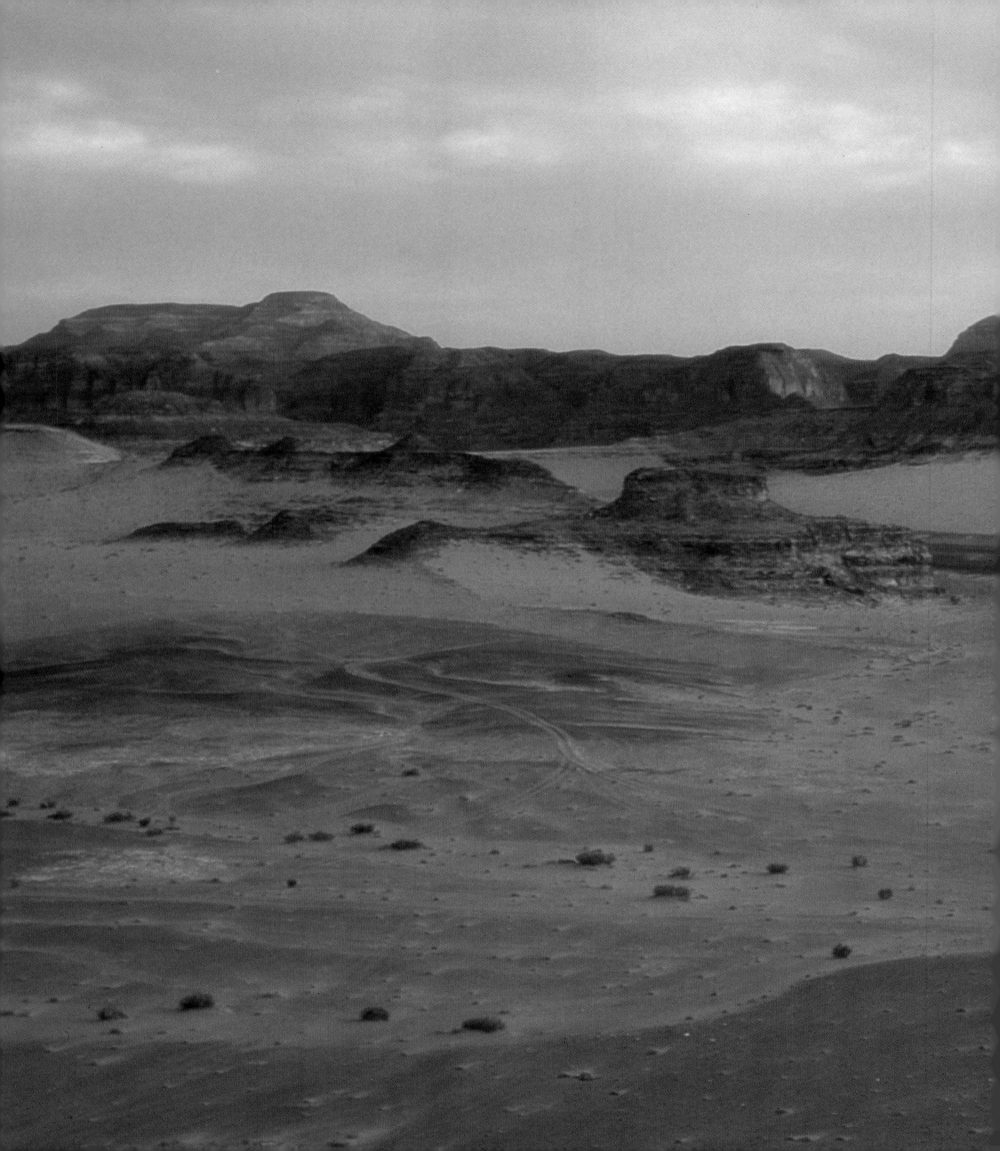

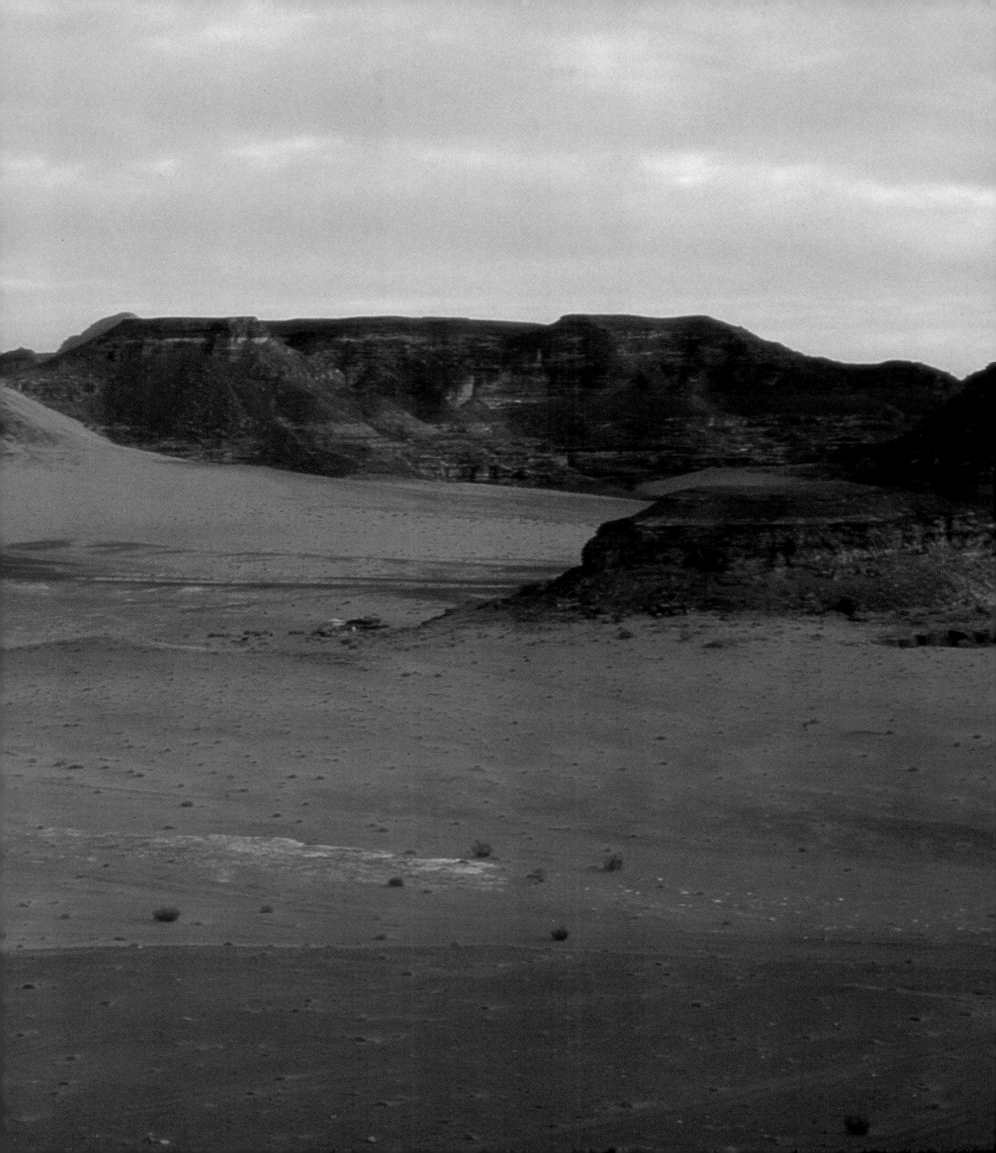

Evening, central Sinai
Abendstimmung über dem Zentral-Sinai
Atmosphère vespérale au-dessus du centre du Sinaï

Mountain on a plateau, central Sinai
Berg auf einem Hochplateau, Zentral-Sinai
Montagne sur un haut-plateau, centre du Sinaï

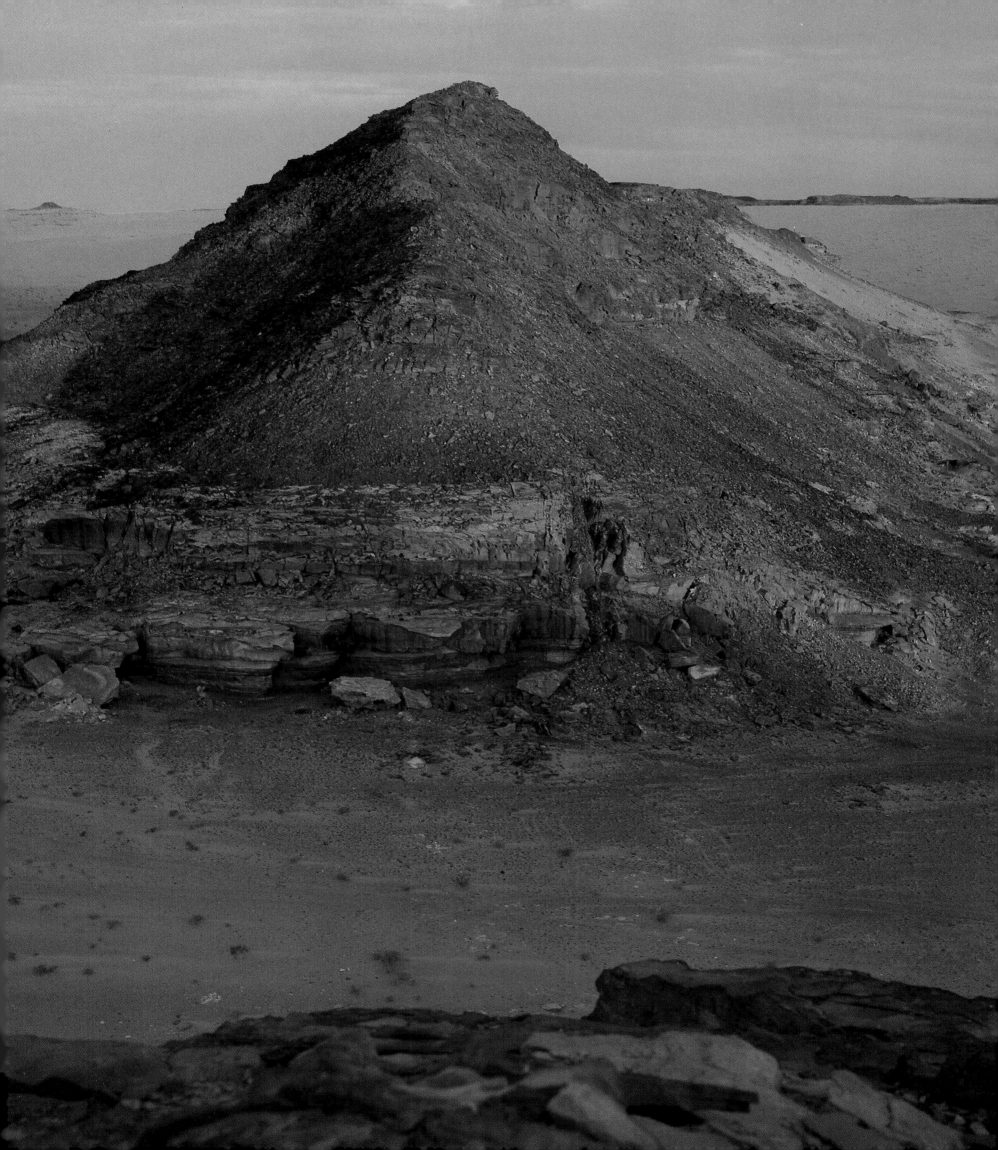

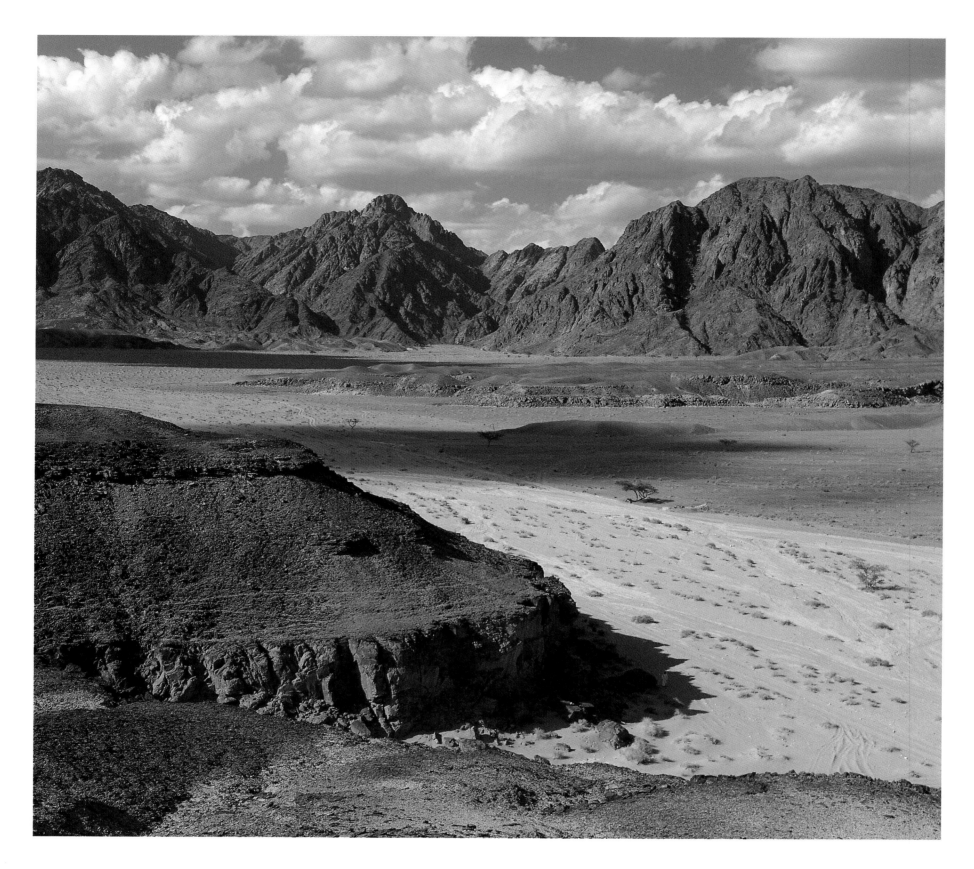

Wadi El Garf, southwest Sinai

Das Wadi El Garf, Südwest-Sinai

L'oued El Garf, Sud-Ouest du Sinaï

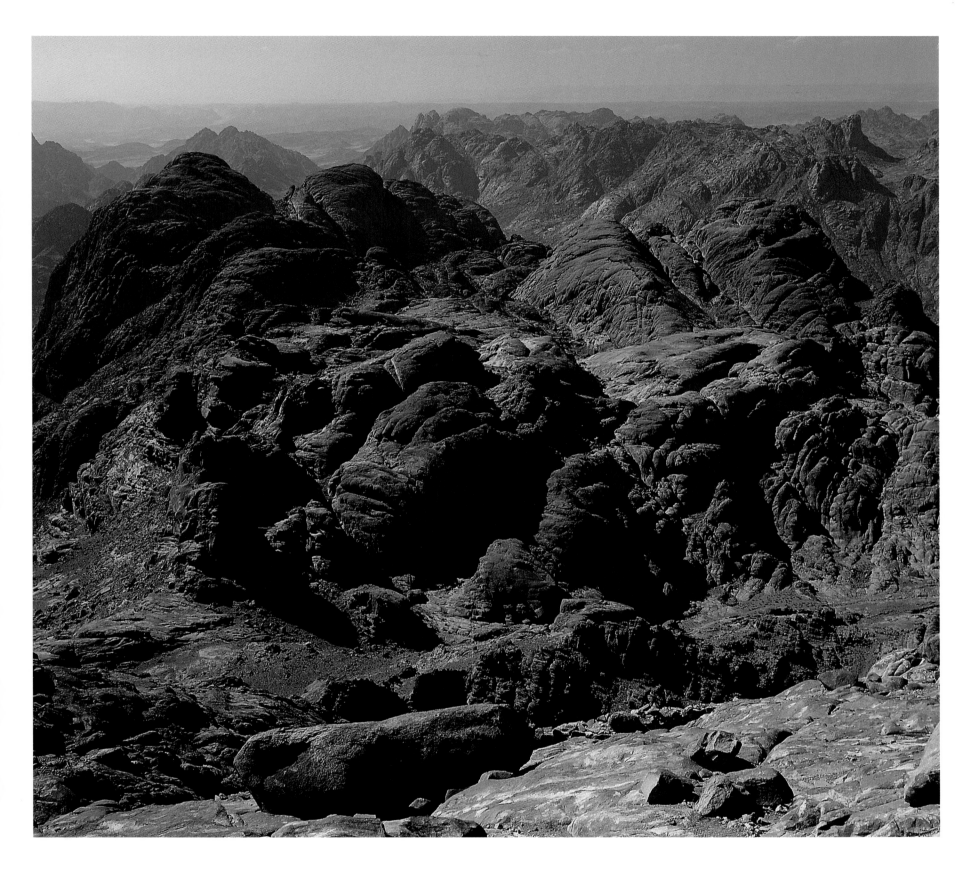

The granite desert of Sinai
Die Granit-Wüste des Sinai
Le désert granitique du Sinaï

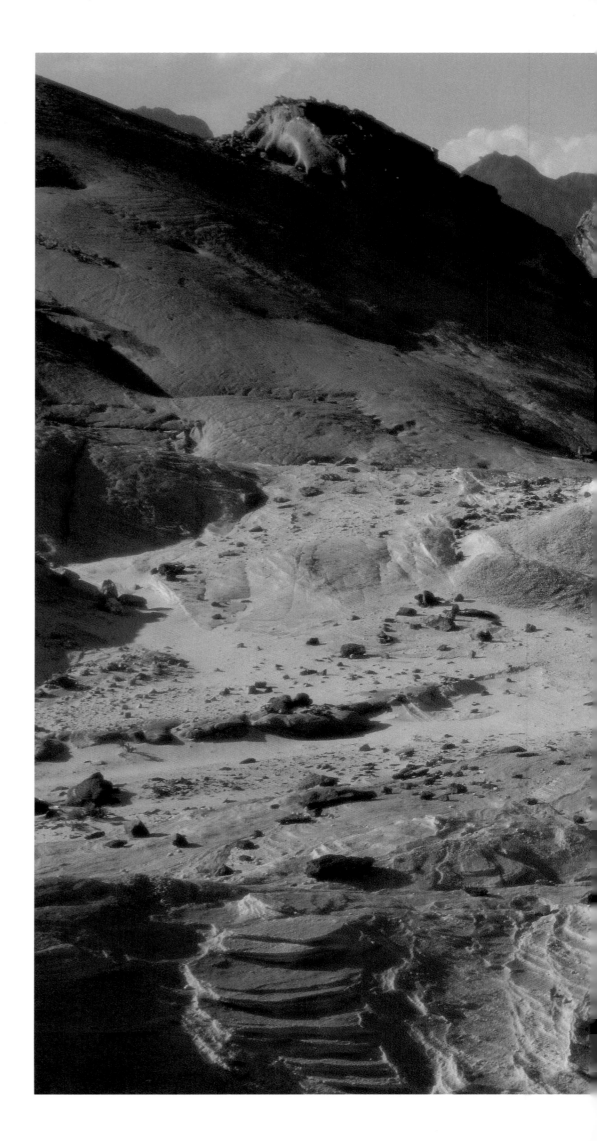

The valley of limestone crags, eastern Sinai
Das Tal der Kreidefelsen, Ost-Sinai
La vallée des falaises de craie, Est du Sinaï

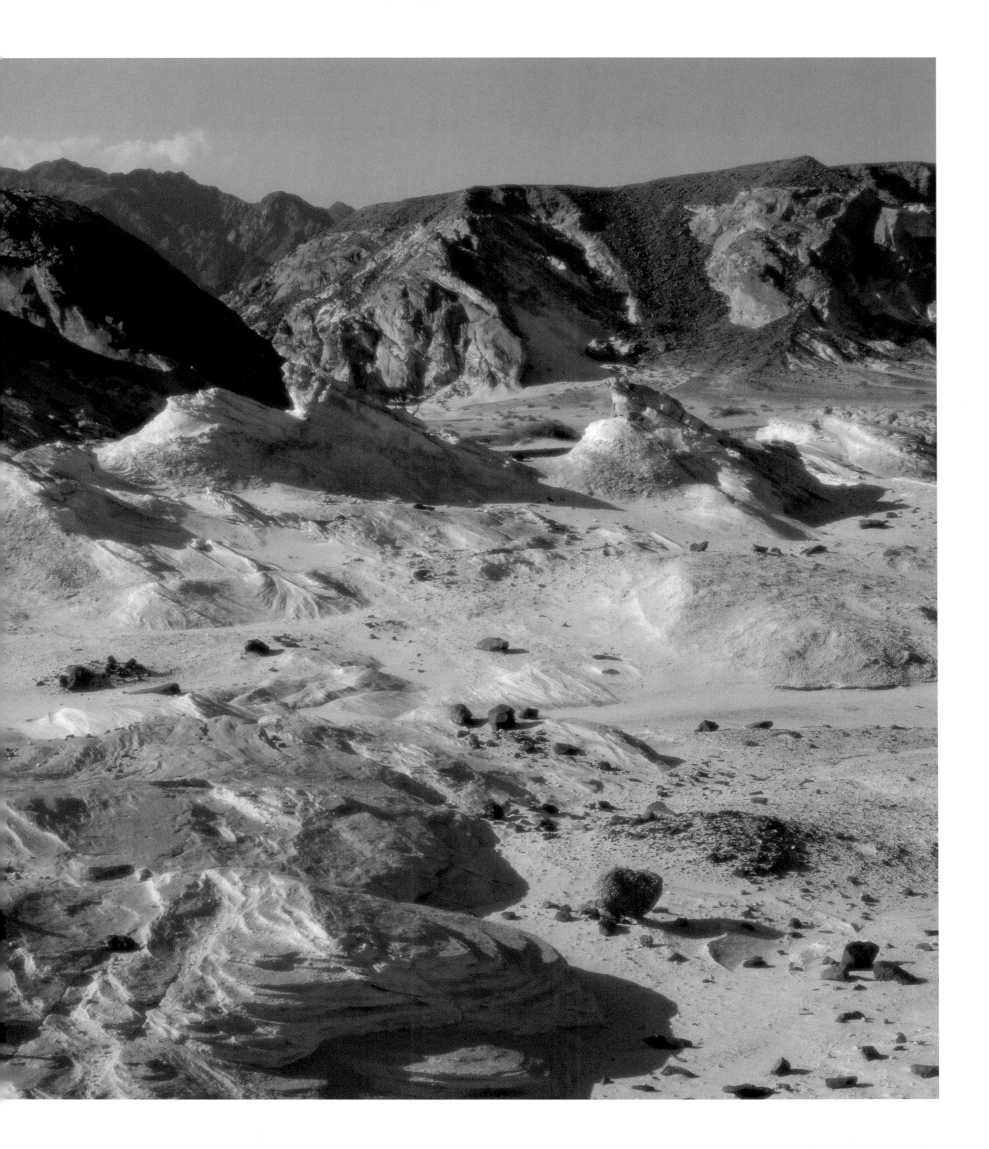

Evidence of the floodwaters in western Sinai
Spuren der Wasserfluten, West-Sinai
Traces d'inondation, Ouest du Sinaï

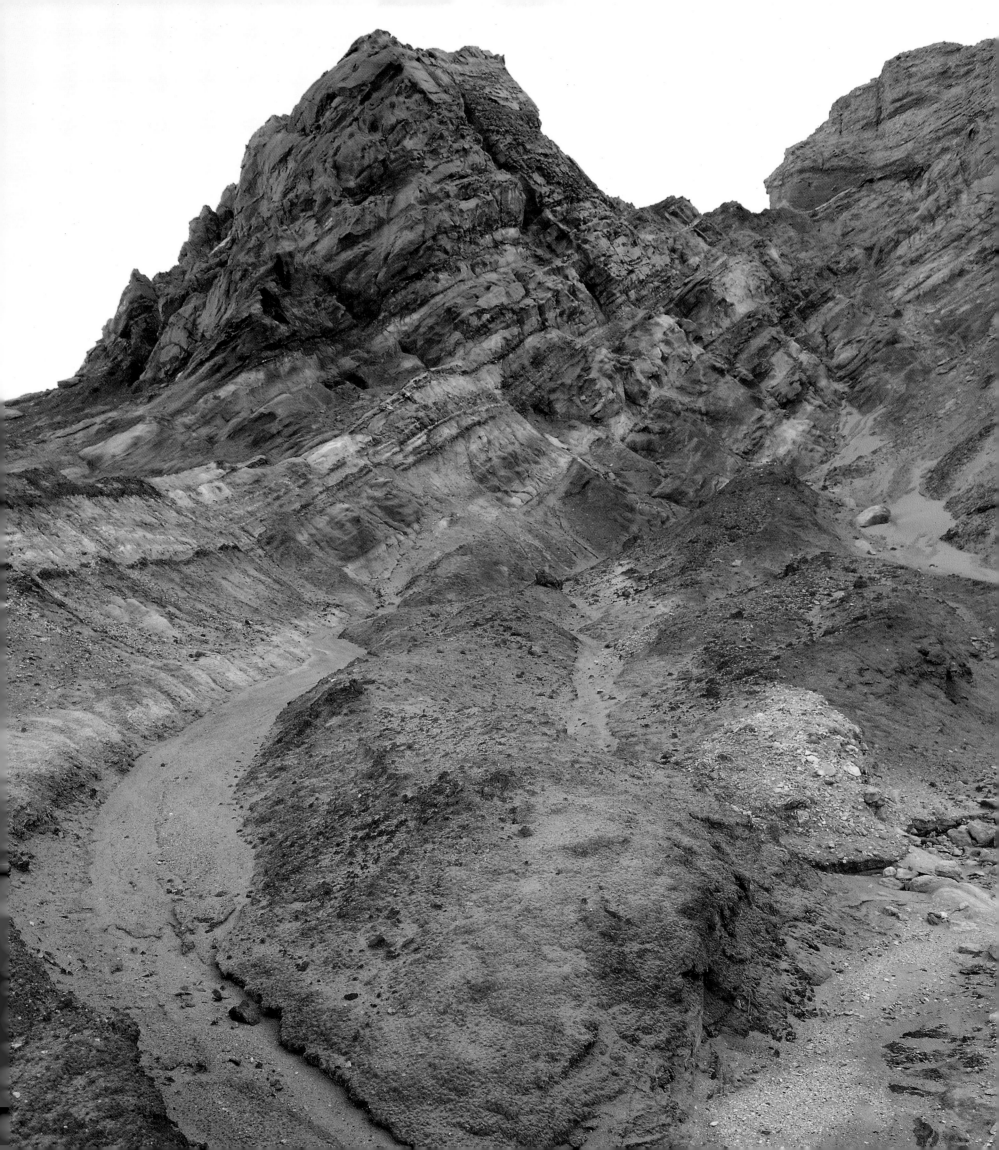

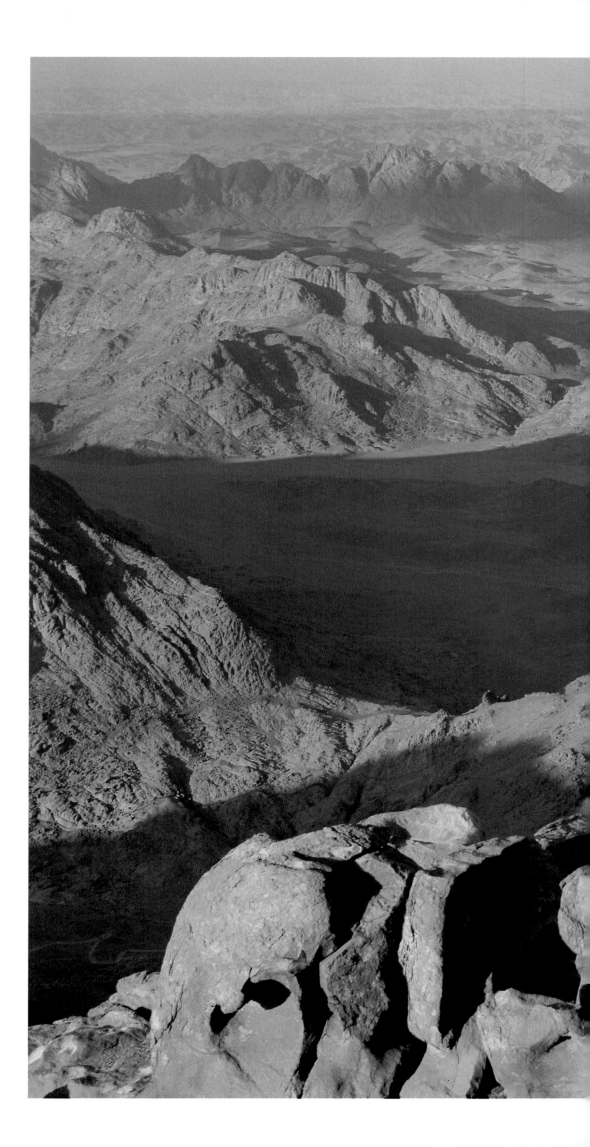

The rock desert of Sinai from Mount Sinai
Die Felsenwüste des Sinai vom Moses-Berg
Le désert rocheux du Sinaï, depuis le mont Moïse

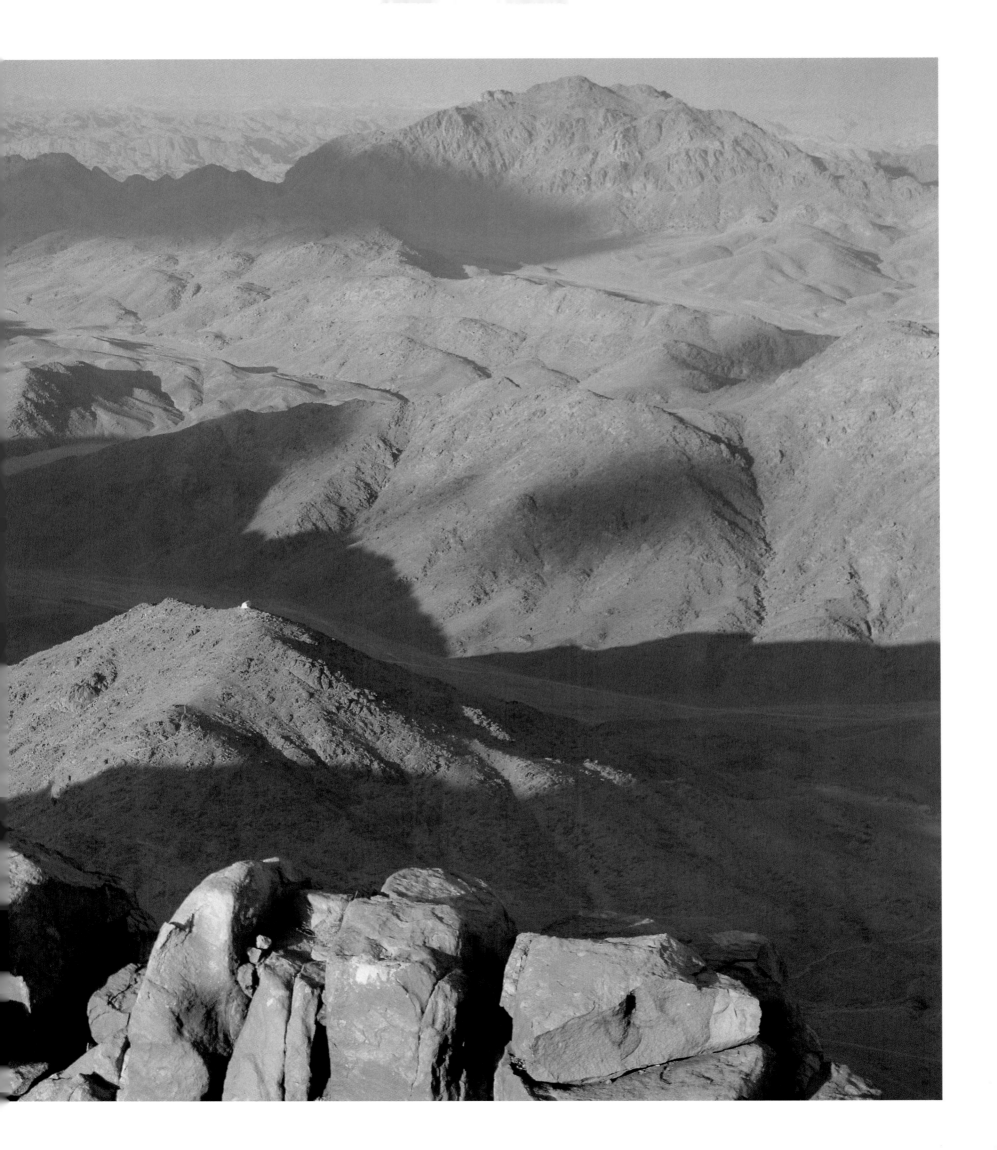